Worldview in Painting–
Art and Society

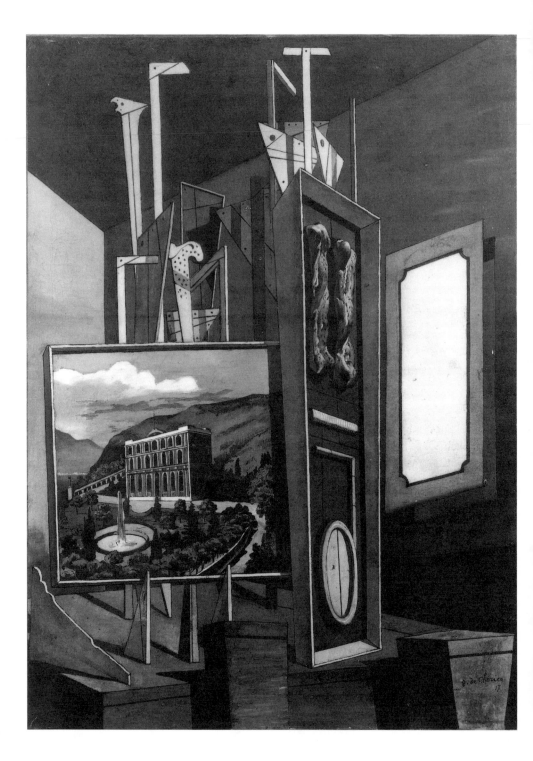

Meyer Schapiro

Worldview in Painting – Art and Society

Selected Papers

GEORGE BRAZILLER NEW YORK

First published in 1999 by George Braziller, Inc.
Text © The Estate of Meyer Schapiro

For information, please write to the publisher:
George Braziller, Inc., 171 Madison Avenue, New York, New York 10016

LIBRARY OF CONGRESS CATALOGING-IN-PUBLICATION DATA:

Schapiro, Meyer, 1904-96
 Worldview in Painting—Art and Society / Meyer Schapiro
 p. cm. — (Selected papers ; 5)
 Includes index.
 ISBN 0-8076-1450-5
 1. Art and society. I. Title. II. Series: Schapiro, Meyer, 1904-96
Selections. 1977. Braziller ; 5.
 N72.S6 S313 1999 98-52977
 701'.03—dc21 CIP

Frontispiece: Giorgio de Chirico, *Great Metaphysical Interior,* 1917, oil on canvas, 95.9 x 70.5 cm., Museum of Modern Art, New York.

Design by Rita Lascaro
Printed and bound in the United States

FIRST EDITION

CONTENTS

The Future of the Arts

The Profession of the Artist

The Responsibility of the Artist

PREFACE

Part I of this volume contains two essays that address the theme of philosophy in painting. The first text, entitled "Philosophy and Worldview in Painting," consists of transcribed recordings of lectures given by Meyer at the Walters Art Gallery, Baltimore (1958), at the University of Texas (1965), at Brooklyn College (1965), at Harvard University (1966), and at Wolfson College, Oxford (1968). The author approved of this portion of the manuscript. I supplemented this text with additional texts from his typed notes and recorded lectures on the subject of philosophy and worldview in painting. They include selections from his "Notes of 1960" as well as essays on Humbert de Superville from his files on Georges Seurat and passages on Bergson, Theosophy, and abstract art. The section on seascapes was transcribed from a lecture the author gave in 1974 in a Columbia University course on the interpretation of art.

"Cézanne and the Philosophers" is a transcription of a lecture given on October 11, 1977 at the Museum of Modern Art, New York, in conjunction with the exhibition entitled "Cézanne: The Late Work."

The second part of this volume concerns the relationship of society, art, and the artist, a subject on which Meyer spoke, lectured, and published. In addition, from the early 1930s on, he wrote notes of varying lengths and short essays on these subjects—the manuscripts, some undated, were all in his files—and they have been minimally edited and

reprinted here. He might have rejected some, he would undoubtedly have rewritten much, since he never picked up his writing without altering it.

Throughout his life Meyer strongly admired artists and felt a deep sympathy with them. (He did not feel he was an artist although he had been painting since childhood.) He remained concerned with these subjects, but it was principally in the 1930s that he wrote and lectured on them, while publishing only a small part of that work.

The relation of the artist to society that so concerned him has not changed for the better since then.

I am grateful to Robin Sand and Robert Melzak for their ready help; to Martin James for advice on Mondrian; Irene Gordon and Paul Mattick for editing the Cézanne text; and to Michael Fitzgerald for assistance in dating "On the Art Market."

<div align="right">—Lillian Milgram Schapiro</div>

PART I: PHILOSOPHY IN PAINTING

PHILOSOPHY AND WORLDVIEW
IN PAINTING

B Y "PHILOSOPHY IN PAINTING" I MEAN THE INTERPRETATION OF a painting or a style of painting as expressing a philosophy or as corresponding in some way to the thought of a philosopher. A style of painting is often likened to a worldview, a mode of thought, a metaphysical system; I shall use these terms interchangeably with *philosophy,* although I'm aware they are not strictly synonymous; I shall try to correct this looseness later.

In reading the literature on art, you have surely come upon comparisons of a painter and a philosophy: Poussin with Descartes, Cézanne with Kant or Bergson; Courbet with positivism and materialism; Gothic art as a whole with scholastic teaching; Greek art with Plato; late antique art with Plotinus; Monet with pantheism; the Impressionist school (in general) with a phenomenalistic empiricism, and so forth.

How are such comparisons possible? Philosophy is a discursive discipline, developed through language, and works at a high level of logical abstraction. We can easily imagine poets and novelists philosophizing, since their medium is language; their poems and stories often contain reflections—analyses and general statements about the world and human nature—and employ concepts that might find a place in a philosophical treatise. But a painting is not discursive; it is, throughout, a concrete individual object; we grasp its parts immediately and sometimes simultaneously, all together as a whole, as we do an object in

nature, without reflection. The comparison with philosophy depends on a special view of both painting and philosophy, which makes painting a type of knowledge and the philosopher's thought an expressive physiognomy of a thinker.

Such comparison is supported by a number of characteristics of painting, at least in our Western tradition, and also in China.

Painting has been an art of representation and, as such, of selected themes interesting to the artist. It therefore rests on a more or less explicit judgment of what is significant or valuable to him in objects and experiences; it exhibits a point of view, his ideas and feelings. Moreover, in representing objects the painter introduces an order among them; he imposes schematas; his picture of beings and things is also a habitual construction in a coherent style, with definite properties that may be chosen arbitrarily or in approximation to what is regarded as most characteristic or typical in the structure of bodies; it implies a widely held general aesthetic theory about what makes for the order, completeness, and harmony of the whole. Further, the representation has expressive qualities, which may be seen as belonging to the things and their meaning or congenial to the artist's feeling for those aspects. One kind of artist, like Giotto or Poussin, seems to us more objective, he varies the expression according to the mood of what he is representing—giving the Crucifixion qualities of pathos, and the Wedding of the Virgin a ceremonial or festive aspect; while El Greco imbues all subjects with an intense excitement or exaltation, which seems to be his constant state of feeling. All this recalls parallels in philosophy, for philosophy, too, is described as a view of the world that varies according to the relative importance given to the objective and subjective components in knowledge, and is marked by a pervading tone of the emotions of the philosopher's personality.

The language of art theory and criticism itself suggests such interpretations and analogies. You will find there—in the written vocabulary of artists as well as of critics and historians of art—the words *form, matter, space, nature, value, valid, real, order, structure, essence, logic, unity, coherence, sign, meaning, symbol, truth,* which are also the currency of philosophers's discourse. In the last decades, they appear even in the titles of pictures—I have seen in a show of abstract painting some years

ago one with the title: *Goedel's Theorem,* and more recently: *Zorn's Lemma,* a title from logicians. Besides, the painters read or hear of philosophy and sometimes frame their reflections on their art with the concepts of recent philosophical thought. Similarly, the philosophers are up on painting and refer to the art in metaphors and illustrations of their thought (as in the case of Ludwig Wittgenstein).

Another ground of such comparisons of painting and philosophy is the historian's conception of the culture of a time and place as a unity based on a common underlying worldview. All manifestations of a period of culture are believed to share certain characteristics; a common style is found in all or most of the higher activities, so that the arts, sciences, religion, social conceptions and ideologies, and other forms of a culture appear to be of one family marked by typical features. With this theory of culture, the historian is likely to look for similarities between philosophy and painting. And philosophy, being the field in which the worldview or mode of thought is most explicit, is especially relevant to the explanation of the style or content of painting as the expression of a worldview.

Without going so far as to assert that a culture is unified through the common worldview or mode of thought in its various fields, other writers have observed in a philosophy a specific content and attitude arising from the problems and needs of the society and culture of its time and place. This was recognized by John Dewey when he explained certain features of Greek philosophy by the forms of Greek society.[1] Since the same situations and values hold for the painter, and since the original artists create new styles that are felt to be reactions against or developments beyond an existing style, there may well be similarities of content between philosophy and painting, in spite of their different means and functions.

Finally, on a completely unhistorical plane, philosophies have been interpreted psychologically as works of art with a personal physiognomic expression, like paintings. This is Karl Jaspers's method in his book on the psychology of philosophers. He discerns a few typical attitudes that appear in far-separated works: the rational, analytic systematic mind; the intuitive, aphoristic, the objectivizing; the inwardly turned thinker; and complex variants of these types. So philosophy is said to

have an expressive, personal dimension that enters into the content of thought as well and suggests an obvious comparison with the artist's work. It is no doubt true that much in a philosopher's writing appears to us more personal, closer to his disposition in other matters, when we know the man himself. No one who had heard G. E. Moore lecture will miss the personal note in his writings. William James was particularly aware of the intimate tie between philosophic reflection and personal traits; he wished philosophers to recognize it and accord it a larger place in their account of the world. This was not because he was a psychologist as well as a philosopher; there have been few psychologists like James, and what makes his treatise on psychology so fascinating, so warmly human, is precisely his deep concern with the human as the individual personal—a theme that was rare in the experimental psychology of his time—it is the same concern that directed his philosophical thinking. Some philosophers have criticized the tendency of other philosophers to imitate scientists in adopting an impersonal analytic approach and pretending to certitude and rigorous scientific results. Those critics believe that the central subject of philosophy should include—take account of—man, not man in general as a rational thinker but man as known through the life experiences and problems of the philosopher himself. It is in this vein that Søren Kierkegaard made his joke about Hegel, who constructed a vast system of the universe, but in this gigantic construction allowed for the philosopher author only the smallest place, the kennel. The same criticism was made of science by the physicist Erwin Schrödinger; he compared science to Dürer's picture of *All Saints* in which the artist who designed the work appears as an insignificant figure in a corner, although it is he who is responsible for the whole. I may remark here in passing that Schrödinger has identified here two fairly distinct activities, science and the philosophy of science. For while the first aims to describe the world including man, the second is interested as much or more in the human process of describing the world, the conditions and norms of knowledge. But his comparison of the scientist with Dürer has a perhaps unintended appropriateness, since Dürer was a highly intellectual artist who wished to build representation on scientific principles, yet impresses us by his religious earnestness and strong personality.

That painting has a philosophical content and that there is much in common to both fields has been asserted by philosophers as well as by philosophically minded poets, critics, and painters. I shall cite a few texts to illustrate this view.

The oldest and most emphatic statement that I know is by Giordano Bruno:

> The first and chief painter is the liveliness of fantasy, the first and chief poet is...enthusiasm...
>
> The philosophers are in a certain sense painters, the poets are painters and philosophers, the painters are philosophers and poets; true poets, painters and philosophers love each other and admire each other mutually. He is no philosopher who does not poetize and paint. Therefore it is said not without reason: to understand is to contemplate the figures of our fantasy... He is no painter who does not in a certain sense poetize and think, and without a certain thinking and painting, no one is a poet. (*Ars reminiscendi,* ed. Gfroerer, p. 529)

More recently, Friedrich Hegel wrote: "Every single phenomenon represented in a work of art should suggest the presence of a greater and more universal idea."

Wolfgang Goethe, writing on style, said that many individual forms of movement should have something to tell us about the world process; and every painting, every poem, becomes a miniature condensation, or let us say, mode of rendering concretely what belongs to a much larger field than itself and which brings us to an experience of a significant totality.

Similarly, Ruskin wrote "that art is greatest which conveys to the mind of the spectator by any means whatsoever the greatest number of the greatest ideas." Just imagine the consequences of that for the judgment of every painting or poem. It becomes then an object of intellectual exploration in order to determine its quantity of ideas and their place in a hierarchy of ideas in which there are the lower, nobler, and the most universal ideas—the ideas of the greatest scope. We can see Ruskin's own difficulty with this statement or perhaps his innocence of

its implications when he said of Kate Greenaway, that the Englishwoman, who made delightful pictures of children for children's books in the 1870s, was the greatest philosophical mind of her age. For him certain profound truths were embodied in her way of drawing children, flowers, and animals. There is something to be said for that point of view if, however, we can be clear as to what it really means, what is entailed by such a description of works of art.

Joshua Reynolds: "He [the painter] like the philosopher, will consider nature in the abstract, and represent in every one of his figures the character of its species" *(Third Discourse on Art).* —"The great painter addresses the mind and the heart, not the eye."

Hippolyte Taine: "Beneath every literature there is a philosophy. Beneath every work of art is an idea of nature and of life."

It is assumed in such statements that both painting and philosophy are forms of knowledge, and give us truths about the world.[2] The authors I have quoted do not always distinguish in art between knowledge of particulars and of universals. The modern literature on painting abounds in propositions about styles as presenting the structure of reality or the laws of nature: This notion appears also in writing on nonrepresentative "abstract" painting.

The literature on art that affirms such correspondences does not follow a consistent method in answering these questions. The scholar selects from the art and from the writings of a philosopher whatever features seems to him similar or analogous. For Gothic art, it is the magnitude, multiple detail, rich articulation, or impression of infinity; these are matched with corresponding features of Thomas's *Summa Theologica.* It is not the specific content of the Schoolman's doctrines or metaphysical propositions but some large aspect of the form of his writings as a style of philosophizing. If, however, one is explaining the sculpture and painting of the time, as did Max Dvořák, then the naturalism and idealized forms of the figures on the portals are interpreted as expressions of scholastic statements about nature as God's creation, exhibiting beauty, order, and goodness. But a scholar who wishes to explain the Impressionist art of the nineteenth century finds in philosophies of empiricism, phenomenalism, and atomism the analogs of the painting of sensations of light and color, and the effect of transient appearance.

Yet if different styles correspond to different worldviews or philosophies, it must be difficult, if not impossible, for an observer to regard all styles as embodying truths about the world. He must reject as false or limited in truth many works of art that express what is in his own view an inadequate philosophy. For a rationalist, much in primitive and later religious art is the embodiment of absurd ideas.

This difficulty, arising from the notion that painting, like philosophy, presents truths about the world, is resolved by another conception of philosophy. It is that philosophy does not give us truths about the world—the special chosen task of the empirical sciences—nor does it give us necessary truths, independent of experience, like logic and mathematics—but analyzes the various procedures and conditions of knowledge. Insofar as philosophers speak about the world, they are simply expressing their feelings, their attitudes; they are like artists rather than scientists. Hence, if painting is philosophical, it tells us nothing about nature, it only embodies or conveys, through aesthetically satisfying forms and colors, an attitude toward the world, an emotional disposition, a state of mind. Truth is not in question.

That the philosopher who speaks about the world in its totality is projecting his feelings rather than giving an objective description, was, like so many other modern ideas, expressed by the Greeks. In Plato's dialogue *Cratylus*, Socrates explains the contemporary dynamical view of nature by the philosopher's inner turmoil, dizziness, and inconstancy.

There are writers who believe that it makes no sense to say such things. The philosopher Rudolf Carnap would accept that statement. He believes that a particular music is monistic and another is dualistic. Such painting has a Platonic attitude, another a Cartesian view. Carnap speaks so not to praise the painting but simply to indicate that metaphysics, worldviews—broad approaches to a totality, to many a problem—are not so in a logical analytical sense but rather in the sense of expressing a life feeling or outlook, which affects us emotionally in the art and metaphysics. But only the art gives us aesthetic pleasure; metaphysics gives us, at least for Carnap, perplexity or a headache or a wish to be done with it as a disease of language. This conviction about the metaphysical or worldview content of art is a particularly strong one, because of suggestive congenial community of terms between meta-

physics—one might even say, philosophy in a stricter sense—and the arts, painting in particular. Many of the terms that we read in books on philosophy and metaphysics and on the theory of worldviews are terms that we meet again and again in the writings of painters, critics, and historians of art—terms like *world, self, nature, cause, time, space, order, logic, truth, duality, and unity*. The number of terms shared by the arts in their specific media and philosophy and metaphysics is extraordinarily large. Hence, it seems natural to connect these two if philosophers raise questions as to whether a world can be understood through a single characteristic feature of a metaphysics, like the painter's "world" as grasped and presented through his artistic style or imagined content.

This is a view that arose in the nineteenth century when the rapid growth of science promised to give positive solutions to problems that philosophers had argued about for centuries without reaching a convincing result. Metaphysics seemed then to belong to an early stage of thought, between theology and science, and had no place in the system of advanced knowledge. It was the view of the physiologist Claude Bernard, who admired the philosophers for their inspiring persistent concern with ultimates, but regarded them as nonscientific minds, who contributed nothing definite to knowledge. Emile Zola, in seeking to found literature on science rather than on philosophy, summarized Bernard as follows: "One has never told the philosophers more precisely that their hypotheses are pure poetry." Claude Bernard regarded the philosophers as musicians, sometimes of genius, whose music encouraged the scientists during their labors, and inspired the sacred flame of great discoveries. "Left to themselves, the philosophers would always sing and would never find a single truth. . . ." Bernard therefore assigned to the philosophers "the role of musicians playing the Marseillaise of hypotheses, while the scientists are rushing to the attack on the unknown." It is clear that Carnap values music above metaphysics, and Zola and Bernard are unmusical.

Another influential writer, Wilhelm Dilthey, has summarized his thought on worldviews in a literary composition, *A Dream*,[3] in which he sees Raphael's great painting, *The School of Athens*. He selects there three groups of philosophers who embody the three types of worldviews. All these are inherent in the nature of the world and in the atti-

tude that finite mind or spirit takes toward it. Each view expresses an aspect of the universe; each is true, but all are partial. They are like the refracted rays of the pure light.

Dilthey continues (this is partly paraphrase and partly excerpt):

> Like art and religion, philosophical systems have as their content a certain conception of life and the world. They do not originate in conceptual thought but deep in the life of the individuals who have erected these systems.... The systems aim to give a total image of the world. They are unscientific and are impelled by an imperious will to express a certain complexion of the soul, undaunted by the contradictions; the systems are narrow, personal, partial attitudes of feeling, like art and religion. They are an expansion of the self in a higher unity of self and world.

The philosopher who has the same goal as the poet—the expression of an ideal of life, or a view of the world in its totality and unity—differs from the poet in his means. The philosopher applies to this common task his powers of thought. This is the primary attitude conditioning the structure of a philosophical system: a search for logical connection and unity. But at the start of every philosophical system is a sustained initial point of view that becomes an immanent element of the subsequently developed system. In the central ideas that are synthesized are elements dangerous to the logical solidity and harmony of the system. An example is Baruch Spinoza's idea of perfection and of mechanistic nature. The vitality of a system is conditioned by its aptitude for explaining the real, which in turn depends on its freedom from contradiction and its satisfaction of our desires. Systems are increasingly broader and more complex, drawing upon older ones, and striving to become ever more rational through reference to the new knowledge acquired by the scientists and in new experience.

The bridge between philosophy and the nondiscursive expressions in art lies in the worldview, that personal outlook or mode of feeling that precedes philosophizing and directs it.

Yet Dilthey's conception of the necessarily limited types of worldview

is not of dispositions without a general character; the types are such large concepts as materialism, pantheism, and subjective idealism; they are already articulated structures of ideas about the totalities of world, soul, or self, which are themselves the outcome of reflection as shaped by temperament and experience.

Dilthey seems to pass lightly from the notion of the worldview as a deep individual disposition in thought to the worldview as a conception.

Worldviews are also superindividual conceptions insofar as one speaks of the Christian, pagan, Buddhist, Jewish worldview. The religions are expressions of worldviews no less than are the arts. Dilthey is able to say that after the Middle Ages the artist expresses more freely his own worldview, which will determine the internal form of artistic creations.[4]

"Worldview" is thus a fluctuating concept and has been applied to social ideologies as well as to philosophies, religions, beliefs, and arts. Borkenau's book on the change from "feudal to bourgeoise worldview" is an attempt to characterize the thinking of successive periods as worldviews arising from the need to harmonize conflicting ideas in times of social change and conflict.

It is not clear why Dilthey denies a truth value to philosophy if it expresses a worldview that corresponds to some aspect of the world, and if it employs logic and scientific knowledge to solve problems. (Do philosophers with different worldviews agree on any points?)

The systematic application to painting was undertaken by Dilthey's disciple, Herman Nohl, in a work entitled *Stil und Weltanschauung*. For each type of worldview he found a corresponding type of style with characteristic dominants in the forms and spaces. As examples of the naturalistic-materialistic view, he cited Diego Velázquez and Frans Hals; of the pantheist, Raphael, Rubens, and Rembrandt; of the subjective idealism of freedom, Michelangelo. The last tends to isolate the human figure and to reduce the environment; its preferred format is vertical. The pantheist favors the horizontal and diffuses the same qualities of the luminous-shadowy or the energetic throughout space, upon man and nature alike; the materialist tends to treat the human as a textured substance similar to that among nonhuman things.

It is evident how arbitrary are these distinctions. Everyone can think

of some aspect of those artists that would justify one characterizing them through a worldview different from the one Nohl has assigned to them. And the same would apply to philosophers. Is Ernst Mach a naturalist, pantheist, or subjective idealist? Are Hobbes, Mach, Spinoza, Comte, and Dewey to be characterized as having one and the same naturalistic or materialistic worldview? A worldview is an attitude, unarticulated, unformulated, implicit in values, choices, and reactions. Philosophy consists of the articulated views, the choices of conceptualized alternatives and interpretations of experience. It may be influenced by worldviews, and the philosopher may discover in the course of reflection that his point of view has sources in irreducible personal values; he may accept these as necessary and build upon them, or he may seek a standpoint in which they are excluded. But, whatever we may find of such origin in his thought, the philosophy owes its interest and importance to what has been reached through reflection and self-criticism, through the urge to achieve a consistent and true account of world and self. In practice, however, we do not separate the results of reflection from the general personal standpoint that we call the worldview, whether conscious or unconscious. We admire in Spinoza, Plato, Kant, a temper of thought, a prevailing attitude, which seems to us noble, or serious, aspiring; or a style of thinking expressed in the form of their writings. Their philosophies are also works of art.

Besides philosophy as a completed view or system is philosophizing, the logically controlled reflection on views, concepts, and interpretations of experience, with respect to their consequences and consistency. It is the argument of philosophers as distinguished from the systematic results. It relates to the philosophy as the brushstrokes and neighboring tones and shapes relate to the effect of the picture as a whole. Many who admire a great painting have never seen the parts and their relations as the working structure of the art. It is here that we recognize the artist as the discriminating, constructing sensibility, solving problems and judging his own decisions.

In painting, all three features of philosophy appear: the unconscious worldview, the systematic style, the active engagement with problems requiring the discipline of this art in reaching new forms, in making decisions that are not merely standard applications of his style.

The terms in which a philosophy or metaphysics is described as a worldview or as a way of thinking will hardly satisfy a student of the philosophy in question. He will be keenly aware of problems, arguments, and solutions that are not encompassed in these broad terms of the theory of worldviews. And he will note, too, that if the worldview is said to be deeply personal, even constitutional, or shaped by the constants of thought in a society, many philosphers have changed their ideas in radical ways. Russell has been a Platonist and an empiricist; Dewey an Hegelian and a pragmatist; Henri Bergson, a Spencerian before he developed his vitalist views. And more recently Jean-Paul Sartre has announced his shift from his older existentialist ideas to dialectical materialism, to orthodox Marxism.

PAINTINGS WITH PHILOSOPHICAL THEMES

The artists offer an occasional glimpse of their philosophical views or their conception of philosophy. I turn at this point to pictures in which there is a theme of philosophy. It may be of a philosophy of art, through a symbolical image of a theoretical idea, a picture of a theoretical idea. Consideration of these works will show the different ways the themes of philosophy and attitudes that one finds in philosophical writings may appear in painting.

There is the obvious and trivial example—a painting usually official and academic, in which the artist has been commissioned to represent symbolically the various fields of culture or virtues like Truth, Wisdom, and Prudence. In the murals of the Boston Library, Pierre Puvis de FIG. I Chavannes has shown Philosophy in an ancient Greek world of whiteness and purity as a solemn dialogue between an old man and a young disciple. It is the image of Philosophy as the Socratic or Platonic discourse, an external reference to the school tradition of philosophy, without a specified or symbolized content of problems and solutions.

Puvis's admirer and contemporary, Gauguin, took metaphysics by the horns and painted a picture with the title: *Where Do We Come From?* FIG. 2 *What Are We? Where Are We Going?,* a series of great questions perhaps inspired by the same questions in a book by the religious reformer Félicité de Lamennais on religious indifference. These questions are so vague that we cannot answer them except by banal statements about history,

FIGURE 1. Pierre Puvis de Chavannes, *Philosophy*, 1896, oil on canvas, 4.35 x 2.20 m, Boston Public Library

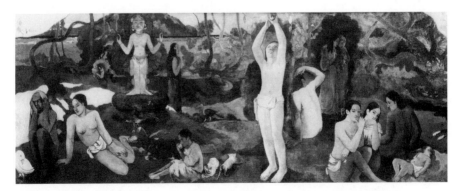

FIGURE 2. Paul Gauguin, *Where Do We Come From? What Are We? Where Are We Going?*, 1897, oil on canvas, 139 x 375 cm, Museum of Fine Arts, Boston

geography, and politics, which seem irrelevant and give us no assurance about a disturbing plight that has prompted these questions. We recognize that the questioning is more important than the answer; it expresses a state of feeling, of wonder, mystery, despair, a melancholy reverie on the uncertainties of the human condition. How does Gauguin represent the questions, if not the answer? By the stages of individual existence from birth to death; from right to left we read the figures of an infant, a blossoming youth, and old age, all against a background of luxuriant nature, and in the presence of an enigmatic idol—the security of the primitive man with his "idol"-god. This conception of the passage from infancy to old age and death reminds us of the popular image, undoubtedly familiar to Gauguin, called "Les Degrès de la Vie," in which the successive stages of human life are represented by figures ascending and descending a stairway, Gauguin's well-known interest in primitive and folk art, as well as the exceptional pattern of his own life, with its frequent displacements— each stage in another world and condition, from an infancy in France, a boyhood in Peru, youth at sea, young manhood in the bank and with wife and children, and his later phases as an artist in Brittany and the Pacific. But in the engraved folk image, there is no expression of a mind brooding on human destiny as in Gauguin's picture with its senescent figure at the left and a mysterious idol in the background.

Paul Klee is more modest and up-to-date. He represents the *Limits of* FIG. 3 *the Intellect,* echoing modern criticisms of rationalism, by drawing an elegant fragile construction that rises toward the immense orange-red sun and cannot reach it. What is most obvious to the eye is beyond the reach of reason. He has found a poetic metaphor of what he regards as the insufficiency of reason, as Samuel Taylor Coleridge years before in writing: "the owlet atheism, with blue-fringed eyes, blinks at the glorious sun in heaven and cries: Where is it?" How reason is limited, what are its boundaries, is hardly a matter for Klee's reflection—it is the conviction or feeling of the incompleteness and pretension of scientists that inspires his ironical picture.

Max Ernst, on the other hand, mocks the vitalists, the amateurs of sentiment versus reason. In painting *The Little Tear Gland That Goes* FIG. 4 *Tic Tac,* tears, a standard sign of emotion as irreducibly human, are a mechanical reaction and issue upon a proper stimulus from an

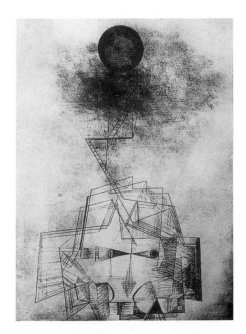

FIGURE 3. Paul Klee, *Limits of the Intellect,* oil and watercolor, 53.8 x 40.3 cm, Staatsgalerie moderner Kunst, Bayerische Staatsgemäldesammlungen, Munich

FIGURE 4. Max Ernst, *The Little Tear Gland That Goes Tic Tac,* 1920, gouache on wallpaper, 35.6 x 25 cm, The Museum of Modern Art, New York

automatic mechanism as simple and regular as the famous watch that a hundred years ago was a model in proofs of the existence of God, the maker of a universe of clocklike regularity.

Other artists were more open to the seductions of the metaphysical. Giorgio de Chirico felt that the pencils, desks, rulers, and other simple objects of the epistemologist's desk, which appear as examples so frequently in modern discussions of the theory of knowledge—that world of intimate or proximate still life illustrating what has been called "sedentary mentalism" (Santayana's phrase)—has an exemplary significance as demonstrative paradigms of thought and knowledge. In his *Great Metaphysical Interior,* he represents such objects as set in FIG. 5 frames—artificial constructions that prop and enclose things and are themselves often associated with instruments of the draftsman and designer. The real objects and also the picture of a landscape with buildings and trees, nature and artificial things, are alike in being isolated on closed prepared surfaces that are framed and assimilated to our human instruments; on the same wall is also a smooth panel (the window or door shade) that carries no object: it suggests in the context of supporting fields, a tabula rasa, the much quoted fiction of seventeenth-century philosophers. We are not sure what is de Chirico's own philosophy or what it was then—for he was to change radically in his art and his thinking about art (and other things). But we recognize in this painting various items that appear also in philosophical discourse, and the title of the picture in question encourages us to follow this suggestion of a philosophical content. If it is said that here language rather than painting provides the content, I shall answer that in literature, too, the label or title tells us what to look for in the poem, e.g., the titles of poems otherwise obscure, for example, Stéphane Mallarmé's *Angoisse.*

In another picture, somewhat earlier, with the enigmatic title *Self-* FIG. 6 *Portrait,* de Chirico plays on a different philosophic note. How do the things here relate to his title? We see some objects—two feet, but one is severed, and since both are white, we recognize them as plaster feet, not organic. We note, too, that they are crossed, and that the left foot is on the right side and conversely. This crossing we must relate to the big X on the wall. And the duality of two feet, two lines in X, reappears in the duality of egg and rod, the two towers, one rising outside the frame; and

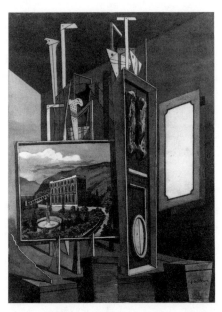

FIGURE 5. Giorgio de Chirico, *Great Metaphysical Interior*, 1917, oil on canvas, 95.9 x 70.5 cm, Museum of Modern Art, New York

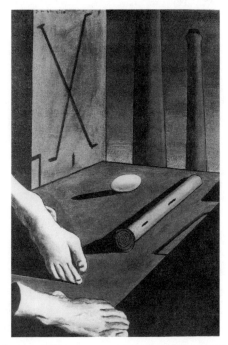

FIGURE 6. Giorgio de Chirico, *Self-Portrait*, 1913, oil on canvas, 80 x 53.1 cm, private collection

the solid and unfilled rectangles on the edge of the supporting wall. What does all this mean? One can guess many things and associate freely; but if one asks what is typical and constant here, it is duality presented in different kinds of paired objects, in simple parallelism, in crossing and reversal, in oppositeness. It was aimed to reconcile the seemingly contradictory systems by treating each as possessing a part of the truth and by combining them into a single whole—but de Chirico represents the world as made up of polar objects, not polar views, the borderland between philosophical and artistic ideas. One can compare it with a work of philosophy written at the same time, which I was to read at college, Wilmon Henry Sheldon's *Productive Duality or the Strife of Systems,*[5] a work that anticipated the now fashionable talk of duality and complementarity, extended from physics to other fields. (Compare also with Paul Klee, in his lectures on art, on duality and polarity as true of art and nature.)

Painters also represent their reflections on their own art, painting—as it were, theoretical pictures, metapictures. Picasso has several times done Artist and Model pictures, which illustrate his ideas about the process of painting. In his etching after Balzac's *The Unknown Masterpiece,* a story FIG. 7 about a picture and a quest for absolute perfection in painting, Picasso shows the living artist studying the living model, herself a kind of artist knitting a sock; the result on the canvas is a tangle of threadlike lines.

In another canvas, the painter, presented as an abstracted geometrical form, observing his model, like himself schematic in form, draws on the canvas a pure natural profile. In both works, the painter's art is a radical process of transformation; in one case, of the natural into the nonrepresentative form, in the other, from the geometric into the familiar living shape, as if nature were a creation that owed its organic living character to the artist's arbitrary decision.

If one of the tasks of philosophy is to reflect on the nature of our activity, then we may call philosophical those pictures that represent the artist at work in a way that conveys some principle of his art. Such theorizing pictures are not common, but among them are several that have genuine philosophic interest.

Dürer's woodcut illustrating the process of perspective representation FIG. 8 is an early example. The German artist was a scientifically minded

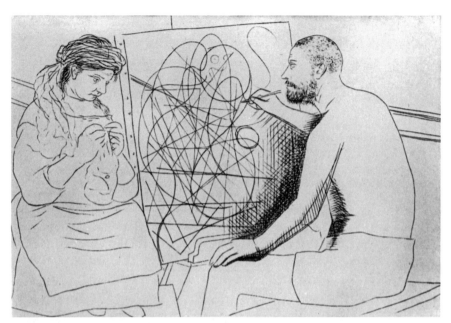

FIGURE 7. Pablo Picasso, *Painter and His Model Knitting*, 1927, etching, 19.4 x 27.8 cm, illustration for Balzac's *The Unknown Masterpiece*

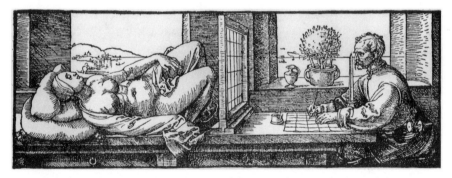

FIG 8. Albrecht Dürer, *Artist Drawing a Model in Foreshortening Through a Frame Using a Grid System*, 1525, woodcut, from *The Art of Measurement* (Nuremberg, 1525) (B. 149), private collection

painter who studied mathematics, anatomy, and other sciences in order to discover rational principles for his art. In his woodcut he lays bare the essential elements of perspective representation—in the center, a framed glass plate marked by a regular grid; at the right, the artist sighting, and in his hand a pencil with which he draws on a horizontal sheet of paper also marked with a grid. The projection of the woman on the glass plane determines a form with respect to the grid, that the artist transfers to his own grid-ruled paper. Perspective drawing is a projective procedure in which, given the form of the object, the distance from the eye, and the position of the eye, the form of the drawing is strictly determined.

We have seen three different modes of projection. This is an objective projection, the others are subjective ones.

I remember when I showed the illustration of Balzac's story over forty-five years ago to an audience at Swarthmore College, and said that, while there are theorems of projective geometry from which—given such a three-dimensional form and such a distance of the projective plane from the object—we can deduce the exact shape of the projective plane, in Picasso's drawing, given the object and the artist, the projection being a psychological and not geometrical one, we cannot deduce what it will look like, unless we have a much deeper and fuller knowledge of personality and some laws of psychological projection. A mathematician can't arrive at the tangle of Picasso, there's no familiar geometrical theorem that would transform the appearance of a human body at rest into a tangle. At the end of the talk, Professor Arnold Dresden, a Dutch professor of mathematics, said to me: "Oh, no, there is a projective theorem of the great Dutch mathematician Brouwer, through which he was able to obtain a tangle out of any kind of three-dimensional compact, closed field"; he referred me to the proof in Luitzen Egbertus Jan Brouwer's published article. I was delighted later to learn that Brouwer was also the author of an important treatise on painting and aesthetics around 1908 or 1909, which was known to Mondrian. One must be careful, however, in framing statements on the differences between projection in the mathematical and psychological sense as applied to a modern painter, above all to Picasso.

A century and a half earlier, Chardin presents another concept of representation. He shows a monkey painting the picture of a plaster Cupid. FIG. 9

30

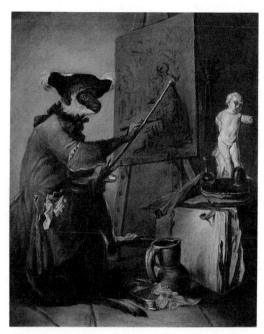

FIGURE 9. Jean-Baptiste Siméon Chardin, *The Monkey As Painter*, c. 1740, oil on canvas, 73 x 59.5 cm, Musée du Louvre, Paris

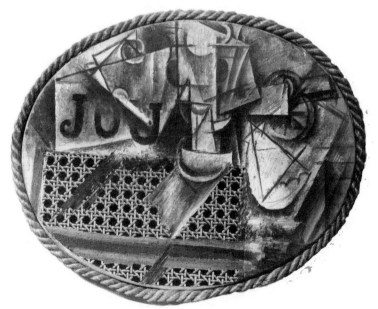

FIGURE 10. Pablo Picasso, *Still Life with Chair-caning*, 1912, oil and oilcloth on canvas edged with rope, 29 x 37 cm, Musée Picasso, Paris

Behind this image lies the ancient topos of the painter as the *simia nat-urae*. Representation is an aping of nature in the double sense of the ape as the imitator of humans and of nature itself as a power of reproduction in reflections and other phenomena. The "simian" is the simulating creature and creation is a kind of simulating of nature. The monkey is the fated eternal companion of the painter. When the artist represented the world around him, he was called the ape of nature; when today he paints abstractly, he is likened by his disapproving rivals and critics to the monkey who smears and splatters. This view of the painter as a monkey has survived the disappearance of representation in so-called abstract art; it was soon noticed that the monkey, when supplied by experimental psychologists with the painter's tools and materials in the zoo, could also produce an art of pure brushstrokes and patches. The painter, it seems, cannot escape his animal nature, whether he represents objects or practices an art of abstract visual forms.

The point of Chardin's picture lies elsewhere, however. The clothed monkey draws the Cupid on his canvas with a monkey's head. He, too, cannot surmount his animal nature; he can see the world only from a monkey's viewpoint, and his ideal figures of beauty are monkeys; just as the old Greek philosopher Xenophanes said that if the animals had gods, these gods would be animals.

The god of the monkey is a monkey. But Chardin's concept is more acute and finely critical. For if man is the ape of nature in his power of simulating what he sees, it is given to at least one creature to represent nature as it appears to be or in its essence. Yet even here the artist cannot escape himself; the objective view turns out in an important detail to be a projection of the viewer. (The style of the monkey-painter is highly realistic; we are able to recognize every object in its details.) Of course, this picture refutes itself in stating its proposition—so to speak; we cannot understand it unless we ourselves are able to distinguish the monkey's brush, the monkey's painting, and the sculptured image of the human Cupid. The observer here is privileged; he sees both the painter and his object as they are in themselves or as they exist for us, the human viewers.

In the *Still Life with Chair-caning* we come to another aspect of intel- FIG. 10
lectual content in painting that is closer to the concerns of some philoso-

phers. Such works by Picasso had been called Cubist by disapproving critics when first shown in 1908–9, although one is not surprised to see there are no cubes in them. The names that classify schools of painting rarely correspond to them, at least after the time when such labels are first accepted as guides to their meaning. The painting is surprising at first because of the apparent uncertainty of the relationships of various distorted elements in the work to our knowledge of previous art and to the inherited practice of the art as a representation of the everyday world. A large part of the surface is made up of a pattern of caning, an interlacing of strands, which as we scrutinize it, turns out to be not a real caning but a printed ornament simulating caning on a real oilcloth that covers the painted table. Oilcloth, then, has been taken from the table and put on to the canvas, but once having put the simulated caning on the canvas the artist paints over it and also pastes a bit of white-ish paper on it. He spells out the letters "J O U"—the beginning of the word "journal"—and imitates on it a cigarette with a cast shadow. Finally, around the whole canvas he winds a rope as a frame—a real rope that reminds us strongly of the simulated intertwined pattern on the canvas, which does not belong to his act of painting, but is an already existing simulation on the oilcloth used as an element inbuilding up the picture. The painter is saying that insofar as the painting relates to what we call nature or reality he is free to use existing elements of reality or to create a new kind of object; all these can be combined to form an imagined object in which the boundary between representation and reality is uncertain. At any rate, we can talk about both representation and the illusion of reality and make statements about them in the same grammar. In all of these statements we recognize a language (so to speak) and the rules of that language. We enter into paradoxes and difficulties when we forget how subtle and vague may be the relationships between the spoken language and the coded or simulated visual language.

This "Cubist" painting makes us think of the acuteness and pleasure of philosophical analysts in the years between 1900 and 1930 in concerning themselves with problems of language and the nature of statements, their connection with observed objects and with logic. The bits of writing in pictures, too, are symbols known from familiar experience but are unlike the things indicated by the writing. They are signs of a

more abstracted and intellectual order. All those drawn and shaded textured surfaces, painted spots and marks, that shape a play of colors, lines, and textured paints, light and dark, often in a rhythm that is ingenious, challenging, and full of conceits of ordered coincidence—meeting, diverging, crossing, disappearing, and re-emerging parts—all these now belong together by their ordered presence on the same framed surface and with surprising qualities and contrasts. If they hold together, it is also through the artist's cutting and spacing of these parts. The enframing rope is analogous in form to the ornament that decorates the oilcloth. What the artist seems to be telling us is that if painting is an art of imitation, it is also a concrete object with a varying surface that has been treated in a special way with varied color, texture, and relief. As a well-ordered whole it is no less "real" than the tablecloth that is one of its elements and includes an illusory space on the canvas. The boundary between the real and the illusory in such painting is shown to be a relative one; one can apply then some real objects that produce an appearance of an elusively shallow third dimension by a subtle choice of overlaid planes that cover discontinuous, yet re-emerging lines or strokes. Certain marks do not effect illusions but stand out as results of visible operations with paint on the canvas. The canvas itself is affirmed as a part of our real world in being framed with a rope, an actual salient rope with three dimensions, which exhibits in a more decided and fuller form certain of the themes on the painted surface, such as the real tablecloth that lies between superposed layers of paint and possesses that imaged reality in an illusory mode. Further, we recognize that the intertwining of the rope, its turning and re-emergence in a double strand, has also to do with the double strand of reality and illusion, of the tangible and the visible, of the first and second order of reality in the painter's work.

In all these examples I have spoken only about the subject or represented idea, without attending to the style. But some of the more interesting observations about the philosophical content of painting have concerned the artistic character of the work or the artist's style in general. It is in the forms and expression that philosophical students of art have found telling analogies with a philosophy or worldview. If, in the examples that I have cited, the connection is with some part of the work

customarily the search for truth or philosophy is precisely the
time when our temples begin to gray and when we would be
unwilling to write a gallant letter. Reflect on this resemblance
between the philosophers and the genre painters.

While Diderot does not say what philosophers he has in mind when
he speaks of Chardin's painting as philosophical, we have little doubt
that he is thinking of the empirical philosophers who have influenced his
own ideas. His interest in the close observation of simple objects and of
the process by which we form our ideas of the world, his belief that
"there is nothing real but our sensations, that neither empty space nor
the solidity of our bodies exists in itself," remind us of the Irish Anglican
bishop and philosopher George Berkeley. And, indeed, Berkeley's ideas
about perception could be illustrated by the style of those artists like
Chardin and the later Impressionists who seem to make light and color
the sole apparent elements of the painting and in doing so reject the
older construction of the picture out of distinctly bounded forms held
together in a geometrical schema.

What could be a clearer statement of the program of the advanced art
between Chardin and the Impressionists than the following passages
from Berkeley's writings:

"There is no other immediate object of sight besides light and
colours." [6]

"All that is perceived by the visive faculty amounts to no more than
colours, with their variations and different proportion of light and
shade...." [7]

For those who see in Berkeley's thought a unique historical corre-
spondence with the tendency of the art of his time, I must call attention
to the fact that a hundred years before the Irish philosopher the same
view of our sensations of color was already expressed very clearly by
Galileo in a letter to a painter. He wrote to his friend Cigoli, that "the
eye, then, sees only length and width but never depth and never thick-
ness (only colors, lights and shadows); we know depth, not as visual
experience per se and absolutely but only by accident and in relation to
light and darkness." He believed, before Berkeley that "colors [are] the
peculiar object of sight." [8]

or with the work as the illustration of an idea that is deliberately represented, and that has often to be read as we read a text, its character as an artistic conception being disregarded, another more subtle approach discerns in the aesthetic of the painting a specific attitude or point of view. This approach has been cultivated especially by German philosophers, critics, and historians whose tradition of philosophy gives the greatest importance to the subjective component in thought and finds in the stylistic or formative aspect of art a resemblance to the organizing features of a worldview. Toward 1800 the philosopher Friedrich von Schelling, inspired by Friedrich von Schiller's reflections on art as a philosophical activity, maintained for a while that art is the keystone of philosophy; it was for him a synthesis of the subjective and objective in which alone truth could be complete and overcome the onesidedness of traditional speculation and science. For such a view the forms through which a work of art becomes expressive and unified, in fusing the abstractness of concepts with the concreteness of the sensuous work of art, give a higher unity to the synthesis.

Before these speculations of the German school, Denis Diderot had written in a concrete way about painting as a philosophical enterprise. In his enthusiasm for the still lifes and domestic genre pictures of his contemporary Chardin (circa 1770), which by many lovers of art were still seen as an inferior, though perfect kind of art, since they lacked the nobility and intellectual content of historical painting, Diderot was led on the contrary to affirm their philosophical character. In describing and praising these works, he found a resemblance of the painter's method and subject to the activity of philosophers, but to a new and modern school of philosophers comparable to the modernity of the painter:

> I must tell you, my friend, of an idea that occurred to me and that perhaps won't occur to me again at another moment; it is that this painting which is called genre painting and which includes still-life as well as domestic life, should be the painting of old men or of those who are born old. It requires only study and patience, no verve, little genius, scarcely any poetry, much technique and truth, and that's all. Well, you know that time when we devote ourselves to what is called

35

If Berkeley's idea—that we experience visually only lights and colors and that all else must be regarded as a fiction of the mind without reality in nature—is applied by Diderot to the interpretation of Chardin's style as a philosophical enterprise, it must be apparent also that Berkeley's philosophy can be applied with equal if not more justness to Impressionist painting. Yet Chardin and Monet are far apart in both spirit and method. For Chardin holds to the tangibility and weight of forms, he builds up, in patient probing, an image of solid objects; while Monet, looks out on an open, indefinite world in which light blurs the forms of things. He creates canvases with a radical dissolution of material things into a continuous field of flickering colors. It is only relative to more traditional painting of his time that Chardin appears highly impressionistic; seen beside the French artists of the next century, he looks weighty and solid and a strict composer; and if he is compared today with any painter of the nineteenth century, it is precisely with Cézanne, whose commitment to the "sensation" of color includes also a search for the so-called primary qualities of things that had been doubted by Berkeley as fictitious.

Diderot in his account of Chardin, therefore, selects only one aspect and ignores others that are no less essential and that distinguish him from later artists who seek to realize a whole in which the represented world appears as a web of light and color.

One could proceed from other aspects of Chardin's work and arrive at a different description, also incomplete, it is true, but as plausibly related to broad ideas of his time. Consider in his *Still Life with Haunch of Meat* the sizes and groupings of objects—features that are as immediately given and as significant for our sense of the character of the work as are the light and color. The humble objects of the kitchen are of different size, but we sense within that difference a clear order; they range from dominant objects—the pitcher and copper pot—to very small ones—the onions—through intermediate objects; and this simple series of progressively ordered magnitudes is so grouped that the largest objects dominate the center and the smaller ones are at the edges. Chardin, while painting still life, the least noble of all genres, the least submitted to an etiquette of rank, has endowed the anonymous objects of the kitchen with the attributes of a social hierarchy, assigning to them

FIG. 11

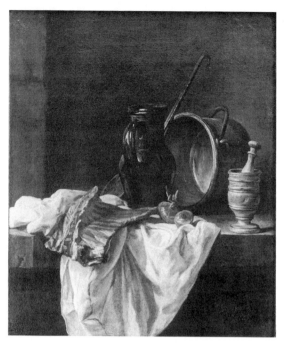

FIGURE 11. Jean-Baptiste Siméon Chardin, *Still Life with Haunch of Meat*, 1732, oil on canvas, 42 x 34 cm, Musée Jacquemart-André, Paris

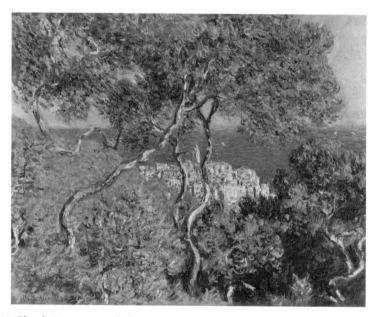

FIGURE 12. Claude Monet, *Bordighera*, 1884, oil on canvas, 73.7 x 80 cm, The Art Institute of Chicago

positions according to their size an selecting a series in which the differences would help to build up a clear image of dominance and subordination also in the light and texture, range from great highlight of copper to the matte effect of the smaller objects. The whole is set up on a stone ledge that stabilizes the group, providing a common space, and isolating it from the spectator's. From the composition alone we could infer the origin of the picture in an eighteenth-century society in which the typical bourgeois appreciation of the intimate, the domestic, and the instrumental is still subordinate to values of etiquette and aristocratic order, to aristocratic ideals of nobility and order. Besides, Chardin has a feeling for the substance of objects, their agreeable textures and weight, which combines the attitude of the skilled artisan and the sensualist— these, too, are important values of his Parisian milieu in the eighteenth-century that would be hard to interpret as corollaries of Berkeley's spiritualistic views. We might find a parallel, however, in the contemporary French materialists Paul-Henri d'Holbach and Claude-Adrien Helvétius—who derive knowledge from sensations and preach an ethics of pleasure and self-interest, but hold to the reality of matter and space that Berkeley has so acutely criticized.

Nearer to Berkeley's conception of the visible world as color and light, I have said, is Monet's art. Here objects are decomposed into tiny FIG. 12 flecks of pigment and outlines are blurred in the continuous play of color and light across the entire field of the canvas. (Berkeley assumed also the notion of a universal medium or substance of which the ordinary elements were merely the modalities—see his writing on *Tar Water*.) It seems to me unlikely that Monet had read the works of Berkeley or even of a French disciple of the British (Irish) philosopher. And I think that if Berkeley had seen works like Monet's—even had they been done in his own time (though this condition would also imply a change in Berkeley's attitude)—he would have found them strange because of the blurring of objects and the lack of symmetry. Berkeley's spiritualistic metaphysics would have been distasteful to Monet who was agnostic and deeply attached to the world of light and color, as basic manifestations of Nature in his art. His way of painting cannot be separated from the objects and scenes that attracted him as his subjects—the spectacle of the street and roads, the skies, landscapes, and

waters enjoyed by the vacationist and traveler—open like himself to new impressions (i.e., sensations). Looking at his works, we discover that Monet has selected certain congenial objects and occasions as the most suitable embodiments of the qualities he valued. The primary role given to sensations of color, rendered by small flecks of the brushstroke, is not only the outcome of a philosophical view about perception. It expresses also a love of color and light and atmosphere and a desire for movement and freedom—a total immersion of the self in the sphere of sensation. That sensations and light precede our visual perception of objects is no more a truth of everyday visual experience than that objects by reflecting light toward our eyes determine our sensations. The commitment to the primacy of one or the other is an aesthetic and even moral commitment. It is true that scientific philosophy in Monet's time, in its effort to reach an adequate view of the process of knowledge, had revived some parts of Berkeley's argument and tried to construct the knowledge of objects from the characteristics of varying and recurrent sensations. But from this account of knowledge to the idea that the primary element in experience is sensation was a gigantic leap.

In the writings of Ernst Mach, who in the 1870s and 1880s argued most persistently for this view, there is a passage that reveals the living experience behind this idea. He tells how as a boy of fifteen he became a Kantian and held the notion of the "thing in itself." "Some two or three years later," he writes, "the superfluity of the role played by the thing in itself abruptly dawned upon me. On a bright summer day, in the open air, the world with my ego suddenly appeared to me as one coherent mass of sensations, only more strongly coherent in the ego. Although the actual working out of the thought did not occur until a later period, yet this moment was decisive for my whole view." He concluded that the world consists only of our sensations and what we call objects are constructions out of persistently connected sensations. Atoms, laws, and scientific entities are only "economical ways of symbolizing experience."

In this report of his path to scientific philosophy Mach seems close to the Impressionist painters who discovered in the brightness of the summer day in the open air the coherence of their own sensations of color and light and developed a method of painting in which that experience became self-evident and challenging and beautiful and the

sources of an endless series of new pictures. But Mach went beyond the moment of revelation, fusing its discovery with a method of scientific analysis and theoretical construction, applying mathematics and aiming at the highest generality and consistency. The Impressionist painter remains with his sensations, he does not seek to form objects or to discover the constancies in the sensations. His attachment to the sensation is lyrical and poetic, and without system, even a provisional one, even though constants and their variations had already been subjects of study and become widely known to painters, who applied that knowledge in their art.

The author of a classic book on the interaction of complementary colors was Michel-Eugène Chevreul.[9] The general notion that the colors of adjacent areas affect each other in luminosity and intensity was apparently known to painters long before. The same white object appears lighter against a dark ground than against a gray ground. Painters who observe this, therefore, lower the value of a color slightly when it approaches a dark area in order to preserve its appearance. But the painters who knew the law of simultaneous contrast could abstract the perturbing factors of vision. When one regards a green in nature and if the green does not appear green enough, one must see what is adjacent and eliminate or change the neighboring color to minimize the perturbing contrast. The problem was posed in the eighteenth century and even by Aristotle. In his *Meteorology,* Aristotle emphasizes that the dyers have trouble in judging colors, especially violet, and that it is a psychological (psychic) rather that a physico-chemical phenomenon. But the specific sense of Chevreul's discovery was that psychological activity transforms the given *(donnée)* of nature.[10]

Mach's resemblance to the Impressionists has not escaped the attention of his critics. When Impressionism as a style was rejected as shallow and unphilosophical, and the younger artists desired an art of more intense feeling and the expression of an inner world, especially of its strains and conflicts, the philosophies that made perception and knowledge the keys to self and nature (being) were criticized as Impressionist. (Mach was lumped then with Henri Bergson and Edmund Husserl, very unfairly, I think, by E. Jaensch.)

Perhaps Mach's thought is closer to Seurat's than to Monet's. But I see

nothing in Mach that corresponds to Seurat's humor and Gothicism, the elements of the grotesque, the lyric, and the popular, and his theory of expression. Yet there is an affinity of temperament in Seurat's scientific attitude to art, which is not to be found simply in his use of contemporary theories about color and light but also in his more effective method of working, his highly constructive approach to the problems of painting, a unique fusion of empirical and theoretical steps in the execution of his large paintings. He observes and analyses, isolates and composes; his great pictures are based on numerous sketches, studies, and abstractions of single features of the whole. Like Mach also is his concern with the invariance or constancy of a motif through many changes of size, position, color. Seurat's theory of expression in painting—the three states of feeling associated with the three kinds of dominant in line, color and value (tone)—seems to depend on Charles Blanc,[11] who reformulated Humbert de Superville's three states of expression: the expansive, the convergent, and the stable.[12] It is not even sure that Seurat read Humbert. Seurat in fixing on the gay, sad, and calm has shifted from the more general formulation of Humbert (a philosopher of nature in the grand style), which includes the emotions in dramatic contexts, to an intransitive world of the emotions of a contemplating mind.

What does it mean to say that a style of art corresponds to a particular philosophy of the same time. What in the philosophy is being compared to what in the style of art? What is implied in the supposed correspondence for the cause of the correspondence? What is the causal explanation tested?

There is still another difficulty to be mentioned: the historical fate of interpretations that relate a philosopher, a painting style, or, better, an architectural style where there is no representation, to a philosophy. We observe that such interpretations survive, even though the description of both the art and the philosophy change. The most familiar example, of course, is of Scholasticism and Gothic architecture. The first writer I know who compared Gothic architecture to Scholastic philosophy was Immanuel Kant, in his essay "On the Beautiful and the Sublime." He wrote that Gothic architecture is like Scholasticism because it is a *Fratzen*, a monster, a grotesque of architecture; in the same way Scholasticism is a grotesque of philosophical thought. But after him

people wrote that Gothic is like Scholasticism because they both are highly rational; they both are determined by a logic of construction in which every single part, even when the building is richly ornamented, looks decorative, yet serves a constructive function. There were others who said, No, Gothic is like Scholasticism because both are irrational; they both are forms of free aspiration toward heaven, and the creation of a multiplicity of details that cannot be reduced to a formula and to which older methods of measurement, or consistent theory of proportions, does not apply. Ernst Renan wrote that Gothic is like Scholasticism because both are rational but are built on weak foundations, hence the buildings are always falling down. Others remarked that Gothic is like Scholasticism because both are unfinished enterprises; the *Summa* is never really completed, nor is the Gothic building. And in recent years Erwin Panofsky has said that Gothic is like Scholasticism not because of logic or rationality, but because they have the same mode of inner development: A Gothic architect builds in a style, A, the next architect negates it in style B, a third architect synthesizes them in style C, which has a new unity; just as Thomas Aquinas, in dealing with a question, states alternative positions and establishes a third solution. However, if you read Thomas Aquinas closely, you will see that if he poses twenty questions, in only two or three of them is his answer a combination or reconciliation of answers made before. In most cases he says: "A is wrong, B is wrong, C is wrong, D is right. I follow D." And sometimes he offers an answer all his own. But the analogy of Gothic and Scholasticism remains.

Professor Étienne Gilson, an admired lifelong student of the history of medieval philosophy, denies that there is any sense in the comparison, since Scholasticism is not one philosophy but many different, often sharply antagonistic, philosophies current in the medieval schools. In reply to my question as to what he thought of the common view of various expositors of "Scholastic philosophy" in relation to the contemporary Gothic architecture, Monsieur Gilson answered as follows (Letter of January 21, 1954):

> I fail to find any relation between Gothic architecture and scholasticism. Leaving aside literary themes, which it is

always pleasant to develop but whose developments belong in art rather than history, I must say that "Scholasticism" is a very vague historical entity. At any rate, it cannot be held synonymous with medieval culture: in both philosophy and theology, medieval culture is much wider than what can be called scholasticism; last, not the least, Gothic architecture appears, fully constituted, at a time when scholasticism is still in its infancy.

The truth remains, however, that I consider such questions purely verbal, and only good for rhetorical consumption. If we decided to tackle the problem be it only in order to test it, we should first find a definition of the term "scholasticism," and this is more that I have ever been able to discover in 40 years.

It is true that in the process of design of a new building innovations in its structure are debated by the architects or craftsmen, but the differences of opinion need not engage the authority of officials of the church. If one finds the analogy of philosophy and architecture in that dialectic process of innovation as the synthesis of a previous practice and a newly conceived alternative, as Panofsky thought, following Hegel's conception of development in history in general as dialectical in form—this was already the form of legal debate on matters of canon law well before the Scholastic model of philosophic dispute.

This does not imply that such comparisons are worthless or uninteresting. It becomes a problem, then, of specifying the whole in such a way that we are able to say that such and such features of a philosophy are like particular features of the architectural style. The problem is not only of selection of details but of the complexity of the whole and of the relative weight or distinctiveness of the particular features in question for understanding the style in a broader more pervasive sense.

And the same applies to philosophy. I have noticed that if Spinoza is likened to Rembrandt, a recent writer on Vermeer likens Vermeer to Spinoza. Yet Rembrandt and Vermeer are so different as artists that one of these comparisons, if not both, must be wrong. However, we can easily see that a writer who is committed to analogies and is struck in

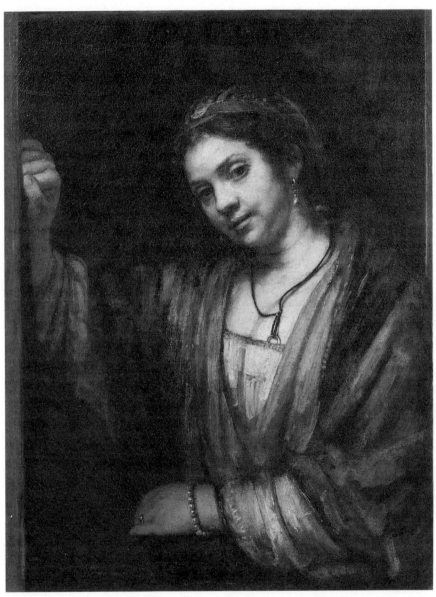

FIGURE 13. Rembrandt Harmensz. van Rijn, *Hendrickje at an Open Door*, 1650s, oil on canvas, 86 x 65 cm, Gemäldegalerie, Staatliche Museen, Berlin

Vermeer's art by the aspect of the rectilinear, the constructed, the con-
crete, might find in his contemporary, Spinoza, an analogy or real resem-
blance of these qualities, especially since he is looking for a
contemporary philosopher in Holland.

On the other hand, a writer on Rembrandt who is concerned with the
ethical and inner life of the portrait subject, is led to Spinoza as a great
ethical thinker.

In Rembrandt's painting we are keenly aware of two powers: light FIG. 13
and shadow as mysterious contrasted entities, shapeless in themselves,
but together making visible the fullness and solidity of a human or other
object presence. This object is of an extraordinary tangibility. It has
weight, texture, grain, dense substance. The body emerges from the sur-
rounding darkness with a relief that exceeds in tactile appeal the objects
in our own immediate space. At every point it seems a resultant of the
play of light and shadow; the brushstrokes of light color, even the high-
lights, contain fine shadows. Here, in a marvelous, elusive way, the
incorporeal light and the opaque matter seem to be one; the flesh lumi-
nous, the light fleshy. And in this miraculous fusion there prevails a
grave existence, a face or a posture or a movement of the hand and
brush that together are deeply compassionate and reflective.

One cannot contemplate this art without thinking of Spinoza. He
believes all is matter, but matter is endowed with spirit and spirit reaches
its height or perfection in the love of the whole of matter, which is God.

How valid is this comparison of the painting and the philosophy?
One could go on to find other points of resemblance, but certain fea-
tures, essential to each, are not easily discerned in the other. The logical
form of Spinoza is not Rembrandt's, and the universal eye of
Rembrandt, insatiably attracted by life as an action of weighted and self-
burdened bodies, an eye attentive to the old and young, the poor and the
great, the spiritually minded and the practical, with equal sympathy, this
eye is not Spinoza's, whose language has few words for the concrete.

The analogies are, therefore, not as far-fetched as appears, but they
reduce the import of the comparison considerably if one points to the
particular distinctive features of style and expression in the works of art,
such as the force of strongly contrasted shadow and light and the pathos
of his religious subjects.

The comparisons of painting with philosophy are of a different kind according to whether philosophy is understood as a broad view or as a particular set of doctrines. In the first case, what is regarded as philosophy is the author's worldview, in the second, his solution or answer to a specific problem. It may be that in a series or system of such answers there is implicit a worldview that disposes the philosopher to these answers rather than the alternatives—so one can speak of eighteenth century British empiricism, and that the recurrence of a limited number of answers in centuries of reflection is due to the limited number of worldviews that are possible. But we would still not regard philosophies and worldviews as equivalent, not even metaphysical systems and worldviews; for the activity of philosophical (and metaphysical) construction has its own qualities that set them apart from the unreflective, spontaneous worldviews. And this feature of philosophy is in question when a style of painting (or the whole work of an artist) is likened to a philosophy; the art is seen, then, not as an unconscious tendency of the artist but the considered result of his perceptions, feelings, ideas, and skills, his thought as a man and as a painter. To say that Poussin is Cartesian is to assert that the ideals of order, clarity, form, and strict coherence, and the search for an absolute perfection based on these ideals, which characterize Poussin's art, are in some way a counterpart in painting of Descartes's philosophy. It is not only a matter of kinship of temperament, but of common values arising within a common frame of French culture at the same moment in French history. This affinity of painter and philosopher seems more plausible when we place beside them the figure of Pierre Corneille and recognize in him another example of the same qualities and values, contemporary with the others. Descartes appears then as the philosopher of French classicism, who constructs a system guided by classic requirements. His writings articulate these requirements, explore their consequences for a large number of concepts, and apply these in a fresh way to traditional problems, just as Poussin's ideals of composition and expression are applied to numerous subjects and yield distinct results. Yet this analogy becomes less clear and even disturbingly vague once we begin to investigate the structure of Descartes's thought and the style of Poussin, taking into account also their histories through which we discover the similarities of the philosopher's positions to those of

other thinkers contemporary with arts that we would regard as the least like Poussin; we would discover also in the artistic neighborhood of Poussin artists like Domenichino and David, whose contemporary philosophical counterparts would be un-Cartesian; yet with these painters we could speak also of rationality, strict order, and moral passion, as with Poussin. Thus, the connection of Poussin with Descartes may be more a matter of such dispositions and values than of the specific content of the philosopher's thought. The distinction between style and matter, the attitudes and the solutions, is ever-present in philosophy and permits a greater freedom in drawing analogies with art.

But can one not go beyond these doubtful comparisons and develop a more comprehensive approach to these problems? Is it possible that in philosophies given as sustained positions of a broad kind, which become articulated through special problems and an analytical approach, there may be commitments of a broad ideological kind from which flow many details, just as in a painting a root attitude may be central? This is a difficult problem, which cannot be solved unless more specific likeness is found within the same cultural milieu.

There is, finally, an aspect of philosophy that is shared by artists. And that is that a philosophy is not the same as Philosophy. The German philosopher Ludwig Feuerbach said: "He who has a philosophy is no philosopher, because he has no doubts, no problems, no questions. He has the security of an attitude and a set position. To be a philosopher is to philosophize." To philosophize is a form of work, of intellectual work. It seems to be concerned with the consequences of one's most general ideas about man and nature and with their consistency, which is not immediately evident without a sustained meditation and experimentation with one's ideas and their structures, with doubts and possible alternatives. In a corresponding way, to be an artist is not simply to have aesthetic ideas, but to work at the aesthetic ideas, to weigh their consequences for the colors and shapes that one uses and for their effect upon a unity to be attained, a harmony, and a particular expression. It is in this sense that I wrote these comments on the relations of philosophy and painting. It is as modes of active work with responsible tasks of thought in which consistency and logical analysis in one's reflection upon what is taken for granted by other philosophers provide the main

drive toward the sustained activity; the artist who in painting has aesthetic apprehensions—his way of seeing colors and forms—is led to reshape what he has learned and done in the past toward a new whole that is more satisfying, more complete and adequate to his own sense of this subject, his style, and his feelings, and to the challenge of new situations and growth in his community.

One assumes that the worldview or philosophy of an individual is a constant like his personality. It may change in some respects because of experiences that shake him and lead him to see things differently (note that change of one's thought or practice is called "changing one's mind"); but then, too, there may persist on another level an attitude, a trait of strictness or polemical zeal, a way of responding and thinking even under new conditions. So the fanatic of politics, when disillusioned, may become a fanatic of propriety, morals, or religion. But in looking for a constant worldview we do not know in advance where to find the most stable features; what appears at first as a basic disposition may turn out to be a short-lived, even momentary, attitude; or it may be a relatively minor characteristic of the artist beside other stable features that further study would disclose. In considering the larger body of an artist's works, his growth or variability, we may come to see what is most constant; yet an habitual feature may be less important for his thought than for his growth and inventiveness as an artist or a response to advances by other artists of the time or to rousing or disturbing events like the Revolution of 1848 in France and the political changes after the Franco-Prussian War of 1870–71.

I shall illustrate the variability of the style and thought-content of an artist's work in a few pictures painted by Corot. At one time he was valued especially for his landscapes with silvery gray tones and misty atmosphere. Foreground and distance had the same misty quality of substance, and all objects—trees, hills, water, sky, and human figures—seem to be formed of a common vaporous matter, delicate and fused with the surroundings. His vision of nature suggested then a concept of spirit and fantasy as understood in modern writings on poetry and painting. Corot was admired also as the painter par excellence of mood, the affinity of passive feeling and a pervading state of nature congenial to a related human sensibility. The boundaries between the

perceiving mind and external objects disappear, the self and nature are merged in the emotion that accompanies this perceptions of nature. Corot's style of painting often fashions a unified world of which the tones, shapes, spaces, and rhythms evoke and sustain that mood of reverie or sadness; it induces a tender relaxed contemplation of an intangible shadowy existence that prolongs the indistinct feeling-toned mirages of the pensive self, swinging gently, absorbed in daydreams of FIG. 14 Arcadian harmony and happiness. The stillness of nature, the secure solitude of small openings in the woods, the calm of enclosed ponds, the innocence of forest dwellers who hang wreathes on trees, cull flowers, dance, and make music for themselves alone, are the chosen elements of this dream of happiness.

Other painters before him have pictured that dream. But Corot created a distinctive style that satisfies a mood of Arcadian reverie. Beside his pictures the paintings by other idyllic artists of rural scenes—the Barbizon school—seem to be realistic close-ups of a more solid material nature, with figures that like actors on a stage might play various roles, and with trees that could serve as the frame or setting for noble actions. Corot discovered properties of tone and form congruent with his sentiment of nature, which bind and reinforce the qualities of the objects allied in feeling with the viewer's mood. A French philosopher, François-Pierre Maine de Biran, still living when Corot began to paint, had already observed the hidden relations between emotion and perception and had written of the affective components of sensations in a way that seems to announce the art of Corot. In a memoir on obscure perceptions (1807) he remarked that "for every tone, for every nuance of light, there is a particular affective impression; and it is thereby that a tint or a mixture of colors becomes most agreeable (congenial)." According to Maine de Biran, there is an immediate pleasure attached to the exercise of vision, as distinct from the pleasure of the perspective, the harmony of colors or proportions of the figures, which is of intellectual origin. This first pleasure arises from the spontaneous and immediate passive intuition, which precedes thought and reflection. Besides, each individual is distinguished from the next by the basic manner in which he feels. The emotional dispositions and states, arising from the inner organs of the body, seem to impregnate the perceived objects or images

FIGURE 14. Jean-Baptiste-Camille Corot, *The Dance of the Nymphs*, 1850, oil on canvas, 98 x 131 cm, Musée d'Orsay, Paris

FIGURE 15. Jean-Baptiste-Camille Corot, *Rome: The Forum Seen From the Farnese Gardens*, 1826, oil on paper mounted on canvas, 28 x 50 cm, Musée du Louvre, Paris

with softer tones and delicate modifications. "Hence the sort of sensitive refraction that shows exterior nature to us sometimes in a smiling and gracious aspect, sometimes as covered with a funereal veil." To the extent that intellectual functions operate in vision, discriminating the precise forms of objects and distances, the affective component recedes. We understand, then, why the general light and atmosphere and a common tonality enveloping all objects are so important for mood in the passive perceptions; for they are more open to the internal factors that determine the feeling-tone in perception. Maine de Biran distinguishes sharply the so-called "passive affective impressions" from the "distinct perceptions"; the first being more closely linked to the autonomic and sympathetic nervous systems.

Clean, distinct forms, bright colors, undoubtedly evoke feeling no less than the vague and muted elements of perception. But for Maine de Biran, as for that phase of Corot's, mood was identified with a particular low-keyed interval in the spectrum of feelings, that special kind of mood in which the mind surrenders to the vague and remote. The rendering of such perceptions also requires of the artist a notable precision; he must learn to distinguish nuances of light and atmosphere that will escape the more practical observer who is attached to well-defined things. The notebooks of Corot contain subtle aperçus on tones and the conditions of harmony in painting that may be placed beside the refined observations of the French philosopher. In the journals of Maine de Biran are passages about his own feelings, his solitude and anxieties, which reveal his kinship with the poets and landscape painters who in selecting a theme or a natural site—a motif of nature—betray the original emotional tendency of their art, a space and tonality of feeling that are to determine also, in some degree, the direction of the personal style.

This account of Corot, which seems to characterize his mature personality, is built on only one part of his lifework. It is the part, one may say, that was for a later time the ground of his appeal. Today it seems to many viewers the less moving, and also the least characteristic of his genius. His art before this stage and after it, too, shows other qualities that call for a different description.

As a young man, visiting Italy in 1826 and again on later visits, Corot FIG. 15 saw the classic land with another eye. His art then was more precisely

constructed, with well-defined forms, clear blocks of light and dark, and local colors. His contemplative view was fixed upon more clearly ordered, more distinct Roman sites that most often included an enclosed stable architecture, an object of focus, in a larger deeper perspective—which Corot rendered with an admiring brush, in response to the beauty of the carefully rendered historic buildings as works of art in clear harmony with the broader natural sites (the Roman and the idyllic).

From these pictures of the city world one could not construct an image of Corot immersed in an atmosphere and dimmed light that subdue things to a subtle tonality and shadowy immaterial substance. They are like others of his works in the implied presence of a perceptive, sharply observant spectator; but his reverie is not dreamlike or fanciful—it dwells on a world of tangible human operations, a reality of solid regular habitations that belong to a remembered respected history still more than to nature.

In a later painting of the town of Douai, he shifts to an urban contemporary world. The format is vertical; the municipality is recognized in the high bell tower as the center, the symbol, of municipal liberties. The format corresponds to the walking or standing observer with no grand horizon or a view of earth, water, and sky. Moreover, in contrast with both of the preceding pictures, the light is found in all four corners of the painting. Corot now values light as a universal quality but not as dramatic or in decline. In an overall grayness related to reverie—a common theme in nineteenth century poetry—the distant and the near are parts of one imagined world.

From which of these paintings shall we infer and construct the worldview of Corot? What constitutes the unity of each of these stages of the artist's growth? In what features can we discern a constancy in his outlook? We must look for details that have not entered until now into our description of his life picture and try to establish an historical continuity. What remains constant perhaps is the touch, the execution. The number of passages between the intervals of light and dark might yield the same number of units in all three paintings. The meaning of individuality will be shifted to the observation of more specific features that lie in the small recurrent unit. We would not be dealing with characteristics that relate him to a type of worldview, but to artistic traits that

mark attributes of personality that are not stable or sufficient to account for the full range of his lifework, which includes remarkable portraits of men and women, and the unique painting of his studio that anticipates so many original features of Cézanne's mature style and even of early Cubism.

We shall now consider landscapes that are not to be understood through texts and that have a more personal, often lyrical side—the landscape as an individual expression, a perception of nature, independent of a preexisting literary content. Our interpretation of such a work is based, to a large degree, on aesthetic components, as well as on the factual, concrete elements of the landscape. The choice of site, of season, the time of day, the moment, the dimensions, the light, the colors, the texture of the painting, and "execution"—all these enter into the meaning and expressive qualities of the landscape. Here we make no strict distinction between the forms, the ideas, and the meanings; the ideas are not only the explicit ones that can be put into words, but—though I am embarrassed to say this so categorically—there are also implicit ideas, a disposition of the artist toward a particular set of values, what is vaguely called his outlook, or *Weltanschauung,* his mode of conceiving nature generally, though linked, of course, with behavior, with habit, and with response to situations.

We see several pictures of the same theme—the ocean—on which we have a large body of poetic and prose texts from the nineteenth century. The first example is the painting by Caspar David Friedrich, a German FIG. 16 Romantic, where, viewing the immensity of sky and water, stands a solitary central figure. He is in black, a monk in costume; his bald spot, a small white point, is contrasted with the vast extension of matter—as in Descartes's philosophy where spirit is located as a point in a little gland and is held to be irreducible to matter, as extension, which it confronts in thought and which it is able to activate. The monk is isolated on the pedestal of the earth, a cold zone, without vegetation, the bare elemental, primordial, inorganic earth. He faces the ocean as a darkness out of which rise in the distance, from the horizon, the clouds that become lighter and lighter. The whole upper stratum of the picture is luminous. One can interpret the painting in terms of a spiritualistic conception, God or spirit manifesting itself in nature through light. Spirit

FIGURE 16. Caspar David Friedrich, *Monk Before the Sea*, 1808-10, oil on canvas, 110 x 171.5 cm, Schloss Charlottenburg, Berlin

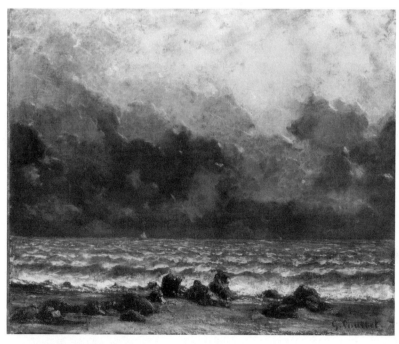

FIGURE 17. Gustave Courbet, *The Sea*, oil on canvas, 50.8 x 61 cm, The Metropolitan Museum of Art, New York

apprehends Divine Spirit, its source, which permeates nature; the material body culminates in mind, as the material world in the celestial light.

Compare that landscape with Courbet's picture of the ocean. Here, FIG. 17
too, are distinct strata of earth, water, and sky; a little boat in the distance shows that man can venture on this immense void, but the foreground is strewn with great rocks, the signs of historical natural catastrophes, movements of the earth. The water is not a still darkness; its gigantic waves advance toward one, and the clouds, too, are in motion—massive, heavy; and the light that seems to emerge from them is on a slanting line, unlike the horizontal lines of the waves, but more related to the rocks, which are peaked like the clouds. This conception corresponds, we may say, to Courbet's avowed materialism. I don't mean materialism in the sense of selfish interest or concern with money; it is materialism in the philosophical sense, the belief that substance is the only existent and has varied forms. It is the materialism of the scientist and of Spinoza, who speaks of God as substance; among the attributes of substance at a certain level of articulation or complex development emerge thought and feeling. In contrast to the thin painting of Friedrich, Courbet applies the paint very thickly and loves the textures that simulate flesh, hair, fur, foliage, wood, cloth, water, sand, earth as substances.

In that sense, one can speak of his landscape painting as a materialist art. In his own time he was called a positivist, but the word *materialism* is more appropriate, I think. He is the contemporary of German writers like Feuerbach, Karl Vogt, and Ludwig Büchner, and French thinkers, who were regarded as materialists in the philosophical and scientific, rather than in the moral sense. One should be careful not to confuse the two; there is a strong tendency among those who wish to discredit scientific materialism—though many scientists don't believe in it—to identify it with moral materialism, as if it were concerned only with the physical or with economic interests; they disregard the importance of the conception as it appears in Spinoza and among the materialist thinkers of the eighteenth century.

In this small image, which has a metaphysical grandeur like the German's, there is also something of the artist's dream of strength and craving for immortality. In a letter to the novelist Jules Vallès, recounting a visit to the ocean, Courbet tells his friend how he cried out: "Oh

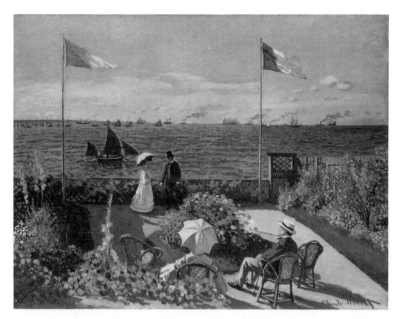

FIGURE 18. Claude Monet, *Garden at Sainte Adresse*, 1867, oil on canvas, 98 x 130 cm, The Metropolitan Museum of Art, New York

FIGURE 19. Claude Monet, *Rocks at Belle-Île*, 1886, oil on canvas, 60 x 73 cm, Ny Carlsberg Glyptotek, Copenhagen

sea, your voice is tremendous, but it will never succeed in drowning out the voice of fame as it shouts my name to the whole world." The immense signature of the proud Courbet—his critics noted with ironic amusement—was the largest of any painter's in his time.

In contrast to both Friedrich and Courbet, is an Impressionist view of the ocean—Monet's picture in the Metropolitan Museum of Art, of the FIG. 18 harbor of Ste. Adresse, outside of Le Havre; Monet's family, his father, and others sit in the foreground, enjoying the scene; there is nothing here of the philosophical mood of either Courbet or Friedrich, no suggestion of mystical illumination and divine presence, the moment of apprehension of spirit through light in an oceanic void. In Monet's painting the wavelets in movement are more pointed and have more striking, piquant details than Friedrich's work, but nothing of the somber weight and massiveness and the marked rhythm of Courbet's water. The sky is joined to the foreground through the poles and flags; and the color of the flags brings into the upper part something of the gaiety of the flowers and the garden and the general sunniness of the inhabited nearer space. The water is enlivened by the movement of the dozens of boats and the puffs of smoke in the distance; the sea, too, is a human space for multiplied pleasures, for stimulation of the senses; the distinct sky, water, and earth are united through common notes of bright color, elements of gaiety and charm. It is the ocean of the vacationist, the tourist, but above all of the holiday, the occasion of rest and joyous contemplation of the surroundings. It has also a philosophical sense that does not engage us, however, in the kind of profound or grandiose perceptions that the pictures of both Friedrich and Courbet do.

When Monet painted the ocean without human figures, as in his later FIG. 19 views at Belle-Île, he fixed upon the great rocks and the water dashing against them. It is a more picturesque conception of the ocean as inhabited by the rocks, which are like outcroppings of the earth within the ocean. Sea and earth, through color and light, seem continuous, unlike the stratified spaces of both Friedrich and Courbet, and in that respect are nearer to Monet's view of Sainte Adresse.

Bergson has been likened with the Impressionists, with Cézanne, with the Fauves, the Futurists, the Expressionists, and the Cubists. The diffi-

culty of the analogy philosopher-artist and the need for specification becomes more obvious when we turn from the conjectured example of Bergson and Cézanne to the well-documented reading of Bergson by the Futurists toward 1910. In the first case we are doubtful, in advance of any documentation, since the philosopher's early works (with his new ideas) appeared at least ten years after the painter had achieved his mature style. They belong to different generations in French culture; and the twenty years between Cézanne's and Bergson's dates of birth mark also a deep change in the outlook of advanced artists. It is not excluded, of course, that an artist can anticipate the ideas of a philosopher twenty years younger than himself; but such a relationship calls for scrutiny of the artist's work and thought with respect to qualities and meanings of which the philosophical import has also to be established; for this we lack a convincing theory of meaning in art so that we must proceed in a speculative and tentative way, admitting the precariousness of the analogies.

But for the Futurists the case is different. So outspoken is their appeal to Bergson (and to Georges Sorel who already applies Bergson's ideas in the social and political field), so repetitive and sloganized their use of his terms *("élan vital," movement),* that one can also regard their Bergsonism as a typical modern instance of vulgarized philosophy, like the widespread currency of certain concepts of contemporary science in the last hundred years: "the struggle for existence," "the survival of the fittest," "relativity," "the unconscious," "the complex," which, in becoming part of popular language, are detached from the fuller and more specific meanings that they possessed in their original scientific context.

The Futurists derived from Bergson a support for their conviction that art should be energetic, insurrectionary, charged with movement, and should express time as a transforming factor. It was not at all necessary for them to go to Bergson for a justification of this view. The concept of modern civilization as self-transforming, turned to the future, with an intense mobility in all fields and especially in technology was too common to need a philosopher's approval. But as a conviction seizes on whatever in its milieu seems to support it, ignoring what may be incompatible in the assimilated ideas, so the Futurists found in Bergson a

FIGURE 20. Diego Rodriguez Velázquez, *The Spinners*, or *The Fable of Arachne*, c. 1657, oil on canvas, 220 x 289 cm, Museo del Prado, Madrid

ready-made set of terms wonderfully suited to convey their own values. And since these terms belonged to a domain of the highest generality—the philosophy of nature and consciousness—their application to the aims of the artists gave the latter a universal sense, a relevance to the totality of experience beyond the special conditions of the aesthetic and the technique of painters. The Futurists, already in their choice of a name, were deliberate ideologists in art. While attacking the cult of the past in art as a stifling conservative force, they called for an even more intense historical awareness and relevance of their new art by asserting the importance of modernity as a state of affairs that required and produced its necessary modern art. Their urgently proclaimed insurrectionary will, declared in manifestos and public demonstrations, delighted in strongly worded, striking generalities about life and art that challenged the inertia of the crowd and the protected official views.

Comparing their ideas with Bergson's, it is easy to see that they appreciated in Bergson the interest in time and change as metaphysical categories associated with the primacy of the vital, the will, the organic. But their own sense of time was historical, and their imagery of movement was aggressive, destructive, mechanical—a displacement of Bergson's evolutionary outlook to the industrial and technological. The "taste" of Bergson, the poetic style, has an entirely different tonality; it finds its adequate imagery in similes and metaphors of natural processes and phenomena, in the rolling snowball rather that the speeding auto, in the refinements of sensation and feeling, not in the angularities and brutal impacts of mechanical forms.

Bergson called Velázquez his favorite painter because he presented motion—the moving wheel in *The Spinners*. But even Bergson's taste for FIG. 20 Velázquez is hardly an evidence of a close spiritual kinship of the painter's art and the philosopher's thought. For the motion that Bergson admired in the Spaniard's pictures is not pervasive, but a local phenomenon, as in the stationary structure of the spinning wheel, or as in the suggestive rendering of the movement of horses' legs where the body as a whole is modeled and textured like an immobile, clearly defined object. One might point to that wheel in which the rapid rotation blurs and even obliterates the form of the spokes, to illustrate the difference between the apparent form in perception and the so-called objective

physical form and motion; and enjoy its aptness to one aspect of Bergson's philosophy that affirms repeatedly the antagonism of the physical and the psychic, the world of inert matter and the incommensurable world of alert spirit. Yet a critic of painting who wished to characterize Velázquez's art would not fail to notice that the tones that render with a new finesse the light and atmosphere of the represented space, determining a subtle gradation of "values," are still applied to a definite framework that isolates a bodily form in its known physical density and surface and even helps to realize these qualities of the human being as a material object. The radical phenomenon of the dissolution of a form in the perception of its movement is represented by Velázquez in a rotating wheel that has a fixed position and a clearly defined circular boundary, as if to maintain the basic stability and closure of the object in a moment of apparent decomposition of its form. The root dissociation of the physical and the psychic in Bergson's thought does not provide philosophy adequate for characterizing Velázquez's art, which preserves more of the physical than Bergson would admit in the process of perception and gives to the most striking example of the Bergsonian duality—in the spinning wheel—a marginal and subordinate place as well as some qualifying residues of the material form. Yet insofar as Bergson discovers in the facts of perception features that distinguish the subjective data or process from the physical descriptions of stable objects, any painting that renders light and motion according to the artist's "impressions" can serve the philosopher as an illustration of his point—disregarding the fact that in this spiritual field of art the rejected materialist conception of nature has also its artistic paradigm in works that isolate, bound, measure, stabilize, and regulate the forms of objects. The number of paintings suitable to Bergson's point is, of course, immense ever since the seventeenth century when the representation of light became an important and, eventually, a central part of the painter's craft. But a philosophical analogy requires a deeper kinship than such an illustration, limited to one detail, would support. We expect, rather, that an artist who saw the world as Bergson did would find in the asserted difference between the psychic and the physical and in the irreducibility of one to the other, the grounds for a style in which the features of the psychic that are most distinctive for this

62

opposition dominated the whole and determined its characteristic quality. And yet, as a philosophy of any interest is more than the affirming of a single principle or value, but develops the main idea or ideas through varied applications and deductions, disclosing relevance to many fields, so the painter's conception of basic forms or qualities is not sufficiently grasped through one detail but owes its individuality and importance to the elaboration in the work as a whole or even in the series of works made over a long period of time, which, in realizing the conception, transformed many aspects of the art. Considered in this light, Bergson's allusion to Velázquez is little more that a casual illustration of a single point that might as well have been made by referring to the same phenomenon of the turning wheel or galloping horse in the world outside the picture. Yet in expressing his taste for Velázquez, the philosopher reminds us that his point of view is more general than what appears in this detail; he is himself an artist, or like an artist in centering his philosophy on the more subtle facts of perception and in representing the world according to the experiences that inspire the painter as well as the scientist.

A study of those painters who have left writings in which they speak of their general ideas will disclose further problems in the matching of art and worldviews.

Among modern painters Kandinsky and Mondrian in particular have left a body of writings to explain their new art and perhaps also to clarify for themselves aims that engaged them in a radical change of their own practice.

Both artists were deeply interested in Theosophy, and Mondrian was in fact a card-bearing member of the Theosophical Society. What is called Theosophy at the turn of the century is a set of exotic speculative beliefs influenced by Asiatic religions and by a spiritualism that is open to irrational fantasies of the magical and miraculous and at the same time to the new physics as a confirmation of spiritualistic ideas and of antimaterialism. It is doubtful that any philosophers in the tradition of modern philosophy, committed to logical analysis of concepts and a concern with the criteria of truth, knowledge, certitude, and scientific methods of experiment and validation, respected Theosophy.

How far can one discern in the work of these artists a connection with

the teachings of the Theosophical movement? In these doctrines one may distinguish two parts: first, a general spiritualistic view that affirms the primacy of spirit, and second, particular ideas about the soul, the emotions, the effects of thoughts and feelings transmitted from person to person in space and by paraphysical emanations, and a symbolism of qualities. Thus, the male corresponds to the vertical as the expression of spirit, energy, and thought; and the female, to the horizontal as matter and feeling. The balanced union of the two is the ideal of human development. These correspondences were noted by Mondrian in his sketchbooks of circa 1912 to 1914.[13] Earlier, in a painted triptych of 1911, he represented three nude female figures with symbolic triangles, the first one with apex upward, the second downward, and the third with the two intersecting to form a star.

The Theosophists believed also that colors were imbued with the qualities of emotions; and in one of their widely read books, Besant and Leadbeater's *Thought-forms,* 1905, there are paintings that illustrate the patterns and colors of various feelings. They make one think of the abstract painting that was to arise in Western Europe fifteen to twenty years later. In Kandinsky's book *On the Spiritual in Art,* a title that already suggests a Theosophical view and was, in fact, translated as *The Art of Spiritual Harmony,* the painter speaks of color in just this sense of correspondence to emotions and suggests a distinct code of equivalences of colors and feeling. FIG. 21

Can one, from the fact of the artists' acceptance of Theosophical teachings and the correspondence of certain elements and themes in their art, interpret their art as a whole or even their abstract paintings after 1911 as an expression of a Theosophical outlook or worldview?

One may argue that in their abandonment of representation for an art that replaced the imaging of material objects by nonmimetic lines and colors that express states of feeling, they affirm the deeper inwardness of spirit. It is true that in previous ages the most spiritual artists produced images and that the East Indians, to whom the Theosophists were indebted for certain of their beliefs and who were regarded by the latter as their teachers, did not find such imagery incompatible with spiritualistic views. But in the West in 1911–12, strong convictions about the irreducibility and self-sufficient nature of spirit might sustain an artist

FIGURE 21. Annie Wood Besant and C.W. Leadbeater, *Thought-forms* (London: Theosophical Publishing Society; New York: J. Lane, 1905), figs. 8-9

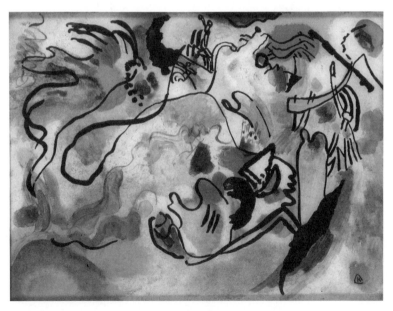

FIGURE 22. Vasily Kandinsky, *The Last Judgment*, 1912, 34 x 45 cm, Musée National d'Art Moderne, Centre Georges Pompidou, Paris

who sought in philosophy and religion a support for his abandonment of representation, which throughout the ages had appeared axiomatic for painting.

If we look, however, at the work of Kandinsky and Mondrian done just before their step to full abstractness, we see that the relation of their Theosophical beliefs to their practice is more complex. Kandinsky's paintings were of lyrically charged landscapes with large brushstrokes and intense colors and were much indebted to the French Fauves painters, who can hardly be ranged among the followers of Theosophy. The Fauves, and especially their most accomplished and original master, Matisse, were convinced of the inherent expressiveness of color and line and appeared to their contemporaries as abstract artists. An article by Matisse, published in 1908 and translated into German, stated in a clear language the principles of expression, harmony, order, and feeling that guided his work. This personal manifesto was the classic statement of ideas widespread among advanced artists at that time and was warmly received outside of France. What distinguishes Kandinsky's book of 1911, which is not yet committed to full abstractness, is a tone of pathos, a tendency to justify the new art and its principles by the need to liberate the individual and spirit in general from the fetters of a current materialism that he describes as already shattered by the latest discoveries of atomic physics and by the writings of Nietzsche.

Among the paintings of Kandinsky during the first years of his abstract art and also just before, are a series of works with religious themes. Their titles—*The Last Judgment, Resurrection, St. George and* FIG. 22 *the Dragon,* etc.—indicate a mood of religious exaltation with apocalyptic fantasies. He has described his own excitement and tension at that time, and we feel in the turbulence and intense, often shrill, colors of the abtract paintings his excited state of mind.

The worldview that one could construct from the characteristics of Kandinsky's painting would hardly apply to Mondrian's first abstractions or the style that grew out of these after 1916. If both are expressions of a Theosophical view then it must be what explains their common features—namely, the use of abstract form, lines, and colors applied freely without mimetic content. But this is also the practice of other artists who are not Theosophists, and it is a large program that is

already defined by the Fauves, the Cubists, and others. It is a broad conception of painting that has been applied by artists of different temperament and outlook, including materialists like Léger and Delaunay, who are wholly in sympathy with modern technology and the modern city. It is the mode of painting that is especially congenial to the advanced architects who also carry the banner of functionalism and economic construction. Abstract art appears, then, as a functionalism of painting; just as the new style of architecture strips the building of all but its constructive and functioning elements, exhibiting these in their pure naked forms, so the artist who is deeply convinced of the idea, already advanced in the nineteenth century, that the colors and forms and spaces are the true aesthetic working elements of a painting and determine its strength and unity and expressive force—this painter eliminates representation as a dispensable superfluity and operates instead with the specifically functioning aesthetic elements. And just as representation, which seems to be a commitment to a particular view of the world, is practiced by artists of varied temperaments and is open to a great range of content, secular and religious, dramatic and lyrical, realistic and fanciful, so abstraction, once established, became a universally open art and attracted many painters who had until then held to representation.

If their adherence to the Theosophical views was, indeed, part of a worldview for both Kandinsky and Mondrian, their actual works as artists underwent decided changes of style and expression after a decade of its practice. In Mondrian's case the appeal of the human environment became stronger within his abstractness, especially during his later years in England and the United States, living in the great cities where he came to enjoy the phenomena of the gigantic metropolitan buildings and the density of the streets, and also American jazz music, which inspired a new scale and density of the units of abstract form and the intertwining of colorful grids in his painting with the significant title, *Broadway Boogie Woogie.*

In the early decades of modernism in art, what is now called abstraction was proposed as a necessary consequence of the essence of painting. It was an art that composed colors and shapes on a plane surface, and the successful work was one in which this essence was realized in an

ordered or harmonious way. The subject of the painting could be disregarded as incidental, and an ideal state was envisioned in which painting had no subject matter but its own elements of form and color, like music. This conception of painting was often expressed in a way that recalled Plato: Beauty like truth resided in ideal forms transcending the everyday world, the illusory appearances of sense. To represent objects was to imitate an imitation, to produce a superfluous simulation. True painting realized ideal essences or expressed the underlying abstract laws of thought or of nature.

It is remarkable to read the later justifications of abstract painting. The aim is now to realize the painting as an object in itself, tangible, material with many marks of the process of its production. It is apprehended entirely in its own terms, without reference to objects beyond itself, without appeal to imagination. It conveys nothing about the world or an ideal immanent or transcendent realm. It is an occasion of the direct experience of qualities uniquely given in the painting-object.

Modern painting of the abstract mode seems to issue from two radically different philosophies, one idealistic and the empiricist. There is also a third point of view, which is more like rationalism in its conception of painting as a logical or quasi-logical activity; here the painter chooses arbitrary forms and colors and arranges these in a concordant whole in which all the elements are consistent, and through relations of space, size, intensity, similarity and difference, he produces an order satisfying to the eye and the mind. These varying philosophies of abstract painting are not simply adapted to different styles of this mode of painting, though certain artists are by temperament and culture more inclined to one philosophy than to another. But they show how loose is the connection between a philosophy of art and a particular practice, even where the latter is radically new and would be expected to generate a new set of ideas about art.

In the last decades, especially in America the empiricist approach has been the more common one, although I doubt that it is acceptable to all abstract painters. The more thoughtful ones must feel in such a conception of painting the absence of important aspects of their own art: the mystery, the unverbalizable content of the particular whole, its vague

suggestiveness, its evocation of the self, and its unspoken moods and fancies, its irreducible penumbra of feeling.

Parallel to the expulsion of ideal essences and meanings in art and the disrepute of representation, a strong current in modern philosophy has revived the respect for essences and reinstated representations, images, fantasies, as genuine data of immediate experience. I refer to phenomenology, for which objects and their representations, the real and the illusory, the handled, the seen, the imagined, and the thought, are all objects of attention or, in the special vocabulary of Franz Brentano and Husserl, are "intentional." Each of them can be isolated for discernment of its inherent features, and a proper discernment will be true to the essence of each presentation. All are given to prehension in characteristic ways. The illusion has its distinctive structure, which separates it from the "real" object. And there are specific perspectives in which the presentations of sense and thought and imagination manifest particular essences or qualities. From this point of view, a photograph, a realistic painting, a picture of imagined creatures or places, all have their empirical sense as modes of being, as essences that are experienced. To be truly empirical, a theory of painting must be open to all these modes of being in pictures rather than single out one of them as alone true to the nature of painting.

One can state the same point by saying that a Giotto is no less ordered than a Mondrian, and that in seeing a Giotto I see a painting and not just an imaged Christ or Saint Francis. Similarly, in looking at a Mondrian, I do not apprehend it as an object of paint and canvas, I do not isolate its surface, I experience it as a colored and shaped whole of the class of paintings—to which the Giotto and the Cézanne belong—and I look at it with other expectations and another mode of attention than when I see a blackboard with writing, or a signpost with a cross or arrow. My experience does not fix upon the object as it does on objects in daily life; with the latter my behavior is more truly abstracting, isolating, classifying. I recognize the type of object, the cue, the sign, and I look no more, unless it is incomplete or possesses an unfamiliar feature that is prominent and resists classification. Perhaps the painting is an ideal empirical object, in the sense that it calls for persistent concentrated looking and attention to all that is there, but in this

sense it is unlike the empiricism of science, which limits looking to observation of a relevant feature in a context of a problem that includes an appeal to generalities. This ultra-empirical attention, which is the appropriate aesthetic attitude, applies also to representation in art; we grasp it fully and in its pertinent aesthetic being only to the degree that we know what is represented. We do see and appreciate the qualities of the human figures conceived by Giotto. A little change in their forms and these qualities will disappear; a little change in the human types and the forms will have a different effect—indeed it is difficult to imagine one without the other.

What we call idealism and empiricism in art are better understood as programs than as descriptions of the art or of art in general. Courbet, refusing to paint angels and proposing to represent only what he had encountered directly, seems an empiricist. But in 1950 a painter who refuses to paint what he sees, since the result would be an unreality, an illusion, is also called an empiricist.

A metaphysics or a worldview is complex enough to admit many different judgments of resemblance to a style of painting, and all the more since a style is also a complex whole. One can easily isolate in the two wholes a few similar elements that will seem to characterize both members of the pair. In this respect the relationship is like that of a color and a feeling or mood. A dictionary of color symbolism will offer an astounding variety of associations with each color; white will stand for death as well as life; for purity and disease; peace, winter, the void, and light, and so forth. This diversity of meaning discredits the idea that there is an inherent quality of a color that will be universally felt and can serve as the ground of symbolism. But the argument is inconclusive; for it may be that white is not a single quality. It is rather a bundle of qualities from which the observer selects the one congenial to his interest and sphere of thought. White is light, achromatic, cold, filmy, unsaturated, and so forth, and each of these qualities may be connected with different objects and experiences. It is possible in a similar way to characterize both a metaphysics and a style of art in multiple respects and to find some points of resemblance. But unlike the symbolism of colors, the interpretation of a style as expressing a worldview or metaphysical outlook or corresponding to the thought or personality of a particular

philosopher, aims at a stricter connection, an objective disclosure of a content of the art and its root in a common mode of apprehending the world or experience. The comparison of style and metaphysics or worldview flows from a theory of both art and reflective thinking. There are, in fact, several theories about this relationship. One asserts that metaphysics is an expression of life-feeling like art; another that they are two ways of expressing the same true perception of wholes; still another that art and metaphysics are occupied with similar problems but approach them differently and that the resemblance lies in the common problems. A correct equation of a style and a metaphysics, worldview or philosophy would require, therefore, a different verification in each theory.

The equation of the philosophy and painting requires the specification of the traits, details, et cetera, of both the work and the worldview or philosophy. However, the constructibility of links between them, whether historical or intellectual, is relevant only for a theory of the unity of the philosophy and painting of a time and place, but not for a general theory of unified worldview in art and philosophy.

(1958–68)

[1] John Dewey's writing on art was only a small part of his work, but he thought it was most important for his philosophy, even crucial. He regarded it as a test of his philosophy. He felt that what he had written about human nature, about learning, knowledge, and experience, was borne out by art. Yet he came to art very late, although he had always been interested in it. And, indeed, in turning to art he said little that is memorable about particular works of art or particular artists; but he has much to say about the making of the work of art and the experiencing of art that I believe is important. That is, he is a philosopher of art whose insight is not into art—he is not a critic or artist—but into the situations, problems, difficulties, obscure relationships of art and experience of art among other fields of our activity. A parallel would be a writer on science who does not possess great scientific knowledge, but who understands with a special acuteness how scientists go about their business, how their results are won and applied. There are not many scientists who are clear about this; I have heard an eminent scientist, a Frenchman, say that there is no such thing as scientific method, that his results depend very much on chance or good luck and a certain mysterious knack, combined with artistic imagination. In a similar way, artists are sus-

picious of attempts to understand their activity. It is for them an action without rules, largely unpredictable; and the result is often a mystery to them. They are rarely sure they have accomplished what they wanted to do; they are often surprised to discover in their works things they had not intended that are better than what they did intend. Now it is just this kind of everyday activity that interested Dewey; a creative activity in which people work through difficulties, experiment, observe, change, destroy, start again, and finally bring their work to a conclusion, which is only the starting point of something new. It is the problematic and effort that interested him most. Art was a field in which the spontaneous and the novel were always emerging from a struggle with a resistant material. In these respects, art was like any human activity that was not pure routine. At the same time, it attracted him by its completeness or finality. The work of art was a finished object that one enjoys without looking beyond it. It is in the stream of work and experience but has a privileged position as a goal or fulfillment in which all the labor is forgotten in the perfection of the result.

One may speak of his relation to art from two points of view, as a philosopher who has written on art, and as a philosopher whose ideas about knowledge, human nature, values, and experience remind us of the art of our time and who therefore takes his place beside the great artists—the poets, painters, and musicians—in shaping a modern vision of life.

[2] The development of visual art is an important development in the power of perception of the forms of objects and a skill of representation valuable for knowledge and memory of natural forms, including the human. Sculpture and architecture are crafts that have advanced since primitive times the construction of shelters and boats; drawing in general is the basis of transmitting the designs of inventors and are indispensable in the experiments with alternative solutions. Michelangelo's talk with a Portuguese artist on the various functions and skills indispensable in the advance and effectiveness of various human interests is quoted by Francisco d'Ollanda:

> ...I sometimes set myself thinking and imagining that I find amongst men but one single art or science, and that is drawing or painting, all others being members proceeding therefrom; for if you carefully consider all that is being done in this life you will find that each person is, without knowing it, painting this world, creating and producing new forms and figures here, in dress and the various garbs, in building and occupying spaces with painted buildings and houses, in cultivating the fields and ploughing the land into pictures and sketches, in navigating the sea with sails, in fighting and dividing the spoils....I leave out the handicrafts and arts, of which painting is the principal font....So that whosoever well considers and understands human works, will find without doubt that they are all either painting itself or some part of painting....

Charles Holroyd, *Michael Angelo Buonarroti,* 2nd ed. (1911, London: Duckworth and Co.; and New York: Charles Scribner's Sons), pp. 253-54.

[3] W. Dilthey, "The Dream," *The Philosophy of History in Our Time,* ed. H. Meyerhoff (New York, 1959), pp. 17-43. Translated from *Gësammelte Schriften* (Leipzig and Berlin, 1914-36), VIII, pp. 218-24.

[4] W. Dilthey, "The Understanding of Other Persons and Their Life-Expressions," *Theories of History,* ed. P. Gardiner (Glencoe, Ill., 1959), pp. 116, 213-25. Translated from *Gësammelte Schriften* (Leipzig and Berlin, 1914-36), VII, pp. 205-20.

[5] Wilmon Henry Sheldon, *Strife of Systems and Productive Duality: An Essay on Duality* (Cambridge: Harvard University Press, 1918).

[6] Berkeley, Georges, *An Essay Towards a New Theory of Vision, The Works of George Berkeley, Bishop of Cloyne,* edited by A. A. Luce and T. E. Jessop (London, 1948, reprinted 1964), I, p. 223.

[7] *Ibid,* II, p. 234.

[8] Erwin Panofsky, *Galileo as a Critic of the Arts* (The Hague: Martinus Nijhoff, 1954), pp. 8-9, 35-37.

[9] Michel-Eugène Chevreul, *De la Loi du Contraste Simultané des Couleurs* (Paris: Pitois-Levrault, 1839). Chevreul (1786-1889) was an important chemist employed at the government institution for fabrication of tapestries to decorate government buildings and offices by preparing for them the pigments used in the artists' preparation of the tapestries. The dyers *(teinturiers)* indicated a problem—the blacks supplied by the chemists were not good blacks, not dark enough, not distinctly *(nettement)* enough black.

Chevreul's chemical test showed that it was, indeed, the best possible black and from an experiment he made to prove it, he concluded that the trouble was psychological rather than chemical. He observed that the painters and dyers at the Gobelins worked on drawings in which the black was put beside a blue and the black seemed to be altered by it.

As a practical corollary of his idea that colors change their appearance when set beside other contrasting colors (simultaneous contrast), he advised painters and dyers to take this into account in selecting colors in areas next to or close to their complementaries—in order to preserve the intended local color *(and value or brightness)*. A man of an older generation than the Impressionists, his taste in art was formed by the teachings of the Neoclassical school and the Academy, which made a point of the necessary correctness of the enduring local colors of objects.

[10] Ignace Meyerson, ed., *Problèmes de la Couleur,* published for the Bibliothèque Generale de l'École Pratique des Hautes Etudes, for the Centre National de la Recherche Scientific, S. E. V. P. E. N. (Paris, 1957), pp. 248-253.

[11] Charles Blanc, *Grammaire des arts du dessin,* 3d ed. (Paris, 1876).

[12] David P. G. Humbert de Superville, *Essai sur les signes inconditionnels dans l'art* (Leyden, 1927-1939; manuscript of 1841 never printed).

[13] Robert P. Welsh and J. M. Joosten, eds., *Two Mondrian Sketchbooks 1912-1914* (Amsterdam: Meulenhoff International nv., 1969), passim. For examples of works see Michael Seuphor, *Piet Mondrian: Life and Works* (New York: Harry N. Abrams, 1957), p. 103, and *Mondrian Zeichnungen, Aquarelle, New York Bilder,* Staatsgalerie, Stuttgart, Dec. 6, 1980- Feb. 15, 1981, cat. no. 89, pp. 86, 175.

CÉZANNE AND THE PHILOSOPHERS

E VER SINCE CÉZANNE'S DEATH, ATTEMPTS HAVE BEEN MADE TO GIVE to his painting some of the interest and value of a particular philosophy. This has been done by so many writers that I cannot deal with more than five or six of them; but they will perhaps be enough to give you a notion of what Cézanne has meant to writers who believe that the work of Cézanne has a philosophical import.[1]

This practice of matching the style of a painter or the content of his work with a particular philosophy or philosopher, as distinct from a large trend in philosophy, rests on the belief that there is, indeed, a kinship between the logically structured ideas of a philosopher and the mind or art of a painter, which issues from his personality. This might seem rather strange because a philosopher, and in this respect also a poet or a novelist, employs the medium of language; he uses words that are intelligible and organized according to a familiar syntax, and is able, therefore, to present ideas in a discursive form. There are novelists who, in the midst of a story, will make statements about the world and human nature, about individual characters and motives of their behavior, as though the author was speaking of and for himself. At such points poets and writers of narrative fiction seem to touch the reasoned thoughts of various philosophers. But a painting is not discursive; it cannot be put into words; it does not represent a sequence of events. It is rather difficult to find equivalents to a philosopher's ideas without doing injustice

75

to the qualities of the paintings, taking you away from them into a region that is not that of the actual substance of painting.

The practice of doing so rests on the belief that a philosopher has a worldview—a conception of things that he encounters and knows, close to his own being and thoughts, and problems or ideas for his reflections—in the same sense that a painter representing his experiences and emotions has a worldview. The philosopher selects some objects and excludes most others, and that selection may imply a particular tendency of feeling and thought. He has what is called a value system. He has, moreover, to organize his elements, and in arranging them, he introduces an element of further selection that can be regarded as analogous in some respects to the logical and systematic aspects of painting. Further, some philosophers have maintained that although all philosophers seek truth, they seek also to satisfy certain demands of feeling and often display, in their style of writing, unconscious tendencies of their personalities. In a corresponding way, a style of writing as an expressive ordered whole has some kinship with broad features of philosophizing or a philosophy. It has even been proposed by a modern philosopher, Richard von Mises, that style has the same relation to a work of art that a theory has to scientific knowledge: It is a set of consistent principles from which one can generate a number of coherent propositions, which also serve as a guide in exploring the world of objects and one's observations. So one has found over the years various features that seem to be shared by philosophers and artists.

That does not mean that every artist has a philosophy or that he is necessarily conscious of his philosophy. Even philosophers are not fully aware of the implications of their thinking, such as inconsistencies, that later philosophical critics may discover, leading them to change their views. They are not prone to examining closely the reasons for holding one philosophy rather than another. There is an extreme further qualification stated by a philosopher of the nineteenth century, Ludwig Feuerbach, that a true philosopher does not have a philosophy. What a philosopher does is philosophize, examine, question, investigate, seek consistency, and discover inconsistency; to claim for himself a complete or perfect system is not a philosophical attitude. It limits his further growth or insight and can only generate the repetition of the same set of

ideas and assumptions. So one can describe the relations of philosophers and painters in different ways, according to the point of view of the philosopher on what philosophizing is.

Since the beginning of the last century, the kinship of philosophy and art has had high repute in Germany. There were philosophers who felt that art was the completion of philosophy. It was the consummation of all philosophical thinking, insofar as philosophy in its effort to describe and to interpret the world was limited to abstractions, to ideas that referred to abstractions of a high order. In order to grasp the truth of statements about things in general, there had to be some means of introducing the concrete world and the individual, both of which are foreign to the philosopher. Moreover, to make visible the activity of the mind of the artist himself in a tangible way, in a work of art, is often akin to the philosopher's task. That has often been observed also with reference to the expression of a culture or a civilization: It is art that makes philosophical thinking more accessible to us in a concrete way, through images in which physiognomy, postures, style, forms, and expression give a richer and finer substance to what would otherwise be vague or abstract. Schelling wrote shortly after 1800, "Art is the only true and eternal organ of philosophy—and at the same time its chief document."[2] He regarded philosophy as essentially one-sided and incomplete because it lacked the concreteness of the work of art. It would finally realize its goal only in works of art. In our own time, the French philosopher Maurice Merleau-Ponty wrote that all painting contains a metaphysics; that underlying every work of art is a sense of reality, whether the reality of the self or the reality of the so-called external world, of nature, which is also an object of investigation or research on the part of philosophers. But the latter cannot achieve the beauty, the concreteness, the immediacy of the work of art; they are limited to the field of verbal abstractions.[3]

Along with such views, there have also been efforts to systematize, broadly, the relation of philosophies to worldviews. These two are not quite the same thing. It has been said that every person has a worldview implicit in his behavior, which he derives partly from experience of the world and partly from his own physical constitution, his powers, and his defects, which lead him to one or another way of regarding things. The

German philosopher Wilhelm Dilthey, who unfortunately is not suffi-
ciently well-known because of lack of good translations, set up a schema
of possible worldviews. He thought there are only three or four possible
worldviews, given the relationships of man to nature, to himself, and to
other human beings. He undertook to write a history of thought in
terms of the limited number of possible worldviews. He distinguished
also between naive expressions of a worldview and a reflective philo-
sophical worldview. The philosopher has the responsibility of formulat-
ing his worldview in a consistent, reflective manner in the light of his
knowledge—scientific or practical knowledge, religious ideas, and expe-
riences—at the time. There is a constant interplay between the sponta-
neous and inherent types or worldview and the forms that they acquire
when submitted to reflective analysis or to a projection with the help of
the range of accepted knowledge.

From this approach have come numerous matchings of works of art
with philosophies. In the eighteenth century, Johann Joachim
Winckelmann said that if you wish to understand Greek sculpture, you
should read Plato as well as look at the sculptures. There you will find
the key or secret of such a conception of form or beauty or expression.
Afterward came the famous analogies of Scholasticism and Gothic, of
Poussin and Descartes, of Rembrandt and Spinoza, also of Rembrandt
and Pascal, and other matchings of a philosopher and a painter,In the
nineteenth century, one noted already that realism in painting and sculp-
ture had something to do with materialist thought or positivism in
France and elsewhere. These were rather easy matchings: The same
words were used in both fields, and moreover, the painters were aware
of what was being said by people other than artists and scholarly critics,
who might not have taken them seriously. Their use of words like *real-
ity,* and *truth to reality,* and terms like *form, nature, and being,* and the
rest of the vocabulary of art criticism and art history tended to stimulate
the search for analogies between philosophy and art.

More recently, in this century, the Spanish author José Ortega y
Gasset wrote a small work on modern art rather hostile to contempo-
rary painting, in which he noted what he called its dehumanization,
because human beings do not appear in those works, as if what man
makes is not human unless there is a picture of man somewhere within

the image.[4] He pointed out that the whole development of philosophical thought is from a naive type of objectivism to a more nuanced and analytical kind in the Renaissance, with scientific elements; finally the object of attention became the thinking mind itself or thought in itself; out of that came a type of philosophy that gave less and less value or independent significance to the external world and conceived of it as if it were a product of mind, of spirit and thought. Ortega believed that the extreme tendencies arising from this view appeared also in an art that denies nature and the human being and is absorbed entirely in what the mind can spin from its inner resources of thought and feeling. This type of analysis has become fairly common.

Hegel's philosophy of art is one of the great monuments of such an enterprise of interpreting not only works of art but the history of art and the nature of art as a process in time in which various stages in the development of mind and of reasoning are manifest also in works of art of the same epoch, in features coherent with the stage of thought.[5] He wrote not only with eloquence, but with an amazingly rich observation of relationships and with great finesse, all the more remarkable given the limited range of works and styles of art available to him at a time when museums did not have changing exhibitions and could not bring to one place many masterpieces of a single school. Only a few art lovers who traveled or who had engravings of works of art that were scattered through Europe could even begin to contemplate the diversity of arts and imagine what sort of relationships might have arisen from them in a particular society.

The practice of matching a philosophy and a style of art has become so common that it is now assumed as obvious, a cliché. Let me give an example of how easily and readily one matches movements in style and movements in philosophy. Herbert Read, in his introduction to a large book on modern painting, wrote that John Constable corresponded to Hegel, Cézanne to Husserl, and Picasso to Martin Heidegger (ignoring Picasso's Cubism).[6] Given this sequence, one will ask, to whom does Pollock correspond? I remember a student in a course of mine, an economist, who presented me with a chart, showing the correspondences after the period of the 1930s and 1940s; there, on one column, were painters, on the other, ideas in philosophy and science. Jackson Pollock

corresponded to quantum mechanics and indeterminacy, i.e., to Werner Heisenberg. This becomes an easy game in which one has a chance of being right; but since there's also the chance of being wrong, it is necessary to validate these comparisons, to find some ground that would justify our preference of one rather than another match or, perhaps, both at the same time, since philosophers often share some ideas, though they may disagree on many points.

To give an idea of how common this was at the beginning of the century, I may mention that Bergson has been linked not only with the Impressionists, but with the Symbolists, Cézanne, the Fauves, the Futurists, the Expressionists, and the Cubists. The question arises then: What is the significance or value of these analogies if the same philosopher can be matched with all these quite different styles of art? Still, there are possibilities of correspondence, insofar as certain terms and concepts of philosophers seem to fit preoccupations of difference painters, poets, and novelists. I should like to mention still another instance of this practice, a letter written in 1906 by a young student, Jacques Rivière, who was an excellent writer and a man of insight, perhaps the first Frenchman to write an interesting book about psychoanalysis. (He wrote on Freud and Proust as early as 1919 or 1920, examining their relationships. He found in them an extraordinary kinship of attitude and of observation.) In that letter of 1906, from his school in Bordeaux, to Alain-Fournier, a novelist (the author of *Le Grand Meaulnes*, 1913) who died in the First World War, Jacques Rivière tells of having attended a lecture by a young philosopher at a socialist meeting in Bordeaux, who spoke of the applications of Bergsonism to art. Rivière wrote: "A thrilling subject about which I've been thinking for a long time already: the striking accord of the really new philosophical theories and symbolist art in all its forms!... Oh, what an exciting subject!"[7] We see that given the attraction of Bergson as a philosopher and his impact on young minds, and the corresponding excitement of this new art for last-year lycée students, the matching of them seemed to be a plausible approach.

The first writer I know who attempted to deal with Cézanne from such a viewpoint in a more methodical way, though not at all strictly— not all methods are applied strictly, though there is a kind of method in

exploring similarities and analogies in studies of art—was a German scholar, Fritz Bürger. In a work written in 1911 or 1912—it was published in 1913—he undertook to characterize the modern movement of art as a whole, then very new in Germany, and under the sway of expressionist pathos and exaltation before the First World War.[8] He undertook to show how Cézanne could be understood better through the philosophers, since the philosophers articulate in a more deliberate and analytical way the ideas that arise among those other than philosophers but remain more or somewhat vague or implied, yet serve as directing forces in the painter's working out of problems of his new art, without determining the precise solutions. He begins by quoting a statement of Schelling, which he attributes, however, to Kant. You'll see why presently. It is the statement that I quoted earlier, "Art is the only true and eternal organ of philosophy—and at the same time its chief document." He believed that every great painter is a philosopher; lesser painters are not truly philosophers. For some reason there is a hierarchy of philosophical intuition among artists according to their artistic rank.

He explores the work of Cézanne, in a way that would not strike us today as satisfactory, though in his time it had a certain freshness, and attempts to show that Cézanne is like Kant, because while other thinkers were occupied with features of the world and tried to do in their way what a scientist does—to describe and explain experience through general laws—Kant on the contrary was interested in the conditions of experience in general and the conditions of knowledge. What is involved in knowing something at all through forming new directing concepts? What are the conditions of valid knowledge, of truth?

For Bürger, then Cézanne, is an artist who, instead of painting the world as it appears to us, in action and movement and with the show of feeling and impulse in the human figures, the manifestation of vitality, the organic in animal nature (by other than human beings), limits himself to the processes common to knowledge in general, as depending on sensation but also a priori components in knowledge as Kant brought out. In the *Critique of Pure Reason* Kant was occupied at first, at least in part, with the nature of time, space, and causality and then with the innate categories that he tried to show are prior to experience and moreover help to constitute experience. In short, he held that when

we see a formed object, it (i.e., the form) is not given to us directly. We recognize it not by sensations, but rather according to built-in structures of thought and reason. We could not speak of an object as having such a form and such a position and having such a relation to other things around it unless we already had concepts of space and time and of relationships and causes (causality). We do not discover these by examining our experience, but on the contrary, it is they that make experience possible.

In the same way, Bürger believed that Cézanne was interested in constructing forms in such a way as to make visible the actual process of emergence of things into experience as constituted wholes and as organized configurations in space and time. To him, Cézanne is like a philosopher of the Kantian school.

While he follows Kant in the revolutionary, innovating aspect of his thought, he was not satisfied with that; Bürger felt that there was in Cézanne also a mystical strain, an intuition of a cosmos, a totality that embraceseverything. Just as Kant, according to certain interpreters, had an aspect of mysticism, in that he presupposed and found necessary as a regulative principle an idea of the whole, even though we have no direct experience of the whole, so Cézanne proceeded from a sense of a cosmic totality. He was a great artist in his ability to shape things so as to make us feel the totality as more than an assembly of apples; even the composition of a group of objects in a landscape as a whole was a piece of something that extended beyond it and would have the same properties throughout, so that the cosmos as an all-embracing whole was delivered to us through his painting by virtue of the mode of composition, and by the coloring and interplay between sensations and forms. These were among his ideas.

Not satisfied with having connected Cézanne with mysticism as well as with Kant's ideas, Bürger found connections also with Husserl and even with Bergson. That was part of the Expressionist pathos, which sought and found in certain contemporary philosophers a strong commitment to the primary place of spirit or mind in the constituting of reality of the world. The world was not given, as such, only to our eyes, or to our constructive thought, but itself had to be impregnated with thought and feeling that have a prior existence in the mind of man or

spring from human nature, that make not only experience possible but the particular modes of experience that were celebrated by Bergson or that Husserl indicated as the avenue of truth by an intuition of essences, of which I will speak presently.

This notion of Cézanne as a mystic had already been expressed by his contemporary, Gauguin, in a letter that he wrote in 1885.[9] Besides describing Cézanne as a man who sits on a mountain top reading Virgil and experiencing the grandeur of nature, he said that he is like a mystic who lies down on a couch and dreams of a cosmos; Cézanne, he said, had something of the appearance of a Levantine, of an oriental mystic. The idea persisted. It appears in his disciple, the painter Emile Bernard, in his account of a visit to Cézanne,[10] and is strongly stressed in a recent book by Kurt Badt, who makes the religious experience and consciousness primary in the formation and qualities of Cézanne's mature art.[11]

A more searching and refined approach to this characterization of Cézanne's thought implicit in his work and, perhaps, even present to some extent in his awareness, is an article by Fritz Novotny.[12] It was published in 1932 in a German periodical and then expanded and carried further in a book, which is a classic in the literature on Cézanne, *Cézanne and the End of Scientific Perspective*.[13] (I owe him much in my own studies of Cézanne.) In his writings, but particularly in the article, he characterized Cézanne's art as having a quality of—how shall I say, I must use a German word for it—*Seelenlosigkeit, Abschiedenheit*. It is a quality of detachment and of dispassionateness, of "soullessness" in the sense not of hardness, cruelty, or inhumanity, but of withdrawal from the normal preoccupations of life. The art of Cézanne, it appears, does not represent human beings in their physiognomy as shaped by impulse, desire, and frustration, and by the wear and tear of experience.[14] There is no searching of the soul of the sitter; likewise, the objects of nature do not seem to have an inside. They are seen as rather cool and without a pronounced expressive face.

This quality Novotny attempts to explain by Cézanne's project, his program: Cézanne—and this is where Kant comes in—is concerned with the problem of representing the world not in its becoming or in its action, but as it is reconstituted in its appearance for the eye, with a rigor of form and a cohesion that are not present in sensation. Novotny

often speaks of the relation to Kant as a means of bringing out more sharply these qualities of mind. He also characterizes Cézanne's space in Kant's terms as a form or mode of visualization, through which objects acquire their position in space, their relations to one another, and finds a striking analogy to Kant in Cézanne's process of building up the appearance of a three-dimensional world of objects modeled, solid, in depth, with some perspective (though not at all the strict mathematical perspective of the Renaissance), building up that world from the cohesive organization of small units of flecked color on the two-dimensional surface. He believes that the two-dimensional surface, the plane of the picture, is the real carrier of the picture and the artist's main preoccupation with respect to order. To create that order on the single plane of the picture, Cézanne has to give objects their specific characteristics. And to accommodate the objects in turn to the two-dimensional pattern, he is forced by his own thought, by his sense of the logic of construction, to deviate from strict perspective, to make certain distortions, to minimize the tensions of converging forms in depth. The book contains innumerable fine observations that pertain to this problem.

Kant was for Novotny a model to such an extent that he was able to say that one can call Cézanne's painting *Erkenntniskritik,* that is, painted epistemology, painted theory of knowledge: not knowledge but the analysis of how knowledge is formed, how things are known. He tries to work that out in a number of different respects and to account through these for Cézanne's detachment from any other meanings or associations. So Kant doesn't ask what an object comes from, what it's used for and what its life history is, but rather investigates how we know that the object is as it is with respect to certain properties, and distinguishes between what comes from sensation and what comes from already built-in modes of perceiving and thinking which are self-evident. These are given, as he said, a priori; without them we could not have knowledge of essential features and relationships of these objects in space and time. Likewise, in Cézanne's pictures it is the two-dimensional plane that determines the three-dimensional aspect, and the three-dimensional aspect of things as they appear must be modified in order to accommodate them to the order of the surface pattern.

I'm afraid I'm not giving a sufficiently precise or nuanced account of

Novotny's thought in his later writings. There he tended to reduce the force of the analogy by declaring it to be just a metaphor designed to make clear the relationships and the character of Cézanne's work. In doing so, he ignored the various questions that arise as to the actual historical relationship between Kant and Cézanne and the extent to which the relationship can be followed through in other parts of the work. At any rate, he felt that the greatness of Cézanne's painting as a turning point in the history of art corresponded to Kant's role in making what Kant called a Copernican revolution in thought, by placing the knowing mind, the knowing agent, in the center of the system instead of it being one object among others in the world that had to be observed. (I may recall in contrast the remark of the Danish philosopher-theologian Kierkegaard about Hegel, that he constructed an immense system in which the philosopher himself nowhere appears as a component. He is like a man who has built a great castle in which he reserved for himself the doghouse at the entrance. He himself is not visible in the castle.) In more recent works, I think, Novotny has not tried to reaffirm that relationship to Kant.

There are important problems here that come to mind because of the assumption that is shared by so many artists after about 1910—it already is evident at the end of the nineteenth century—that when we look at a painting in perspective, we actually see all the parts of the work—the colors, the lines—as a pattern on the surface. Although that is regarded as axiomatic by many teachers of painting, I've never been able to experience it myself. When I try to see a pattern in the painting, I see some parts of the painting but I cannot see all of the painting in one glance, just as I cannot see all of a three-dimensional object in nature, in three dimensions, in a single perception. And when I look at the painting as a whole in order to grasp the objects—their depth in space, their volumes and shadows and lights—I do not see the whole as a flat pattern. I've yet to come upon a careful study of the relations between the two-dimensional and three-dimensional aspect of representation. I believe that we cannot go further with this analysis, which has been so fruitful for understanding many features of Cézanne's art, unless we study afresh this relationship of the two-dimensional to the three-dimensional. The modern conviction that all past art that is good, insofar as it

has spatial representation in three dimensions, was really designed to form a flat pattern on the surface, has remained a dogmatic assumption and requires, I think, further testing.[15]

I turn to another approach to Cézanne; it is that of one of the members of this symposium, the speaker at the Museum of Modern Art during the great show of Paul Cézanne's late works. Mr. Hamilton found in Cézanne not Kant but Bergson.[16] He observed that what is significant in Bergson is the discovery of time as a fundamental, irreducible component in our experience; it is not to be confused with the measured time of clocks, of scientists, of time tables, but is time as lived, time that Bergson called *durée,* or duration. It is not made up of points that can be isolated separately but is characterized by flow, by indivisibility and interaction, and is essential to memory as well. This sense of time Hamilton finds in Cézanne's painting because—in a still life, for example—one object on the table is represented as if seen from the right and another one as seen from the middle of space and still another as from the left: there is no consistent fixed point of view. The whole space has been rendered not as beheld at one moment in time but at successive moments. Therefore, he supposes, Cézanne is the first artist who introduced time into painting.

His idea is all the more interesting because he regards as the opposite, as an example of the absence of time in painting, the Impressionist painting which so many writers think Cézanne has reformed or broken with or corrected by introducing stability, order, solidity, timelessness. For Hamilton, Cézanne was responsible for the temporal in pictures rather than the eternal, stable character that is so familiar a phrase in descriptions of his work. René Huyghe, who at one time was director of the Louvre and is now teaching in Paris, said in a paper, years before, that Impressionism corresponds exactly to Bergson because Impressionism introduced time into painting. Monet set up several canvases, one for each hour, before Rouen Cathedral and painted it as it appeared at that moment, so that the moment of experience of the landscape or city scene was introduced for the first time into painting. Looking at each picture as a phase of changing light and atmosphere, we have at once a sense of the condition of things at an instant of encounter, not an instant in a quantitative sense but as experienced by

us in our awareness of time as flowing, its passage in the course of hours, even of some minutes.

This concept of Cézanne's as a painter of time is questionable. If there are in his pictures different perspective points of view in the rendering of various objects on the table, no spectator can indicate in what order they were done. Which was seen first and which after? In what sense can one speak of a flow of time, of the temporal in them? Finally, one must recognize that in Impressionist paintings, as in much painting in the seventeenth, eighteenth, and nineteenth centuries, very little knowledge of perspective is required to discern the many vanishing points in the picture. Few paintings made after 1700, especially of landscape and even of architecture, show strict linear perspective in the convergent lines and foreshortenings; the artist sees his objects separately and empirically. Looking at an object, the eye shifts; the result is a whole in which there are many small discrepancies and sometimes large ones. They are especially pronounced in the works of Pissarro, for example, and also of Monet. One cannot truly attribute to Cézanne such a temporality as Hamilton ascribed to him—Bergson's attitude to durée, to time—without also asking about its existence in earlier art, especially among Impressionists.

More recently Forrest Williams, a disciple of Husserl, ascribed the latter's ideas—at least his older ideas as they were before about 1914—to Cézanne, by observing the program of what is called phenomenology.[17] It would be difficult to convey in a few sentences the distinctiveness of that program. But at least one of its aspects, which has been sloganized often as "back to the object," can serve as an indication of the alleged connection of Husserl and Cézanne. Earlier philosophers of the late nineteenth century, some of whom were robust empiricists, with great confidence in the fruitfulness of direct observation and reasoning from observation and careful study of the appearances of things, regarded sensations as small psychic units out of which were built our knowledge of the objects that produced these sensations; through various associations of these sensations with each another, one constituted a knowledge of the objects. In opposition to them, Husserl thought that we experience objects as wholes so that associations are not so pertinent to knowing what the essence of the object is. They can only be distractions. He

proposed a method in which the object is contemplated as given to us, while we suspend interest in what caused it, its use maybe, what is happening elsewhere or is visible in its surroundings. By attentive looking at the object—by meditating closely and focusing on it as a whole, and on its color, its structure, its forms—one can arrive at a general truth, an essence that has a universal character, and that provides him with a certitude that is parallel to the certitude of mathematics, for example, as an a priori science.

This program has had an important effect upon psychologists. The Gestalt psychologist Kurt Koffka, a pupil of Husserl, and Wolfgang Köhler himself have written about their indebtedness to phenomenology as an approach:concentrating on the way a phenomenon presents itself to us, without questions about anything but its mode of appearance and its presence, its inner boundaries, and its qualities (construction) as a formed inner experience of sensations. (There are exceptions, though, which take us beyond the sensory qualities, where the objects are things of use and part of their essence is their function, what they do, with which Husserl believed that one could construct a better knowledge.)

For the philosopher Forrest Williams, Cézanne is like Husserl in that his program is a return to objects: a restoration of the object that had been eroded by the Impressionists, through a commitment to an atomistic method of painting in which small points of color, rendering little effects of light called sensations, were regarded as presenting the real nature of the object. Important qualities of the directly perceived sensory object—its solidity, weight, texture, tactility, spatial volume, local color, and its coherence, constant as well as fluctuating appearance, what makes all these sensation point elements seem to belong to one thing that can be isolated—all this, which disappeared in Impressionist painting, was restored by Cézanne. And just as his efforts had a great effect on all later painting, so later philosophy and psychology profited by the phenomenological approach.

This phenomenological approach appears with more subtlety and eloquence in an exploratory article by the French philosopher Merleau-Ponty around 1945—it has been translated several times since—who came from the school of Husserl and regarded himself at one time as a phenomenologist.[18] In writing about Cézanne in an article, "Cézanne's

Doubt," he does not mention Husserl in applying his method. Moreover, he is not limited by Husserl; he has also read Freud and other psycho-analysts; he has studied Gestalt psychology and has been interested in the psychology of personality and the effects of the types of bodily construction. From his acquaintance with these four or five different fields—he had already studied them in two of his books, one on the psychology of behavior and the other on the phenomenology of perception—he tries to reconstitute, in thirty or forty pages, Cézanne's art and his point of view, his attitude, with a richness of observation and reference. I recommend it to you highly as an example of a rounded investigation that brings to the study of the painter the knowledge of several different fields.

Merleau-Ponty has taken over from Novotny certain important ideas. (In his book on the phenomenology of perception, he quotes Novotny's article of 1932, so there is no question in my mind whether Merleau-Ponty has read him.) He accepts Novotny's idea that expressiveness in Cézanne's painting has been reduced and short-circuited by an attitude of detachment and complete indifference to all that is human in things and even to the human psyche as legible in expressions of the face or in gestures and posture. He tries to show how all these have come about through a psychological process. He does not make it depend only on the program of bringing to the two-dimensional canvas a complete three-dimensional world, so that its coherence is on that plane surface. He also mentions that as a factor in the coolness and detachment and the apparent nonhuman aspect of Cézanne's work. But he also believes that the process in painting has a psychological root in the artist's personality.

Merleau-Ponty approaches it first through a concept of temperament. He finds in Cézanne, in the light of what is known about his reactions to people—his fear of others, his escape from them, his loneliness—what is called a schizoid temperament. Following the ideas of the German psychologist Ernst Kretschmer, he believes that temperament is grounded in a type of physical constitution. Cézanne, he supposes, has a schizoid bodily structure, which is a factor in his temperament and in his reactions to people. He is shy, easily troubled by challenges from others; he inclines toward solitude and is afraid of his own impulses. He

doesn't trust himself, nor does he have confidence in the reactions of others. After many efforts to overcome those anxieties in his early work, in which his impulses are given free rein through violent pictures of murder and rape and other destructive situations, he tries to change his way of life. He undergoes a conversion, which is a resolution. It becomes a project.

Here Merleau-Ponty applies the ideas of his friend and associate Sartre, the existentialist approach of Sartre and Heidegger to the individual's existence as defined. Within a framework that includes death as the horizon, and also the consciousness of his own infirmities and difficulties, the individual wills to surmount them by an action on which he stakes his life and in which he submits himself fully to a goal set by himself, which has a heroic character.

Finally, since Cézanne is so deeply repressed and frustrated a person, there is a need for transposition of his impulses to another field. Here Merleau-Ponty makes use of Freud and imagines a determining traumatic episode in his childhood, though he doesn't indicate what it is. The one event he does mention, a later disturbing episode that brings out Cézanne's great horror of being touched, he does not recount correctly. The French painter and writer Émile Bernard met Cézanne in his old age and tried to take his arm when Cézanne stumbled; Cézanne was so disturbed by the contact that he ran away. Later he regretted his violent reaction, and when they had made up, he explained to Bernard that years before, while he was descending a staircase, a boy sliding down the banister touched him; that contact left a scar, a trauma; since then he was frightened if anyone touched him. But actually the boy did not touch him; the boy gave him a kick in the behind, a sharp one. For anyone who knows psychoanalysis, that story would suggest a quite different explanation and solution. But Merleau-Ponty does not go into that at all. He assumes that there was a traumatic infantile experience that determined the direction of his life.

And yet Merleau-Ponty, as a good existentialist and activist, doesn't want to believe in strict determination of an artist's career and the character of his work by any single event, so he presents Cézanne as a man who was determined from his childhood on, but at the same time was free, because every act springs from himself, and from within. From this

account he derived the intensity of Cézanne's commitment to an absorbing task in which the emotions are excluded, so he avoids expression of his feelings, which have led to painful episodes in his youth. As an artist he gives himself a project in which he masters his feelings and everyday life problems by mastering an absorbing, lifelong objective that is free from emotion.

All that, however, does not square with the many episodes in Cézanne's later life and the many pictures in which he confronts human beings and also allows his imagination free play, especially in erotic themes. Besides, from Cézanne's own writings we know that for him the landscape of Provence is very beautiful, a place of old memories that were dear to him, charged with the poetry of happy experiences. He wrote of them with strong intense feeling and spoke of his painting as a process of realizing those more agreeable feelings. One can therefore question whether Merleau-Ponty's account is adequate, or at least sufficient, for understanding the relationship between Cézanne's personality, his reactions to the world around him, and the character of his art.

Cézanne's doubt and the existential sense of his enterprise as a painter have been the subject of a book by Kurt Badt, which I mentioned before. It is an attempt to find a single principle of Cézanne's thought and feeling that would open the way to a better perception of numerous features of his art: the choice of colors, the mode of composition, the actual course of development of his art, and the relation to the subject matter. Badt finds in certain of the subjects, especially in the *Card Players,* some reference to early family life and history.

That effort to find an existential basis for Cézanne and to move from the notion of the absence of emotion in Cézanne to a viewpoint in which the art of Cézanne is deeply charged with feeling and springs from emotional experiences that reappear in the work, in a transformed way, has become familiar; it seems as if it follows necessarily from a statement of Picasso in 1935. While in the early years Picasso spoke of Cézanne as the great master who guided him toward Cubism and toward an art of pure constructiveness, in which objects appear as arbitrary designs of a painter who is seeking an order and strength of forms, in 1935 he said, "What forces our interest is Cézanne's anxiety. That's Cézanne's lesson,...the rest is sham." [19] Of course, he exaggerates. He doesn't believe

the rest is sham, but that's his way of shattering the narrow contemporary image of Cézanne. Picasso himself had shifted from his older Cubist approach in the 1920s and 1930s to an art that led him to say, "[M]y aim in art is to make things which give off emotions and which engage the spectator in my emotion." Having himself changed his position in that way, and having become more conscious of inner conflicts, personal problems, and frustrations, Picasso came to see Cézanne from a new viewpoint, closer to his own.

Hence follows the effort of Badt to speak of Cézanne as a religious painter and a man whose painting is a manifestation of his existence, not an escape from it, as Merleau-Ponty thought (although for Merleau-Ponty that escape is itself an existential fact and a manifestation of a schizoid temperament). Badt, like certain modern theologians and philosophers of religion, regards as religious any deep commitment that binds a person fully, that engages all his energies, and in governing his relationships with human beings tends to make him a solitary, utterly possessed by his task. For him the monk, the priest, but especially the hermit are models of the truly religious nature. He admits that many artists have been religious in that sense without having religious beliefs of a confessional, theological (dogmatic) kind. Moreover, he believes that Cézanne had undergone a religious conversion in the early 1870s, perhaps as early as 1872; he has also what was called in the nineteenth century cosmic emotion.

There was a time in the late nineteenth century when those who were sensitive to manifestations of nature in its "totality"—we cannot say "totality" except in quotation marks—in abandoning confessional dogmatic religion, a religion of ritual and theology, could still feel that in one experience of what one called cosmic totality or cosmic emotion they were in touch with something that was like older ideas of God, like pantheism, for which God dwells in all things. There are beautiful examples in the writings of Gustave Flaubert as a young man, in his twenties. In the 1840s and 1850s, the critic Theophile Thoré described a vision— his first view of the ocean—what is called the "oceanic experience," the sense of an immensity in which the individual is swallowed up and feels his own nullity but is happy to be engaged in it because what possesses him is so vast and perfect, so complete and free from contingency and

the chaos of accidental details. This idea of cosmic emotion is another trait of Cézanne's, which Badt believes springs from his religious conversion. He becomes a churchgoing Roman Catholic and goes regularly to mass, but refuses to paint what is ordinarily recognized as a religious picture, though he had undertaken religious subjects in his art during his younger days. It is in Cézanne's painting rather than in an everyday piety that Badt finds a truly and deeply religious personality. There he is original and pursues a religious vocation.

Whether that would not apply to many artists who are not at all like Cézanne is a question. I remember Paul Tillich, who taught at the Union Theological Seminary in this city for many years, saying that a man's ultimate commitment is his religion. At a lecture that I attended, he was asked: "Babe Ruth's ultimate commitment is to hit home runs. In that his religion? Is he religious therefore?" Tillich answered: "Yes, if a man is so completely given to an ultimate goal, then that is his religion." But the actuality of religion as a set of binding obligations and beliefs, governing the whole way of life and not just a single routinized activity is another story; it is questionable whether one illuminates religion in limiting the sense of the words to conforming practices and sets of beliefs.

But even the account of Cézanne's religious conversion is doubtful. He wrote a letter to a friend, Pissarro, around 1879 and speaks of reading certain anticlerical magazines; he tells with pleasure of a friend from his old circle in Aix, now a small politician in Marseilles, beating the backs of the clerical party, the priests in that city. These are not the words of a loyal, devout Roman Catholic. But the question of how religious faith explains Cézanne's art is another problem. Whether Badt is justified in finding in the use of the color blue and other features of the art a connection with that religious attitude is hard to say.

Not only Badt, but the philosopher Heidegger, the master of existentialism who later disavowed the name, found an existential commitment in Cézanne.[20] In a published talk with the painter André Masson Heidegger remarked about Cézanne: "Cézanne was no philosopher, but he understood everything about philosophy. He summed up in a few words everything I struggle to express. He said, 'Life is terrifying' [C'est effrayant la vie]. And that...is all I have been saying for the past forty years."[21] Of course, that is not the philosophy of Heidegger; we would

not take him seriously at all if it were. It was the rhetorically condensed substance of what he said to Masson. His statement, however, is interesting because the context in which Cézanne said "C'est effrayant la vie" was a walk on the road to Mont Sainte-Victoire, in the course of which he paused before a spot where a new soap factory was being planned.[22] Cézanne was horrified that this beautiful site of landscape he had painted so lovingly was being desecrated by industry, technology, science, and commerce. He just couldn't stand it. Heidegger had the same feeling about technology. In a later book, his *Introduction to Metaphysics*, he wrote of technology, science, and industry as the real curse of modern life, as utterly destructive of culture and artistic values, and declared that desecration to be characteristic of the United States and the Soviet Union.[23] We recognize the ideological framework for Cézanne's horrified remark and his feeling that "C'est effrayant la vie," at that moment.

I should like to ask now, having summarized the views of those scholars and philosophers about Cézanne: What did Cézanne himself think about philosophy, what did he say that has in itself a philosophical import and employs philosophical terms? We have another access to ideas of Cézanne's through a recorded conversation. He was visited in 1904 by the young painter Émile Bernard who had been a friend of van Gogh and of Gauguin. Bernard spent a month in Aix, seeing Cézanne almost daily and recording Cézanne's conversations. They corresponded later for two years. In these talks and letters are many statements by Cézanne on his theory of art and his views on philosophy in general. They are among the most unusual documents of a painter's relation to philosophy that we could expect to find.[24] Lawrence Gowing, in the admirable essay that he wrote for the catalogue of the late works of Cézanne in the exhibition at the Museum of Modern Art, has made use of many of the statements in their dialogue for interpreting certain features of Cézanne's color and his attitude to sensations and to perspective.[25] I would like to add a few remarks.

When Bernard engaged Cézanne in conversation, he made it clear by his questions and his challenge that he himself had a Platonic or Neoplatonic notion of art and aesthetics. He believed that the painter is not committed to representing the world as it looks to him, the every-

day encountered sphere of light and color and appearance. For the Platonist—and this is true of the theorists of the Renaissance, who regarded Plato and the Neoplatonists as their guiding masters—the world of appearances is an inferior world, the ground of opinion and not of truth or real knowledge. It is subject to constant changes and is affected not only by the mutability of those phenomena, but also by the idiosyncrasy of the observer. It varies from person to person. It has no stability, no logical coherence even for the single individual who in his response to works of art is so often influenced by the publicized opinion and practice of the painters who represent just those attractive appearances as an adequate and stirring matter skillfully reproduced on the canvas. When we know something truly, it is in terms of model ideas that have been built into our thought and that ultimately come from God or from a purely spiritual source of knowledge, the essences of the natural that permit us to introduce order into this chaotic world.

The aim of the artist, therefore, is to achieve in his art representations that are beautiful by virtue of a vision that the artist has of an ideal and perfect beauty, something not seen in things, but perhaps available in looking at things through a refined selection among them of those features that do coincide with or support that ideal beauty, which is an Idea. This conception was especially important in the later fifteenth, sixteenth, and seventeenth centuries. It was shared by Michelangelo among others and by some of the Mannerist painters and theoreticians and survived into the nineteenth century. This was Bernard's conception of art in his later years. Moreover, he believed that for painting to be true to the nature of painting and to the ideal, it should not represent perspective and depth and should aim at ideal forms already found in classic models. These preserve a traditional experience of those ideal beauties. The painter is thereby assured of a better approach to that ideal truth in cohesive forms and in beauty.

This was Bernard's conviction. Cézanne replied: "That's all the dreaming of professors, of philosophers. That's all nonsensical and worthless. That's an academic game. You will never get anywhere with it." The argument continued until Bernard said, "What do you believe in, then? You must have a theory. You must have some basis for your art." And Cézanne replied: "I know only two things: sensations and

logic." A strange view for a modern painter. It's almost as if he were to say: "I belong to the school of logical empiricism, I'm with Carnap and Neurath and their school. I believe in only two things: what you can observe and the reasoning about the observable; and in nothing that belongs in the heavens or that is a God-delivered idea or an a priori synthetic proposition generated by the mind itself." I do not believe that Cézanne was a logical empiricist *avant la lettre* or that the statement is a sufficient account of his thought or work. Under further prodding he admitted that he recognized also feeling and temperament. But they were an individual contribution to a process in which what you see and your concern for the logic of relationships among the colors and shapes of things you put on the canvas generate the artist's own successful pictures.

This view leads us to ask: What exactly did Cézanne mean by "sensations," a term that appears often in his talk and letters? Did he mean what the Impressionists meant by sensations? After all, the Impressionists were attacked because their painting of sensations led to the disintegration of objects, to the practical minimizing of objects in favor of light and atmosphere, so objects were somehow suspended and even lost in the vaporous medium of atmosphere or in the iridescences of light. So there must be something more than sensation.

Yet that isn't altogether just to the theory of sensations. In the nineteenth century the philosophers, physiologists, and physicists who talked about sensations as the ground of knowledge were inclined to explain the solid appearance of objects, their weight, all the other properties, by the sensory experience. That was a program of Ernst Mach in his influential book *Analysis of Sensations* (1886). It was also a program of other scientists who thought that they could reconstitute our knowledge of the world through analysis of sensations, which included motor, visual, and aural sensations, kinesthetic sensations, inner-bodily or so-called somatic sensations. All of these combine or are combined in reflection and by various spontaneous processes to yield us our ideas of things—*thing* is a term we use in order to designate a recurrent complex of sensations. This, at least, was the philosophy of many scientists and philosophers of the empiricist school, who also gave great weight to logical analysis of what was delivered by sensation. So, for Cézanne, if we

wished to find a contemporary philosophical school that made sensation the basis of observation or identified observation with a complex of sensations, and that, moreover, gave to logic the function of constructing hypotheses, of reasoning from them, of applying mathematics, of making inferences and thought experiments, then one could say that Cézanne was nearer to those modern philosophers than to others. But I have no reason to believe that he was acquainted with the writings of Mach, nor that he came out of that school.

There is, however, a tradition in French philosophy that goes back to the eighteenth century and of which the leading master was Étienne Bonnat de Condillac, a philosopher who in the 1740s and 1750s wrote a *Traité des Sensations,* a treatise on sensations, in which he tried to show how the individual's knowledge and all the processes of the human mind could be derived from a successive addition of sensations to an initially lifeless, neutral status or model, which would eventually begin to talk. Besides that Condillac wrote a *Traité de Logique,* in which he analyzed the procedures and rules of logic to show how the "enchainment" of ideas in thought could all be derived from a few basic logical operations. There is in the French tradition of Cézanne a body of thinking that has a decidedly positivist character; it is often accused of materialism, though some of the philosophers denied that.

It was continued after the time of Condillac by the so-called *idéologues,* Antoine Destutt de Tracy, Georges Cabanis, and others. I might mention a propos of Dr. Cabanis that he referred the differences between individuals to differences in their ways of experiencing sensations, a consequence of temperament and constitution. This notion of temperament added a creative factor in the organizing of sensations, a notion opposed to the later conservative idea of temperament as of something disturbing and capricious. When in Balzac's novel *Cousin Pons* a character, the Baron Hulot, disgraces his family by his immoral behavior, altogether unfitting for a man of his years and station, he is reproached, "Monsieur le Baron, you are not a man, you are a temperament." A temperament is an evil, a destructive factor rather than a constructive one. In the same way, Renan, after the Franco-Prussian War, attributed the defeat of France to the fact that Frenchmen were temperaments rather than stable personalities, not really good bourgeois. It is also the theme of Hippolyte

Taine after his first phase, especially after 1870. But the notion of temperament as creative, as it appears in Cézanne's letters and conversations, has its positivist productive sense and its individualizing, rather than willful, capricious sense, as in the writings of the *idéologues* and of some later positivistic writers

There appear also in the writings of Cézanne certain words that make us feel that whether he had read philosophers or not, he had perhaps in his schooling at the lycée in Aix absorbed some technical notions from a tradition of philosophical investigators. He speaks for example of his *"petites sensations,"* a phrase that is often quoted. The two words together appear in the writings of Gottfried Wilhelm Leibnitz and Maine de Biran, among others, to designate the character of sensation below the threshold of attentive perception. Leibnitz wrote that when you hear the sound of the ocean, that sound is the resultant—the word is often mistranslated "the result"—the resultant sum of the thousand single sounds from the motion of parts of the waves; you cannot analyze that sound into its components, but without those components you would not have the particular summating effect of those successive sounds of the community of sounds of the wavelets.[26] That idea is also applied by Leibnitz to explain aesthetic experience. When you look at a picture, you have an immediate impression, the effect of a complex or rich totality, but if you are asked afterward, "What did you see? What is there?" you couldn't possibly recall, and yet everything in the picture had an impact on the whole.[27]

The *petite sensation,* which is below the threshold of perception, is important for grasping the nature of aesthetic experience, but also that of ordinary sensory experience. That example of Leibnitz is quoted at length and with approval by Hippolyte Taine, an art critic as well as philosopher, in his book *De l'intelligence,* which appeared in 1870; it was a favorite reading of Cézanne's old friend Zola. We can well imagine that it played a part in their frequent talks on biology. Zola was much interested in this tradition of thought, which he felt had a scientific biological basis. He was aware of the great advances made in the study of the physiology of sensations. The treatise of Helmholtz had appeared in the 1860s and encouraged confidence in the notion of sensation as an ultimate building block of experience of the sensory world.

I would like to cite still another example. Cézanne at one point spoke of the "confused sensations" that we bring with us from birth. The notion of "confused sensations" didn't refer simply to the first experience in the womb or at birth; it was also a term of Leibnitz's and Maine de Biran's, who gave great importance to the difference between the distinct sensations and the indistinct or "confused" ones. The "confused" ones were regarded as entering into aesthetic experience, too. Here, then, are terms that belonged to contemporary philosophy and science and appeared again and again in Cézanne's letters. He at times uses the word "apperception" rather than perception. This means that he was aware of the discussions in the early nineteenth century as to the question of the activity or passivity of the mind with reference to sensations. Condillac had been unjustly criticized on the ground that he did not give enough importance to attention as prior to sensations, but he believed it was itself a property of an initial sensation.

A last instance of Cézanne's awareness of the philosophy and psychology of his time, whether direct or indirect, is his famous sentence about treating nature "by the cylinder, the sphere, the cone, everything in proper perspective so that each side of an object or a plane is directed toward a central point."[28] This represents a commitment to scientific perspective, to geometrical perspective. We know that he was an excellent student in science. He won prizes in the lycée at Aix for his excellence in physics, chemistry, geography, and cosmography, as well as in Latin and Greek, but didn't do well in history. For sciences that require analytical thought and logical powers he did extraordinarily well, and might have come upon certain of those notions independently. It is generally recognized that Condillac was a favorite author in the lycées and the teaching of philosophy in the 1850s and 1860s. The young Cézanne could have derived certain conceptions from him. But this particular text, I believe, may come from a quite different source.

Why did he choose of all possible solids the sphere, the cone, and the cylinder? (I might mention that it is an often misquoted text. Willy-nilly, people introduce the cube among the three because they see it and remember it backward from later Cubist painting, which was supposedly influenced by it. But Cubist painting doesn't have spheres, cones, and cylinders generally. Matisse in a letter or an interview recalled it as

the cube and the sphere—a sign of how little it was understood.) There is another philosopher, an unexpected one, who belongs to the tradition of empiricism but is a critic of the old sensationist views. He doesn't suppose that we simply experience sensations prior to experiencing objects. He believes that we see objects, and that distinguishing sensation as a primary impact from a sense organ requires a special mode of attention (but is not involved immediately or consciously in our perception). I refer to Thomas Reid, the founder of the so-called Scottish "common sense" school of philosophy. In a work called *An Inquiry into the Human Mind on the Principles of Common Sense* (1764), he wrote, "I conceive that a man born blind may have a distinct notion, if not of [the figure, and motion, and extension of bodies], at least of something extremely like to them." [29] Dr. Saunderson, the blind professor of mechanics and mathematics at Cambridge University, was famous for having been able to solve mathematical problems with the help of constructed wooden strips that formed the geometrical patterns on which he had to operate. With his fingers he would feel those wooden devices and ask for additions: He could demonstrate theorems and discover new ones with their help. This presupposed a concept of space no different from that of the seeing minds who could agree or disagree with him. Diderot wrote about Saunderson, in his *Letter on the Blind,* but Saunderson became widely known through writers on vision and perception in the nineteenth century and through philosophers who were concerned with the question of the nature of space. Reid had said "I take it for granted that Dr. Saunderson, a blind man, had the same notion of a cone, a cylinder and a sphere and of the order, motions, and distances of the heavenly bodies as Sir Isaac Newton." [30] He chose the same three rounded solid forms that Cézanne was later to cite. He goes on to say, "every point of the object is seen in the direction of a right line passing from the picture of that point on the *retina* through the center of the eye." [31]

We have the same text with the two components in a book by the Scottish philosopher in 1764. Reid's book, *An Inquiry into the Human Mind,* is a rare work. What can one make of this extraordinary coincidence? It's not hard to trace its possible effect on Cézanne, for it was translated into French by a leading French philosopher, Théodore

Jouffroy, in the 1830s; Jouffroy was an outstanding teacher who was responsible for reforms in education and had great prestige in the lycées and among philosophers in the 1840s. He approved of the "common sense" attitude that we see things and not just colors and that the world of action determines to a large extent what we select to notice, what we remember, what our perceptions are, how we organize them—all this in contrast to the conception of a purely passive, seemingly mechanical constitution of the world of objects through accumulating sensations and then comparing and connecting them with one another. We are able then to suppose a possible transmission of Reid's idea through the availability of his book and the teaching of Jouffroy and his disciples in the 1840s and 1850s when Cézanne was a student at the lycée in Aix.

There was, besides, another aspect of those ideas of Thomas Reid that must be taken into account for the problem of the three-dimensional content of a picture and the surface plane, and the touches of the brush. How did Reid come to deal with the geometrical problem, what he called the geometry of visibles, in a work on knowledge, *An Inquiry into the Human Mind*? He wished to refute the teachings of the British philosopher Berkeley, who had paradoxical ideas on the reality of the external world, ideas that came up also between Cézanne and Bernard when Bernard questioned whether we should take seriously all these objects that Cézanne was painting. Some, Bernard thought, are just evanescent, ephemeral. They have no real existence; we are creating them ourselves. Cézanne answered in the words I've already quoted: those are the speculations of German professors. He refused to take seriously any of the advanced idealistic philosophies of the nineteenth century.

We see that Cézanne shared a framework or milieu of thought in a French tradition that has absorbed ideas of British philosophy, of Locke, also of Hume and of the later Scottish school, and of Condillac, to some extent. I may add, with regard to Reid and the Scottish school, that Reid's name appears in a novel by an author who was a favorite of Cézanne's and whom Cézanne praised, Edouard de Goncourt. This novel, *Madam Gervaisais* (1869), is a poignant story about a brilliant woman who is constantly studying the works of Reid and undergoes a crisis in her religious beliefs and faith.

The point of Reid's argument was that between the geometric properties on a plane surface and the three-dimensional, quantified, measurable properties of a seen and handled object there was a definite set of rules of transformation. In consequence, Berkeley was wrong in assuming that there was no connection between the two. That is a confirmation of common sense, which is able to organize action and behavior in the world by passing from the way things look to the way things are—their invariant recognizable properties under different transformations—applying experience of the changes of the appearance of the object from different distances and angles, and of touch and effects of bodily movement and postures, ever since childhood. Cézanne, in giving importance to perspective and two-dimensional projection, was aware of a mode of thinking about our knowledge of the world and of appearance in which the perspective phenomenon is constructive, a reality of the world—a law-like relationship between three-dimensional objects and their two-dimensional projections—while also subject to the range of spectral colors that he retained from the Impressionists.

I think I've talked too much already and have not yet solved any problem. I wish to mention a last detail that relates to Cézanne's awareness of philosophy. In a letter (to Émile Bernard; John Rewald will tell me whether I'm wrong) he speaks of his son as a great philosopher. He writes, "I do not mean to say that he is either the equal or the rival of Diderot, Voltaire, or Rousseau."[32] He has an idea, therefore, of philosophy of which he approves, but that is the philosophy of the Enlightenment, of Condillac's time. It is the philosophy of the period in which rationalism is persuasive and in which ideas are said to be derived from sensory experience. That is true also of Rousseau. In his book on education, *Émile,* he commits himself to that view, though he questions other parts of empirical philosophy. So if Cézanne is to be located within a philosophical tradition, it is the French tradition of empiricism and rationalism, but not the kind of a priori rationalism that depends on Plato. He holds also to a belief in the fundamental importance of theory for practice and the testing of theory in practice; he conceives of the activity of the individual as a constructive one in which sensations are sifted and correlated and the world of objects, solid and flat, is put into an ordered form.

These basic ideas are still fertile, though they are formulated in quite different ways, in the twentieth century. They do not belong to the philosophy of Bergson nor to that of Heidegger (who does, however, as an existentialist, place the individual in the world and make his activity essential for his sense of himself and of things, his existence, but with a metaphysical search and pathos with stipulations that are not those of the older empiricist views). If we look at the later attempts to treat Cézanne's work as the bearer of a philosophical message, we can discover certain good observations shared by several of these philosophers and Cézanne, but not a standpoint that enters into many features of his work. Moreover, insofar as Cézanne's awareness of philosophy and his statements about his own paintings are concerned, we would have to give more weight, I believe, to that continuing French tradition of the eighteenth and nineteenth centuries—not the Cartesian one, but the one that stems finally from the British philosophers. It meets in Cézanne's lifetime a rationalism and a feeling about sensation that is more ideological, that belongs to the enjoyment of sensation and sociability within the world of sensory things and finally within the situation in which individual temperament and feeling are decidedly important for evaluating these sensations and their constructive contribution to the work of art.

(1977)

[1] This text was originally delivered as a lecture at the Museum of Modern Art on October 11, 1977.

[2] F. W. J. von Schelling, *System des transcendentalen Idealismus, Sämtliche Werke,* ed. K. F. A. von Schelling (Stuttgart and Augsburg, 1856–61), vol. III.

[3] See "Eye and Mind," trans. C. Dallery, in M. Merleau-Ponty, *The Primacy of Perception,* ed. J. M. Edie (Evanston: Northwestern University Press, 1964).

[4] José Ortega y Gasset, *The Dehumanization of Art,* trans. W. Trask (Princeton: Princeton University Press, 1948).

[5] See G. W. F. Hegel, *Aesthetics. Lectures on Fine Art,* trans. T. M. Knox, two vols. (Oxford: Clarendon Press, 1975).

[6] Herbert Read, *The History of Modern Painting, From Baudelaire to Bonnard: The Birth of a New Vision* (Geneva: Skira, 1949), p. XVII.

[7] Jacques Rivière et Alain-Fournier, *Corrrespondance 1903–1914* (Paris: Gallimard, 1926), I, p. 265

[8] Fritz Bürger, *Cézanne und Hodler: Einfürung in die Probleme der Malerei der Gegenwart* (Munich: Delphin, 1918).

[9] Letter to Emile Schuffenecker, January 14, 1885, trans. in Linda Nochlin, ed., *Impressionism and Post-Impressionism, 1874–1904* (Englewood Cliffs, N. J.: Prentice-Hall, 1966), pp. 157–60; see p. 159.

[10] See Emile Bernard, "Une conversation avec Cézanne," in *Mercure de France* (Paris), June 1, 1921, pp. 372–97.

[11] Kurt Badt, *Die Kunst Cézannes* (Munich: Prestel, 1956).

[12] Fritz Novotny, "Das Problem des Menschen Cézannes in Verhältnis zu seiner Kunst," in *Zeitschrift für Aesthetik und allgemeine Kunstwissenschaft* XXVI:2 (1932), pp. 1–31.

[13] Fritz Novotny, *Cézanne und das Ende der wissenschaftlichen Perspektive* (Vienna: Anton Schroll, 1938).

[14] This is true especially after the 1870s—see the change from the early paintings with intense erotic content, and the later nudes with wrestling or struggling figures but no facial expressions [note by M. S.].

[15] I have omitted discussion of this inadequacy of Novotny's comparison of Cézanne and Kant, its applicability to much art since the fourteenth century, and its neglect of the importance of the empiricism of both Kant and Cézanne [note by M. S.].

[16] George Heard Hamilton, "Cézanne, Bergson and the Image of Time," in *College Art Journal* XVI:1 (1956), pp. 2–12.

[17] Forrest Williams, "Cézanne and French Phenomenology," in *Journal of Aesthetics and Art Criticism* XII:4 (1954), pp. 481–92.

[18] Maurice Merleau-Ponty, "Cézanne's Doubt," trans. J. Bigney, in *Partisan Review* 13 (1946), pp. 464–78.

[19] Christian Zervos, "Conversation avec Picasso," in *Cahiers d'art* 10:10 (1935), pp. 173–78; trans. in Herschel B. Chipp, ed., *Theories of Modern Art* (Berkeley: University of California Press, 1968), pp. 266–73, see p. 272.

[20] In this sentence, from "found" on has been added by Paul Mattick.

[21] Otto Hahn, *Masson,* trans. R. E. Wolf (New York: Abrams, 1965), p. 23.

[22] Emile Bernard, *Souvenirs sur Paul Cézanne et Lettres* (Paris: À la Rénovation Esthétique, 1924), p. 19.

[23] Martin Heidegger, *An Introduction to Metaphysics,* trans. Ralph Mannheim (New Haven: Yale University Press, 1959).

[24] Emile Bernard, *Souvenirs sur Paul Cézanne et Lettres* (Paris: Rouart et Watelin, 1921).

[25] Lawrence Gowing, "The Logic of Organized Sensations," in William Rubin, ed., *Cézanne: The Late Work* (New York: Museum of Modern Art, 1977), pp. 55–71.

[26] G. W. Leibnitz, *New Essays on Human Understanding,* trans. P. Remnant and J. Bennett (Cambridge: Cambridge University Press, 1981), p. 53.

[27] See *ibid.* II. xxxix, pp. 257–58.

[28] Letter to Émile Bernard, April 15, 1904, trans. in L. Nochlin, *op. cit.*, p. 91.

[29] Thomas Reid, *An Inquiry into the Human Mind, on the Principles of Common Sense*, 6th ed. (Edinburgh: Bell and Bradfute, 1810), p. 157.

[30] *Ibid.*, p. 156. [I have not been able to locate the reference to the cone, cylinder, and sphere, though Reid says on p. 157 that "Dr Saunderson understood the projection of the sphere, and the common rules of perspective..."—Paul Mattick].

[31] *Ibid.*, pp. 256–57.

[32] To Charles Camoin, 22 February 1903, in Paul Cézanne, *Letters*, ed. John Rewald, trans. Marguerite Kay (London: Bruno Cassirer, 1941), p. 228.

PART II: ART AND SOCIETY

The Social Function of Art

THE FUNCTION OF ART

OF THE INTERPRETATIONS OF THE FUNCTION OF ART IN HUMAN society the most popular today among philosophers is that which considers art an ideal human creation embodying perfect order or harmony, and hence offering to man in all his pursuits a model of perfection. Thus, art is primarily the ordering and understanding of life; and so a modern critic could say of literary criticism that it is an art rather than a science since it is an ordering or understanding of both life and art. The same may be said of science and religion and also of ethics, and hence the distinction between these so different interests is lost and the definition of art becomes very vague.

Art as a type of order and art as a type of understanding are two different things, and therefore the identification of these two types parenthetically must be questioned; usually it is a rhetorical grouping of the two types, an unanalyzed grouping that betrays a misunderstanding of most of the terms.

Thus, architecture is a type of order that makes no assertions about life or even about materials. And science is a type of order that also aims at understanding of life, yet is not art. There is also art that represents in a poignant way an intensely experienced world but is very disorderly when compared with Classical architecture.

The idea of order and harmony in art has two contexts. The first is the wider context of all human utterance that has an internal structure

and of which the parts have a necessary relation to each other and the whole; such utterance may be violent, restless, unstable, yet perfectly organized. There is the limited context of a given style, in which apart from the organic consistency of forms, the forms combined and the manner of combination are simple, regular, stable, orderly. A bad work of the second type is more orderly in appearance and intention than the most rigorously composed work of the first type. Hence, we must distinguish between order as an absolute structural character and order as an expressive character. The Gothic building is ordered but not as orderly as a Greek temple.

In a Gothic painting or tympanum may be represented a hierarchy that is conceived as rigid, static, pyramidal in meaning, but of which the formal whole is restless, and includes intangible elements; on the other hand, a Hellenistic relief of genre figures or actors may be cast into a mold of simple ordered forms. The first is specifically philosophical, judging, ordering life; the second is a genre representation without comment or conscious idealization of the subject, but its form has ideal grouping.

If we were to say to a Hellenistic man enjoying a genre painting, that the representation gave him understanding of life and, secondly, offered him an ideal of order, the Hellenistic man would reply:

Sir, the object renews my experience of life but does not add to my understanding; for if I enjoy this as something I have seen every day, and as something real, surely I will not understand it better when it has been transferred to a dead surface in a reduced size and cut off from all that came before and after; but if it is something I have never seen before and adds to my knowledge, it is not because it is a work of art but a facsimile of something unusual like the pictures in scientific books. As for the skillful workmanship that enables the artist to transfer the scene to canvas, I admire it; but it teaches me nothing about life.

But, the philosopher replies, *does not this skill with which it has been reproduced suggest to you that life might be led more skillfully, more beautifully?*

I do not think of life when I enjoy the work; in fact, if I were to take lessons in skill as models of a successful life, I would seek not among artisans who handle materials other than my own, but I would consult

histories and biographies of successful societies and men, in which the skill of action pertains more readily to the guidance of our own lives. The skill of the sculptor tells me nothing about really human things.

But what of the dramatists who describe lives and moral issues?

I agree they are nearer to the kind of art you describe, but they are rather a preliminary guide prior to the real conflicts, since they deal with imaginary situations that are solved according to the moral rules we honor; hence, their importance in the education of children. But for mature men the difficulties arise from special situations that cannot be handled by direct use of these moral guides. They do not tell us how to change the state or whom to trust. They simply repeat in noble language what we already know.

But are not the novelists more inventive, more analytical? Don't they search the darkest corners and reveal to you the bases of your thoughts and actions?

That they do, but because of this inquiring method they abandon all order, all clarity of narrative, and try by an informal method of presentation to suggest in the very order and kind of narrative the very life they wish us to grasp. But in doing so we lose all sense of the better and the worse in life, since all things are inevitable and natural; and also of the important and unimportant, since everything flows into everything and no part is distinct. We thus reexperience more subtle aspects of existence, but we must sacrifice the clarity, the ideal orderliness, which you have supposed to be one of the virtues of art.

(early 1930s)

THE STUDY OF ART AS HUMANISTIC

THE CONCEPT OF THE STUDY OF ART AS "HUMANISTIC" IS A HANG-over of classical education and corresponds to the gradual sub-stitution of the teaching of classical "civilization" and arts for the grammar of classical languages. And just as the latter had become a ster-ile discipline as soon as the values of contemporary classicism had died out by the middle of the nineteenth century, so the study of classical civ-ilization and arts had ceased to have the older humanistic meanings when this classicism had died. The universalizing of the concept of art to include nonclassical arts destroyed the original normative and ideal value of the classical; and this was evident in the reactionary nature of movements that attempted to restore classicism in the twentieth century as a moral as well as cultural value. Hence the concept of "humanistic" is infected with a suspicious partiality toward the classical and the tra-ditional; the very fact that the humanistic is opposed to the scientific in spite of the fact that for the Greeks the sciences were not outside a lib-eral education indicates the reactionary sense of this new desire for the "humanistic." The "humanistic" is not the "human," it has an archais-tic flavor and smells from decrepitude every time it is dusted off and pre-sented as a fresh ideal. If art is a potential value for everyone today, if we are able to study past and distant art with pleasure, it is because we are not Greeks or medievals but moderns—and have both a historical awareness of our own position in time and a better conception of the

universally human. The label of "humanistic" isolates the arts and philosophy from the sciences and social life and intimates pretentiously that the arts are a separate region in which the human being is truly formed, just as did the classical pedagogues of the nineteenth century with their teaching of Latin and Greek.

The fact that the teaching of the sciences in many cases has little cultural or civilizing value does not justify the segregation of the arts as a counterfield; the same may be said about the teaching of the arts, which is also notoriously bad. We cannot wait until a better society exists.

If the humanist says that those are matters for politicians not humanists to decide, that it is the business of the humanists to educate the politicians in tradition and morality and culture, then either he believes that tradition and morality and culture are sufficient to guide the politician and that humanist teaching will train people to preserve humanist values (in which case, he must find the means to introduce this humanist training and perhaps he will have to resort to fighting to achieve this, but lacking the politicians trained in humanism to fight for him, he will have to give up the prospects of humanism in despair), or he believes that all he can possibly do is train people for humanism, whether that is sufficient or not to achieve a good life, because as a scholar he has only one duty and that is the teaching of humanism.

We recognize that the students of the humanist discipline since the early period have been responsible for some of the blackest crimes of history, that in the camps of nonfascists and fascists are products of both humanist and nonhumanist disciplines, and that from this discipline can be deduced both policies of kindness and of brutality, the preservation and the destruction of art.

It requires a certain shameless complacency to believe that all that is good in the last hundred years comes from humanist ideals and the bad from the antihumanist. Perhaps that is so, but then we must conclude that humanism is to be found everywhere, perhaps least among the humanists.

(not dated)

Art and Social Change

HE INTERPRETATION OF THE SOCIAL CONTEXTS OF ART IS CONDI-
tioned by the aesthetic theory and social context of the inter-
preter. Thus, an Impressionist painter, or a painter of abstract
pictures, who believes in art for art's sake, and in purely pictorial
value, will either disregard any social moment or determinism in art
or consider the social significance of art as purely individual—society
being the sum of individuals who respond to art according to personal
needs. Art is socially valuable because it is necessary for individual
culture or imagination; what is good for the individuals is good for
society, society being a collection of individuals. The individual, aes-
thetic context is affirmed in denying the importance of nonaesthetic
factors on artforms. For example, it is asserted that the subject mat-
ter is negative—the same subject appearing in various styles; further,
that there is often a direct contradiction of subject matter and form or
aesthetic expression. It is shown also by such men that the illustrative
interest—i.e., attention to a specific content for its own sake—may
spoil art, that it is, in other words, distinct from or opposed to the
aesthetic values of art. As for the great historical parallelisms of style
and content or of content of art and social forms and interests, these
are denied by those who hold such a position. Their whole attitude
may be perceived in the smallest details of their criticism. Roger Fry
is an excellent example.[1] He explains the decay of Greek art by the

excessive attention to the human figure; the development of still-life and abstraction by the artist's independence of religious subjects, and so forth.

This position is characteristic of bohemians, of aesthetes, of idealistic philosophers, of those who are interested in art as a pole of being or creation distinct from that of everyday affairs.

The contrary view pertains to artists, aesthetes, critics, philosophers, and social reformers who are deeply interested in a given content, whether religious, political, human, and so forth, or who are devoted to projects of reform or who wish to use art as a weapon of propaganda. For them the style becomes a technique of expression, a means of transmitting a specifically human content. The history of art is therefore rewritten in terms of content. Every change in ideology brings in a new style or a new art—every change in the content of art is produced by a specific social change, which is material in origin, even though expressed on a nonmaterial religious, philosophical level. Hence, Christian art is the art of the church, Renaissance art in Italy is the art of a landed aristocracy in league with the church, and Northern art is the art of an incipient bourgeois class. The Baroque develops with early capitalism into modern forms. Romanticism is bourgeois assertion against feudal powers; abstraction is the loss of confidence, the failure of nerve of a disintegrating bourgeoisie, and so forth. The vital art of the nineteenth to the twentieth century is the art of social protest and revolution.

It is evident in this contrast of opinions that the first group is attentive to the aesthetic aspects of art, the second to the content, and only rarely to the forms. It is by criticism of the nonaesthetic method of the second that the first achieves the appearance of strength or a well-reasoned position. For no interpretation of art can convince us if it is limited to the content of objects, to those meanings that are not illustrated by stylistic, formal differentiae.

The great weakness of the aesthetic position, however, is in the aesthetic domain, just as the real weakness of the social view will be revealed upon analysis to be, not only in the neglect of the formal, aesthetic in art, but even in the conception of the content of art.

For if a work of art is, indeed, a whole there cannot be an inconsis-

tency of form and content. The mind that conceives the whole, we can say a priori, does not conceive two separate things. It does not accept a purely traditional inert content and impose a form on it, like a costume on a neutral mannequin, just as the mind does not accept all sensations indifferently and clothe them with arbitrary, independently constructed ideas. The content is itself a creation of an order related to that of pure formal design; it presents itself already as a traditionally designed form, or if it is a text, its interpretation even as a content implies a given viewpoint of the artist that is related to his manner of conceiving any forms. It can be shown empirically by the science of iconography that the transformations of content in art are intimately related to changes in style; that the same theme, let us say, the Last Supper, or the Crucifixion, undergoes a rich transformation that corresponds to a change in style. Hence in the same period, two men as opposed as Nicolas Poussin and Rembrandt van Rijn, have not merely two different styles, but corresponding differences in subject matter. The meanings of their pictures are as distinct as their forms.

If this is so, then we cannot speak of forms and contents as distinct. We cannot say that the contents are conventional materials for aesthetic ordering. The unique correspondence of shapes and meanings that is essential to aesthetic richness is so complex that it cannot be disproved by showing, as Fry does, a martyrdom rendered in soft, gentle colors and with an idyllic quality in the whole. For where the style is idyllic and soft, the assigned subjects like martyrdoms have a corresponding episodic quality; they are set in a gentle landscape, the figures are of a quiet human type, the execution of the saint is no more, no less realistic than the painting of the trees or the light and shade; no more, no less formal as an action than the handling of the color and the line. We must discover in any analysis of content those aspects that are central in the artist's conception of the subject. The horror of the incident may be a meaning that exists for us from the very nature of the historical episode, but it may be iconographically minimized in the picture without our being aware of the fact, because our concentration is not so much on the picture as on our feelings about its effects. Only by a comparative study of the same theme in various styles can we arrive at a proper judgment of the content of a work, for we acquire

by this comparison a more exact polarity in description and a more precise characterization.

The correspondence of forms and style can be illustrated by the Last Supper.

1. Primitive type—*sigma* table with Christ at one end; no setting, but illusionistic detail; prominent fish and bread and wine.
2. Early medieval—horizontal band; movement of Christ to center.
3. Renaissance—further individualization; space and perspective; real gesture, but coordinated.
4. Baroque—angular view; light and shade; dramatic quality.
5. Northern art, sixteenth to eighteenth century—view through kitchen.
6. Nineteenth-century impressionistic—insubstantial disembodied, spiritualistic conception; light, etc.

These correspondences are not organic in an absolute sense; there are many discrepancies and only a general relation. The problem is to discover what elements of a content are pertinent in a given style. Thus, in early Christian work, we must ask how the iconography differs from the pagan manner of illustrating a story, distinguish between the specific iconography of the theme and the iconography of the period, analyze the relation between iconographic manners and repertoire of subjects, and finally consider the formal style. They cannot coincide, just as language cannot coincide formally with its content; in language we distinguish between vocabulary, grammar, syntax, rhetoric, and content. So in a given period all these are distinct from the preceding period, but not uniformly distinct. Some are more persistent. Every new content develops its necessary vocabulary; the general change in contents must affect rhetoric and syntax. This is evident on the differentiation of poetry and prose. When poetry becomes genre, familiar, its form relaxes toward prose forms. The works of poets of different styles have different content and imagery.

The question of social change and art becomes then a problem of dis-

covering the manner in which a new content modifies the conventional manner of expression: the manner in which purely aesthetic changes, occasioned by social changes, modify content to accord with newer forms, for example, portraiture under Impressionism, choice of moving objects, and so forth. But insofar as the formal change may be socially conditioned, we must distinguish between those social changes that operate on the artist directly and those that operate indirectly.

Another question is the relation of social factors to the quality of art. Why is art bad or good? Abundant or skimpy? We should handle this by analyzing first the most obvious instances of such relations, and not merely of good or bad, but of other qualities, such as sculpturesque and picturesque, genre and mystical. The questions must be framed very carefully, for the idea of good and bad is misleading. In any period there are good and bad works, but in some there are works of greater scope and power (among the bad and good) and so forth.

Typical of the "aesthetic" position is Fry's formulation of the psychological problem of Baroque art. He asks, Did the dog wag his tail because he was happy or was he happy because he wagged his tail? The confusion of cause and concomitant circumstance is evident. It is impossible to say that the Baroque age was dynamic, unenclosed, and so forth because its art had that character, the art being simply one element of Baroque life and therefore inadequate to account for its whole. The question should be framed in such a way that the alternative would not be the influence of the art on the age, but the existence of a common factor determining both the artistic qualities and the social ones. In this remarkable style in which the work of art is actually stirring, theatrical, immediate in its effect, and expressive of powerful emotions, unlike the secluded easel styles of the nineteenth/twentieth century, the aesthetic critic sees a possible autonomy in art and even influence on life, despite his normal assumption that the two are distinct. Confronted by an extreme emotionality in Baroque art, instead of drawing the obvious conclusion that here a contemporary preoccupation has imposed itself forcefully on art, he comes to the paradoxical conclusion that on the contrary these great emotions and actions in life are the result of artistic styles.

The real error may be understood more easily if we translate Fry's alternatives into correct physiological terms. Did the dog wag his tail, lift his ears, secrete various belly juices, stand in such and such a way, et cetera, because he was happy, or was he happy because he did all these various associated things? Then the wagging of the tail (artstyle) can no longer be regarded as the specific cause of the happiness.

(early 1930s)

[1] Roger Fry, *Vision and Design* (1920; republication, Meridian Books, 1957).

THE SOCIAL BASES OF ART

W HEN I SPEAK IN THIS PAPER OF THE SOCIAL BASES OF ART I do not mean to reduce art to economics or sociology or politics. Art has its own conditions that distinguish it from other activities. It operates with its own special materials and according to general psychological laws. But from these physical and psychological factors we could not understand the great diversity of art, why there is one style at one time, another style a generation later, why in certain cultures there is little change for hundreds of years, in other cultures not only a mobility from year to year but various styles of art at the same moment, although physical and psychological factors are the same. We observe further that if, in a given country, individuals differ from each other constantly, their works produced at the same time are more alike than the works of individuals separated by centuries.

This common character, which unites the art of individuals at a given time and place, is hardly due to a connivance of the artists. It is as members of a society with its special traditions, its common means and purposes, prior to themselves, that individuals learn to paint, speak, and act in the current manner. And it is in terms of changes in their immediate common world that individuals are impelled together to modify their no longer adequate conceptions.

We recognize the social character of art in the very language we use; we speak of pharaonic art, Buddhist art, Christian art, monastic art, mil-

itary art. We observe the accord of styles with historical periods; we speak of the style of Louis XV, of the Empire style, and of the Colonial style. Finally, the types of art object refer to definite social and institutional purposes—church, altarpiece, icon, monument, portrait, and so forth. And we know that each of these has special properties or possibilities bound up with its distinctive uses.

When we find two secular arts existing at the same time in the same society we explain the fact socially. We observe, this is a peasant art, this is a court or urban art. And within the urban art, when we see two different styles, it is sometimes evident without much investigation that they come from different groups within the community, as in the official academic art and the realistic art of France in 1850. A good instance of such variety rooted in social differences is illustrated by the contemporaries, Jean-Baptiste Chardin and François Boucher, an instance already grasped in its own time.

There is overwhelming evidence that binds art to the conditions of its own time and place. To grasp the force of this connection we have only to ask whether Gothic sculpture is conceivable in the eighteenth century, or whether Impressionist (or better, Cubist) painting could have been produced in African tribal society. But this connection of time and place does not by itself enable us to judge what conditions were decisive and by what necessities arts have been transformed.

But all this is past art. The modern artist will say: Yes, this is true of Giotto who had to paint Madonnas because he worked for the Roman Catholic Church. But I today take orders from no one; my art is free; what have my still-life paintings and abstract designs to do with institutions or classes? He will go even further if he has thought much about the matter, and say: Yes, Giotto painted Virgins for the church, but what has that to do with his art? The form of the work, its artistic qualities, were his personal invention; his real purpose was to make formal designs or to express his personality; if we value Giotto today, if we distinguish him from the hundreds of others who made paintings of the same subject for the church, it is because of his unique personality or design, which the church certainly could not command or determine.

If—disregarding here the question of Giotto's intentions—we ask the artist why it is then that the forms of great artists today differ from the

forms of Giotto, he will be compelled to admit that historical conditions caused him to design differently from the way one does today. And he will admit, upon a little reflection, that the qualities of his forms were closely bound up with the kinds of objects he painted, with his experience of life, and with the means at his disposal. If Giotto was superior to other painters, his artistic superiority was realized in tasks, materials, conceptions, and goals common to the artists of his immediate society, but different from our own.

If modern art seems to have no social necessity, it is because the social has been narrowly identified with the collective as the anti-individual and with repressive institutions and beliefs, like the church or the state or morality, to which most individuals submit. But even those activities in which the individual seems to be unconstrained and purely egoistic depend upon socially organized relationships. Private property, individual competitive business enterprise, or sexual freedom, far from constituting nonsocial relationships, presuppose specific, historically developed forms of society. Nearer to art there are many unregistered practices that seem to involve no official institutions, yet depend on recently acquired social interests and on definite stages of material development. A promenade, for example (as distinguished from a religious procession or a parade), would be impossible without a particular growth of urban life and secular forms of recreation. The necessary means—the streets and the roads—are also social and economic in origin, beyond or prior to any individual; yet each man enjoys his walk by himself without any sense of constraint or institutional purpose.

In the same way, the apparent isolation of the modern artist from practical activities and the discrepancy between his archaic, individual handicraft and the collective, mechanical character of most modern production do not necessarily mean that he is outside society or that his work is unaffected by social and economic changes. The social aspect of his art has been further obscured by two things: the insistently personal character of the modern painter's work and his preoccupation with formal problems alone. The first leads him to think of himself in opposition to society as an organized repressive power, hostile to individual freedom; the second seems to confirm this in stripping his work of any purpose other than a purely "aesthetic."

But if we examine attentively the objects a modern artist paints and the psychological attitudes evident in the choice of these objects and their forms, we will see how intimately his art is tied to the life of modern society.

Although painters will say again and again that content doesn't matter, they are curiously selective in their subjects. They paint only certain themes and only in a certain aspect. The content of the great body of art today, which appears to be unconcerned with content, may be described as follows. First, there are natural spectacles, landscapes, or city scenes, regarded from the viewpoint of a relaxed spectator, a vacationist, or sportsman, who values the landscape chiefly as a source of agreeable sensations or mood; artificial spectacles and entertainments—the theater, the circus, the horse race, the athletic field, the music hall—or even works of painting, sculpture, architecture, and technology, experienced as spectacles or objects of art; the artist himself and individuals associated with him; his studio and its intimate objects, his model posing, the fruit and flowers on his table, his window and the view from it; symbols of the artist's activity, individuals practicing other arts, rehearsing, or in their privacy; instruments of art, especially music, which suggest an abstract art and improvisation; isolated intimate fields, like a table covered with private instruments of idle sensation, drinking glasses, a pipe, playing cards, books, all objects of manipulation, referring to an exclusive, private world in which the individual is immobile, but free to enjoy his own moods and self-stimulation. And finally, there are pictures in which the elements of professional artistic discrimination, present to some degree in all painting—the lines, spots of color, areas, textures, modeling—are disengaged from things and juxtaposed as "pure" aesthetic objects.

Thus, elements drawn from the professional surroundings and activity of the artist; situations in which we are consumers and spectators; objects that we confront intimately, but passively or accidentally, or manipulate idly and in isolation—these are typical subjects of modern painting. They recur with surprising regularity in contemporary art.

Modern artists have not only eliminated the world of action from their pictures, but they have interpreted past art as if the elements of experience in it, the represented objects, were incidental things, pretexts

of design or imposed subjects, in spite of which, or in opposition to which, the artist realized his supposedly pure aesthetic impulse. They are therefore unaware of their own objects or regard them as merely incidental pretexts for form. But a little observation will show that each school of modern artists has its characteristic objects and that these derive from a context of experience which also operates in their formal fantasy. The picture is not a rendering of external objects—that is not even strictly true of realistic art—but the objects assembled in the picture come from an experience and interests that affect the formal character. An abstract art built up out of other objects, that is, out of other interests and experience, would have another formal character.

Certain of these contents are known in earlier art, but only under social conditions related to our own. The painting of an intimate and domestic world, of moments of nonpractical personal activity and artistic recreation (the toilette, the music lesson, the lace maker, the artist, etc.), of the landscape as a pure spectacle with little reference to action, occurs, for example, in the patrician bourgeois art of Holland in the seventeenth century. In the sporadic, often eccentric, works of the last three centuries in which appear the playing cards, the detached personal paraphernalia, the objects of the table, and the artistic implements, so characteristic of Cubism, there we find already a suggestion of Cubist aesthetic—intricate patterns of flat, overlapping objects, the conversion of the horizontal depth, the plane of our active traversal of the world, into an intimate vertical surface and field of random manipulation.

Abstract forms in primitive societies under different conditions have another content and formal character. In Hiberno-Saxon painting of the eighth century the abstract designs are not freshly improvised as in modern art, as a free, often grotesque, personal fantasy, but are conceived ornamentally as an intricate, uniformly controlled and minute, impersonal handicraft, subject to the conventional uses of precious religious objects. Hence, in these older works, which are also, in a sense, highly subjective, there is usually a stabilizing emblematic form, a frequent symmetry and an arrangement of the larger units in simple, formalized schemes. In modern abstract art, on the contrary, we are fascinated by incommensurable shapes, unexpected breaks, capricious, unrecognizable elements, the appearance of a private, visionary world of emerging

and disappearing objects. Whereas these objects are often the personal instruments of art and idle sensation described above—the guitars, drinking vessels, pipes, books, playing cards, bric-a-brac, bouquets, fruit, and printed matter—in the older art such paraphernalia are completely absent. A more primitive and traditional content, drawn from religion, folklore, magic, and handicraft—Christian symbols, wild beasts, monsters, knotted and entangled bands, plait work, and spirals—constitute the matter of this art.

A modern work, considered formally, is no more artistic than an older work. The preponderance of objects drawn from a personal and artistic world does not mean that pictures are now more pure than in the past, more completely works of art. It means simply that the personal and aesthetic contexts of secular life now condition the formal character of art, just as religious beliefs and practices in the past conditioned the formal character of religious art. The conception of art as purely aesthetic and individual can exist only where culture has been detached from practical and collective interests and is supported by individuals alone. But the mode of life of these individuals and their place in society determine in many ways this individual art. In its most advanced form, this conception of art is typical of the rentier leisure class in modern capitalist society and is most intensely developed in centers, like Paris, which have a large rentier group and considerable luxury industries. Here the individual is no longer engaged in a struggle to attain wealth; he has no direct relation to work, machinery, competition; he is simply a consumer, not a producer. He belongs to a class that recognizes no higher group or authority. The older stable forms of family life and sexual morality have been destroyed; there is no royal court or church to impose a regulating pattern on his activity. For this individual the world is a spectacle, a source of novel pleasant sensations or a field in which he may realize his "individuality," through art, through sexual intrigue, and through the most varied, but nonproductive, mobility. A woman of this class is essentially an artist, like the painters whom she might patronize. Her daily life is filled with aesthetic choices; she buys clothes, ornaments, furniture, house decorations; she is constantly rearranging herself as an aesthetic object. Her judgments are aesthetically pure and "abstract," for she matches colors

with colors, lines with lines. But she is also attentive to the effect of these choices upon her unique personality.

Of course, only a small part of this class is interested in painting, and only a tiny proportion cultivates the more advanced modern art. It would be out of place here to consider the reason for the specialized interests of particular individuals; but undoubtedly the common character of this class affects to some degree the tastes of its most cultivated members. We may observe that these consist mainly of young people with inherited incomes, who finally make art their chief interest, either as artists and decorators or as collectors, dealers, museum officials, writers on art, and travelers. Active businessmen and wealthy professionals who occasionally support this art tend to value the collecting of art as an activity higher than their own daily work. Painting enters into little relation with their chief activities and everyday standards, except imaginatively, insofar as they are conscious of the individual aspect of their own careers and enjoy the work of willful and inventive personalities.

It is the situation of painting in such a society, and the resulting condition of the artist, which confer on the artist today certain common tendencies and attitudes. Even the artist of lower-middle-class or working-class origin comes to create pictures congenial to the members of this upper class, without having to identify himself directly with it. He builds, to begin with, on the art of the last generation and is influenced by the success of recent painters. The general purpose of art being aesthetic, he is already predisposed to interests and attitudes imaginatively related to those of the leisure class, which values its pleasures as aesthetically refined, individual pursuits. He competes in an open market and therefore is conscious of the novelty or uniqueness of his work as a value. He creates out of his own head (having no subject matter imposed by a commission) works entirely by himself and is therefore concerned with his powers of fantasy, his touch, his improvised forms. His sketches are sometimes more successful than his finished pictures, and the latter often acquire the qualities of a sketch.

Cut off from the middle class at the very beginning of his career by poverty and insecurity and by the nonpractical character of his work, the artist often repudiates its moral standards and responsibilities. He forms on the margin of this inferior philistine world a free community

of artists in which art, personalities, and pleasure are the obsessing inter-
ests. The individual and the aesthetic are idealized as things completely
justified in themselves and worth the highest sacrifices. The practical is
despised except insofar as it produces attractive mechanical spectacles
and new means of enjoyment or insofar as it is referred abstractly to a
process of inventive design, analogous to the painter's art. His frequently
asserted antagonism to organized society does not bring him into con-
flict with his patrons, since they share his contempt for the "public" and
are indifferent to practical social life. Besides, since he attributes his dif-
ficulties, not to particular historical conditions, but to society and
human nature as such, he has only a vague idea that things might be dif-
ferent from the way they are; his antagonism suggests to him no effec-
tive action, and he shuns the common slogans of reform or revolution
as possible halters on his personal freedom.

Yet helpless as he is to act on the world, he shows in his art an aston-
ishing ingenuity and joy in transforming the shapes of familiar things.
This plastic freedom should not be considered in itself an evidence of the
artist's positive will to change society or a reflection of real transform-
ing movements in the everyday world. For it is essential in this antinat-
uralistic art that just those relations of visual experience that are most
important for action are destroyed by the modern artist. As in the fan-
tasy of a passive spectator, colors and shapes are disengaged from
objects and can no longer serve as a means in knowing them. The space
within pictures becomes intraversable; its planes are shuffled and disar-
rayed, and the whole is reordered in a fantastically intricate manner.
Where the human figure is preserved, it is a piece of picturesque still life,
a richly pigmented, lumpy mass, individual, irritable and sensitive; or an
accidental plastic thing among others, subject to sunlight and the dras-
tic distortions of a design. If the modern artist values the body, it is no
longer in the Renaissance sense of a firm, clearly articulated, energetic
structure, but as temperamental and vehement flesh.

The passivity of the modern artist with regard to the human world is
evident in a peculiar relation of his form and content. In his effort to cre-
ate a thoroughly animated, yet rigorous whole, he considers the inter-
action of color upon color, line upon line, mass upon mass. Such
pervasive interaction is for most modern painters the very essence of

artistic reality. Yet in his choice of subjects he rarely, if ever, seizes upon corresponding aspects in social life. He has no interest in, no awareness of, such interaction in the everyday world. On the contrary, he has a special fondness for those objects that exist side by side without affecting each other, and for situations in which the movements involve no real interactions. The red of an apple may oppose the green of another apple, but the apples do not oppose each other. The typical human situations are those in which figures look at each other or at a landscape or are plunged in a reverie or simulate some kind of absorption. And where numerous complicated things are brought together in apparent meaningful connection, this connection is cryptic, bizarre, something we must solve as a conceit of the artist's mind.

The social origins of such forms of modern art do not in themselves permit one to judge this art as good or bad; they simply throw light upon some aspects of their character and enable us to see more clearly that the ideas of modern artists, far from describing eternal and necessary conditions of art, are simply the results of recent history. In recognizing the dependence of his situation and attitudes on the character of modern society, the artist acquires the courage to change things, to act on his society and for himself in an effective manner.

He acquires at the same time new artistic conceptions. Artists who are concerned with the world around them in its action and conflict, who ask the same questions that are asked by the impoverished masses and oppressed minorities—these artists cannot permanently devote themselves to a painting committed to the aesthetic moments of life, to spectacles designed for passive, detached individuals, or to an art of the studio.

These are artists and writers for whom the apparent anarchy of modern culture—as an individual affair in which each person seeks his own pleasure—is historically progressive, since it makes possible for the first time the conception of the human individual with his own needs and goals. But it is a conception restricted to small groups who are able to achieve such freedom only because of the oppression and misery of the masses. The artists who create under these conditions are insecure and often wretched. Further, this freedom of a few individuals is identified largely with consumption and enjoyment; it detaches man from nature,

history and society, and although, in doing so, it discovers new qualities and possibilities of feeling and imagination, unknown to older culture, it cannot realize those possibilities of individual development that depend on common productive tasks, on responsibilities, on intelligence and cooperation in dealing with the urgent social issues of the moment. The individual is identified with the private (that is, the privation of other beings and the world), with the passive rather than active, with the fantastic rather than the intelligent. Such an art cannot really be called free, because it is so exclusive and private; there are too many things we value that it cannot embrace or even confront. An individual art in a society where human beings do not feel themselves to be most individual when they are inert, dreaming, passive, tormented, or uncontrolled would be very different from modern art. And in a society where all men can be free individuals, individuality must lose its exclusiveness and its ruthless and perverse character.

(1936)

THE ARTS UNDER SOCIALISM

NDER WHAT CATEGORIES CAN ALL VISUAL ARTS BE GRASPED AS A
whole? How to reconcile the technical realism of architecture
with complete distortion in painting? How to reconcile the highly social
characters of architecture with the subjectivity and bohemianism of
painting?

The common characters are most readily grasped in formal analy-
sis of shapes and by observation of common antecedent arts. The con-
cept of Impressionism fits all visual arts; it was achieved in painting
by the study of nature and direct participation in nature; in architec-
ture by the study of new materials and practical functions of building,
and by the architect's participation in engineering and in practical life.
This common realism, however, produced the opposite of an ancient
realism—a highly spatial subjective form. In painting its necessary
development is clear, but in architecture it appears difficult to disengage
the formal development from actual technical necessities. But careful
analysis will show that whatever the practical necessity, the aesthetic
result, as formulated in a style, was Impressionist. The technique was
honored, in fact, as the source of form. In the Middle Ages the technique
was glossed as a Christian symbol; in modern art, the forms are glossed
as techniques. In other words, the modern form is rationalized as an
abstraction. It becomes the form of a nonhuman material—technology;
non-human, insofar as it is not an ideal end, but only a means.

In Post-Impressionism the divergence becomes greater between building and painting. For although both assert an abstract form that is common to the two arts (and note how sculpture disappears), painting derives it more and more from feeling or private imagination, architecture, more and more from technology, materials, real functions. The common formal characteristic are (1) simplification, (2) open design, (3) transparency, (4) informality, and (5) complete disintegration of masses into planes, points, lines, and so forth. What then is the link between the arbitrariness of the painter and the rigorous conformity to technique by the architect?

We must analyze the nature of this technique, as well as technique in general. The Renaissance architects knew technique very well, but it was always a means of realizing an artistic project. The modern architect wishes to learn technique as a means of discovering artistic projects. In other words, whereas technique is subordinate to design in the first, the reverse is true in the modern work. Does this correspond to any change in technique and to any change in design? And does it correspond to any change in the technique of designing?

The chief changes technically are as follows: (1) substitution of machine for hand labor, (2) substitution of steel and concrete for stone and brick, (3) skeletal and tension or cantilever for simple compression, and solid wall construction, and (4) abolition of ornament. The fourth is a consequence of the first and of change in style toward geometrical, Post-Impressionist form.

The architect in identifying himself with the engineer has abandoned all social-aesthetic symbolism in building. He has identified his form with the nonsymbolical, noninstitutional aspect of the building, in other words with the pure materials of construction rather than the symbolical additions that constitute the everyday reality of buildings as works of art. Thus, in identifying himself with the pure process of construction, which is a machine process and independent of the meaning of the building, architecture as an art has become more and more abstract. This is evident from comparison with an old church, in which the positive architectural conception was not the technical part but the ornament, the enrichment, the monumental aspect of the whole. To remove all these, to reveal only the underlying skeleton, is to create an abstraction

of a church—a church without its specific religious reality. Hence, we see that the modern architect, despite his technical realism, is more abstract than the academic architect.

The change does not strike us in that way, unless we are uncultivated (in which case the building appears bare and abstract); otherwise the building seems appropriate, in fact, inevitable and real. What is abstraction with respect to older style has become concrete for us. This can only be because the change in style accords with new values or meanings in building. These values and meanings are easily discovered. We can grasp them at once if we ask, What is the typical modern building? It is the factory, the bridge, the office building. These determine the style of our dwellings; they are even the models for churches. It is, therefore, primarily because our civilization is industrial and capitalistic that our style of architecture is abstract; or expressed negatively—the absence of religious or social ideal meanings in our life corresponds to the preponderance of the economic-technical motive, which is nonmoral, instrumental, irreligious. But it has its proper aesthetic in technological form, which is a scientific unimaginative solution of problems, of which the process of solution is really external to man. The old imposed design was a creation of man; the modern architect desires a design imposed not by man, but by the materials and the technique, and the purely practical purpose. The modern abstraction in architecture thus emerges as a correlate of the nonhuman, nonrepresentational style in painting and the theory of abstract, meaningless form, determined by the conditions of pure design.

If this style is an industrial-capitalist style, what are the possibilities of its survival under socialism? Why is it also the style of Soviet Russia? We must recognize that although socialism will destroy private gain, it will continue the industrial organization of capitalism. It will idealize efficiency, technical realism, cooperation, planning, and so forth, which are the ideals of modern capitalism. It will employ the same techniques, honor the same type of men—technicians, organizers, planners—and encourage the further development of the existing capitalist arts. In fact, insofar as technique will be understood as the redeemer of mankind, it will acquire an ideal value, a symbolic meaning, which will only establish more firmly the existing capitalist style. Thus, the most subjective

form in art will be the typical form of an objective socialist community. This paradox is no real paradox, for subjective and objective as used here are not polar; the subjective pertains to vision, to space, to shapes; the objective to knowledge of a specific field. Now the same contrast exists in physics and chemistry; as these become more and more objective, more refined and exact, their language or symbolism becomes more mathematical and conceptual, the more difficult to understand.

In a classless society, without real divisions, there can be no necessary aesthetic subject matter. The only aesthetic necessities are private; this is already intimated in the nihilism and extreme individualism of modern artists. As art loses its social subject matter, it seems to become more and more personal or private. Thus the future of painting would appear to lie in a complete laicization—every man his own painter.

The socialists who anticipate a new type of art under socialism are mistaken; there will be either a persistence of the most radical modern style or a gradual disappearance of painting and architecture. Painting will become a private art, and architecture will be resolved in pure engineering. As soon as design loses its autonomy, the architect becomes superfluous. He is simply the engineer who specializes in houses. The higher cultivation of the individual under socialism should make it possible for any engineer to develop talents in designing, to conceive in an original manner. The painter will give way to the cinema director whose peculiar art it will be to organize art, not to create it directly, concretely. In this he will resemble the engineer and will be the opposite of the old painter. He will plan his work on paper, as the engineer plans a bridge; then others will carry it out. But in the finished product will be no trace of the direct physical participation of the artist. The film is reproduced mechanically; a hundred people participate in the single project. The form of the film is even more abstract than that of painting; for it is motion of various kinds; the most intangible metaphysical entity—the younger brother of space.

(1937)

THE VALUE OF MODERN ART

ODERN ART, AS YOU ALL KNOW, IS A HIGHLY PROBLEMATIC AFFAIR. During the last fifteen or twenty years, especially, it has been questioned on political, social, moral, and other grounds. In Germany, under the Hitler regime, it was banished as a form of Bolshevism. In Russia, the present government, which is the inheritor of Bolshevism in a way, has also denounced modern art as "bourgeois cosmopolitanism." The director of the Metropolitan Museum of Art in New York, the greatest museum in the United States, has written an article in a very respectable magazine, *The Atlantic Monthly,* saying that modern art is characterized by two things: It is meaningless and it is pornographic. How it can be both is difficult to see. The president of our country, too, has condemned modern art as unhealthy. And people who are sympathetic to modern art, even in accepting certain of its values, nevertheless regret that it is unable to solve the great problems of our time. In fact, they ask that the painters and sculptors accomplish what the politicians, the moralists, and the scientists themselves have failed to do.

Given this highly problematic character of modern art, I believe it desirable that we begin by describing in what way contemporary art differs from older art. This is somewhat difficult because the artists themselves, in attempting to give an account of their own practice, have made contradictory statements. Thus, there are artists who believe that modern art is a direct reflection of our age and others who believe it is a cre-

ation altogether independent of what is happening in our time, which permits the individual to enjoy a realm of freedom that he will not experience elsewhere. In a corresponding way, the rapid succession of different styles in modern art has led to repudiations of one form of modern art by the artists who practice another. And because of this obscurity, conflict, and constant shifting within itself, modern art has become difficult to describe—at least in simple terms.

However, if we consider the art of our time—and I speak only of that art which is fresh and original and could not have been done in a previous age—I believe it is possible to discover in it certain features that set it apart from the work of preceding times. I wish to speak first of those features of the art of our period.

The first thing to take into account is that for many modern painters, students, and collectors of modern art, the main difference between modern art and older art is that modern art does not have subject matter. Modern art for them is an entirely artistic or aesthetic affair that has reached the condition of certain types of music in which the qualities of the forms alone have become the carriers of the whole meaning of the work of art. I believe that this view is not correct. Actually, there are in contemporary paintings and sculptures recurrent subjects, themes that appear again and again. If we look into these themes without a bias as to whether they are good or bad; if we approach them in the way in which a student of Greek art inquires into the subject matter of Greek sculpture, or as a student of Renaissance art approaches its mythological, moral, historical, and religious themes, we shall also discover in the art of the last fifty or seventy-five years types of subject matter that are sufficiently standard and characteristic. It is not necessary that the same artists employ all these themes, but taken together they constitute a complete world of contemporary themes in the same way that the religious themes of the Middle Ages constitute the subject matter and ultimately the ground for what is called the content or iconography of the art of the Middle Ages.

The themes that appear most often in modern art are the following. In the first place, the painters and sculptors represent those things that belong to the direct experience of the eye—all that we consider spectacles or aesthetic objects within life itself. An enormous amount of paint-

ing is directed toward landscape, still life, and beautiful human beings and toward imagery of sport and entertainment: in other words, that part of our everyday world that we experience simply by looking at it. It is the world of recreation and pleasurable perception—an important part of our lives. You have only to look into your own experience and ask how much time and thought you give to spectacle and the appearance of things and to your own appearance, and you will recognize in this commitment to the representation of that part of our world that we experience mainly by looking at it and by enjoying its qualities the importance of this type of theme in modern art.

A second essential body of themes in modern art we may call the world of the artist, that is, the representation of the studio, the immediate environment of the artist as a place of work, with the model posing, and with the objects that are bound up with his awareness of his own role in the world.

That, too, corresponds to an important part of your lives. You are concerned with your individual occupation and your immediate environment insofar as these pertain to your dignity as a man with personal aptitudes and a capacity for creativeness.

A third part of modern art is devoted in a curious way to the consciousness of art itself. There are many paintings that are made up of patches of color, lines, figured spots, sometimes called abstract art. It appears to be an art completely emancipated from any subject mater. But if we reflect upon it, we discover that these shapes, these rectangles, and these circles, are not "pure" forms. The work is not well ordered because it is built of circles and rectangles. Its quality depends on how the circles and rectangles or those freer painted marks or operations of the hand that we call touches or strokes are organized. There are bad abstract works and good abstract works. What is common to all of them is that the constituting elements—the geometrical figures, the strokes, lines, marks, and touches—do not form images or signs for objects, but are themselves ideal figures or elementary operations in the shaping of things; these, too, are an important subject matter of art, drawn from art itself.

Finally, and especially in the last twenty-five or thirty years, an immense part of modern painting has to do with the world of the self,

that is, the interior world of the artist, those experiences that are not open to direct inspection by others, how he feels, what he imagines and dreams, the free associations and other spontaneous formations of the personality. That world has become increasingly important in modern imaginative painting and above all in what is called Surrealism. To grasp its character, let us compare it with old Romantic painting. When the artist Eugène Delacroix wished to represent a disturbed state, the despair of a man who feels isolated and misunderstood, he painted *The Poet Tasso in Prison,* mocked by the others. Delacroix's own mood was conveyed by an image of an historical personage and event. The modern artist, on the other hand (with the guidance of previous experience of forms and with foreknowledge of the qualities he wants to achieve in his work), will produce spontaneously, by a kind of inspired doodling process, various forms abstract or vaguely representative, which, in their charged shapes and in their pure mode of activity, will appear physiognomic to a sympathetic eye, a clear deposit of a mood, just as handwriting reflects a personal disposition and the manner in which you talk and your unconscious movements are projections of your state of mind and your person. So a modern artist, instead of painting *Tasso in Prison,* will try to release that feeling of constraint, in an ordered structure of colored marks that by their tones, their crisscross, their collision, and their actual density in the field are direct and vivid carriers of the artist's otherwise incommunicable state of mind. To illustrate further how free fantasy and dream are for the modern artist a distinctive type of theme, we may compare this art with pictures of visions and dreams in the fifteenth and sixteenth centuries. When an artist of the past wished to paint a dream, he represented in the lower part of the work a sleeping figure, and over the head of this person or in the surrounding space, his dream was projected in light and shade and perspective with realistic color, as if it were a waking vision. It was, indeed, a picture of the dream, but the dream as verbalized, elaborated, and restored to the theater of waking life. It lacks just those characteristics of the dream that make the dream for us a distinctive interior "experience." To use a technical word, the old painting does not accord with the phenomenology of the dream; we miss in it certain qualities by which we distinguish a dream from waking life, even before we attempt to interpret the dream.

For example, in dreams the world is not colored as it normally is. In most dreams there are no colors, as was remarked by the French poet Gérard de Nerval. The sun does not shine and there are no cast shadows in that world. That is not strictly true, but it is significant of attempts to describe precisely the dream's appearance. In dreaming, objects are unstable. As you see a face it becomes another face or fades. You cannot see its contact with the ground. Words are heard that make no sense, and there is a constant displacement, a strange involvement, of ideas. In order to paint a dream or fantasy veraciously, as one paints an exterior landscape, one must invent an entirely new method. You must be attentive to interior experience in the same way that the Impressionists were attentive to aftereffects and to blue shadows. When the Impressionists first painted blue shadows, people called this madness, for shadows were known to be brown. (The great psychologist William James wrote that shadows are brown, because as an art student he had worked with William Morris Hunt, who told him to paint shadows brown.) The blueness of shadows discovered by the painters was an extraordinary experience, which soon became a commonplace of ordinary perception. It gave a new flavor to the whole environment and made vision itself a subtler, freer, more delightful activity. The modern projection of our inner world, the striving to create images that are true to our interior life, we may say is an attempt to represent the blue shadows of the mind—to give the same kind of empirical attention to what is experienced internally as to what is referred as outside. There is, indeed, a kind of realism in this subjective modern art.

To summarize what I have said about the peculiarity of the modern themes, they pertain to a special region of experience and a typical modern individual. If the art of the Middle Ages is about supernatural beings whom one never saw directly or in ordinary vision, if the art of the Renaissance is about mythological and historical figures, and if the art of the Baroque period is rich in moral and political allegories, then the art of the last seventy-five years is about ourselves. It is about the world of the individual who feels himself most free, most conscious, most himself when he is sharply perceiving, when he is actively aware of his own inwardness, and when he exploits inventively the essential materials and processes of his profession more fully conscious that the irreducible and

indescribable aspect of his inner life is no less real than the things outside. In other words, what happens in his mind is just as much a part of reality as what goes on outside his skin, but he must be very careful not to confuse the two realms, although they are continuous with each other and interact in certain ways.

If that is the character of modern art, we can see that its very subject matter, which is normally disregarded as accidental or even as non-existent, bears a close relation to familiar ideals and values of the present moment. Modern art is concerned in a creative, imaginative way with those aspects of our experience that are most important for psychology today, with the perception, the life of feeling and all that determines individuality, all notions about personality, and with all those values of everyday life in which the individual is most deeply aware of his own being, with one large exception, for the values and experiences that belong to the economic and political sphere are excluded. But in all that pertains to the world of the self and to individuality as perceiving, sensing, feeling, as self knowing, engaged in and exploring its own creativeness and liberty, with respect to all these the art of the last seventy-five years is of our time and embodies the most important values of our culture.

Let us turn now from the *what* of contemporary painting and sculpture, to the *how* of contemporary painting and sculpture. What kind of forms are created? How does the work of art look—that strange, fascinating, and disturbing art that puzzles so many people at the present day? In the same manner that we are able to distinguish the art of the Renaissance from the art of the Middle Ages, the art of Egypt from the art of Mesopotamia, by careful observation of the forms, so we discern in the immense diversity of modern art a broad constancy in its structure and expressive means. It may be defined through a few elementary features.

Modern painters by and large—and I speak of what is most constant and rooted in advanced contemporary practice—wish to produce a work of art in such a way that the finished product gives you a most vivid sense of its making, its becoming, the intensity and immediacy of the artist's inspiration or response to some perception or feeling. Hence, in modern painting, the touch or stroke is so very pronounced. You see that already in Impressionist painting, which at first glance looks like a

hodgepodge or turbulence of many small strokes forming a thick and interesting crust on the surface. Through that materializing of the operation process in the modern work of art, the importance given to the stroke as a perfectly visible object, we become as much aware of the artist's activity and mood as we are of the total image that is brought about through it. There is finally a fusion of the two, so that we cannot easily distinguish them. The quality of the mark, stroke, or touch, whether as a discontinuous small unit or as a prolonged, continuous line—a tangle or labyrinth—pervades the whole; it is a trace or track of the artist in producing the work, but also a constituting form. That is a basic aspect of contemporary art.

Another important element is the concreteness of the surface of the object of art. In older painting the canvas is a kind of window through which you view a scene. The modern painter treats the surface of the canvas as a concrete definite tangible ground, as an object in itself. Instead of looking through it in order to view an imaginary scene, you look at it in order to experience the artist's action on the plane of the canvas, his pigment and fabric of colors and forms. As a result, the old notion of painting as a marvelous, ingenious art of illusion gives way to a new frankness and directness of expression. All that the artist does is at once apparent as an effect or deposit on the surface, and therefore, the concrete elements of the stroke merge with the plane of the canvas (or with the actual structure of the piece of sculpture in three-dimensional space) as a materialized object. That vividness and simplicity of the object distinguish it from older art to such an extent that when we find older paintings that have both this touch and this surface quality, we think of those works as being precociously modern and congenial to contemporary sensibility.

A third aspect of modern painting and sculpture we shall call randomness. The work is so designed or constructed that the composition though well ordered looks undesigned, independent of any a priori scheme. The artist does not aim at symmetry or a legible pattern. He does not build up a rhythm that can be read off in a single manner. It is not written to a script or program that determines a regular extractable schema, a triangle or circle around which the figures are clustered or some other canonical arrangement. But he seeks a form that, in its

aspect of contingency, randomness, and the accidental and concealed relationships in its frequent discontinuity, and in its many partial, segmented elements, gives us the most vivid sense of an order built out of unordered elements that in the end look only precariously ordered. The result is a constant interplay among chance, incompleteness, and the final order, completeness and rightness of elements. But it is a rightness of the final order that preserves a maximum asymmetry and appearance of accident in unpredictable relationship of the parts: hence, in Cubism, the frequent segmentation of elements, the fractioning of the world, and the conjunction of unexpected parts. It is a means of affirming the artist's liberty and creativeness and his fidelity to experience, the freshness of his approach to the canvas or sculpture. What you see in the work has just been created and is a victory over the disorder and shapelessness of things. It has not been thought out in advance. It does not conform to an already established order but suggests the actual fluidity and contingency of the world. The modern painter is, therefore, indifferent to blank verse, to sonatas, to fixed forms that already exist as established canonical forms or types or presuppositions. And that is, in turn, important for our open sensibility with regard to the individual, morality, and personal life, all that pertains to growth and invention, to discovery within life itself.

There is a fourth aspect of modern art that is related to all these and that we may call transformation. By this we mean that the work is so constructed that we are aware, simultaneously, of a raw material that has provided certain themes or elements of form and the final processed result, in such a manner that both are somehow preserved in the work. To grasp this clearly, let us recall the attitude of an artist of the Renaissance, for example, Leonardo da Vinci, who recommends to the painter that he look at the veinings in marble or clouds, for suggestions of battle scenes, horses, landscapes—various objects that he can then transpose to the canvas and make into a delightful picture. And he must put them in good order, Leonardo adds. Many artists have resorted to such stimuli in order to invent forms, but in a finished Renaissance painting that has been inspired by such an experience, you will not be able to discern the clouds or marble veinings that were the starting point of the work—the scaffolding of the picture has been removed finally—whereas

in a modern painting, the artist preserves in various parts of the work the traces of the original instigating object or experience. You see, therefore, both the point of departure and the final result on the same surface, close together. The energy of transformation, the real action of the artist in time, is visible in the completed work. He thus materializes not only the touch and the fabric of the work and the immediacy of raw experience through the element of randomness, but also the temporal process of creation. There is already an approach to this in Impressionist work that is premodern. If you look at an Impressionist landscape from close-up, you see many small spots of color that are so astonishing, so loose and free, an amalgam of small units of sensation or perception, that you cannot make out very much of what is represented. And we are not surprised that people coming upon these for the first time in the 1870s believed that they were not really representations, but frenzied daubings by insane artists who produced that turbulence of brushstrokes. When you stand off at a distance, however, you begin to make out trees, clouds, buildings, human figures. The work was intended for two modes of vision. There is a span here between the point of view from which the fabric of the pigmentation was created and the point of view from which the represented objects themselves were brought into harmony and made to constitute the beautiful three-dimensional image. In a corresponding but more advanced way, in a Cubist picture, the artist studies a guitar or mandolin—which belongs to the world of free manipulation (and play) in a private sphere—and plays with the forms. He reduces them to marks or strokes, in order to create "abstract" harmony, but you will discern in various parts of the work recognizable elements of those instruments, or drinking vessels, although they are no longer in their original form, but are clearly submitted to the active transforming process.

These, I believe, are some of the main features or constant elements within the art of the last fifty years. And, as I said before about the thematic material, to the extent that you observe in painting or sculpture of the seventeenth or eighteenth century an approximation to these elements, to that extent you will feel that those works are more modern. And further, you will discover, I believe, that they are associated with thematic material that is somewhat closer to modern themes than the religious and mythological art of their time.

I have then, I hope, made clear that what appears at first sight a chaotic and utterly individualistic projection of fantasies and an eccentric production of modern artists, constitutes a style or mode of our period, like the older art.

Secondly, the body of the material is attached to a series of themes. It has its own coherent character, which we recognize as typical of our time, as belonging to our world very much in the sense that the Greek mythological themes belong to the Greek world. There is a close parallel, in other modern fields, for example, in architecture, where the great changes in style have occurred in certain special themes of building—in the private dwelling, that is, in a space reserved for the self; in the factory those constructions that belong to technology and industry; in department stores and other buildings devoted to display of consumers' goods. The department store, the exposition building, are themes of architecture that belong to the world of display, perception, consumption. Whereas, the advances of older architecture were primarily in buildings of institutions that pertain to the state, the church, the aristocracy, to moral and political functions, only within the modern world do we find this far-reaching continuity of the personal, the individual, and private sphere within art. In modern art for the first time we see the creation in a highly and even integrated way—although it is fashionable to speak of modern art as an art of chaos and disintegration—of a set of values that are focused upon the individual, but are ultimately social as well as individual values. Indeed, it is not easy to distinguish these.

Let us consider the attitude of the artist toward his profession and his work. Is it different from that of an artist of the fifteenth or sixteenth century? I believe the following to be true of the modern artist and to be less true or untrue of the artist of the Renaissance period or Middle Ages, or of all those great periods to which we are sometimes urged to look for a model for the reformation of our own diseased, disintegrated culture: The modern artist is committed to the idea of endless invention and growth. He is haunted by the notion that his way of working in 1950 cannot be the way in which he worked in 1940. He has an ideal of permanent revolution in art. Of course, that is not easily realized. Observing the whole process historically we may say that in the last seventy-five years there has, indeed, taken place a revolution in the visual

arts that is as far-reaching and profound as the revolution in physics or in social and economic thinking and that has consequences for our whole outlook upon culture and everyday life. But it is not a revolution that has been constant in the sense that every year something turns over completely. There have been more and less certain crucial moments and periods of standstill. The years around 1875 were of extraordinary importance in the development of Impressionist painting. The years from 1885 to 1890 marked a new wave, a new impulse of revolutionary change in the ideas about art—not only in painting and sculpture, but in literature and poetry and, to some extent, in music a few years later.

Then in the decade from 1910 to 1920 there was a third perhaps more basic revolution, but since that time there seem to have been no revolutions in art. Nevertheless, these ideas concerning the nature of the artist's activity as a permanent self-transforming activity have been maintained. Even if the artist cannot make a revolution in art, he is committed to the notion that the practice of painting is not the conservation of a style or of a way of working, that one does not create a method in order to then live by it and perfect it. The artist must be ceaselessly open to new possibilities and suggestions and is impelled by a restlessness and conception of integrity to search for means of developing and surmounting his actual style. In that respect he is like the most advanced natural scientists and mathematicians, who feel that there are always latent in problems unforeseen relationships that, if disclosed, would at once require a complete opening of the whole field and a change in their habits of thought. He is like them in his willingness to entertain the most absurd and contradictory possibilities concerning his problems; even at the expense of his sanity with respect to all that he has done before, it is worth trying, and he is dissatisfied unless he has tried and discovered what might come out of it. The result may be a failure, in which case he buries the object and turns to something else.

But that attitude of constant self-transformation and growth has room for an ever-widening possibility and the conviction that the materials of the artist, even though they are limited by unmodifiable conditions of perception and human nature, nevertheless, are so structured, so bound up with contingencies and unknowns, that we are certain that sooner or later something new will emerge. And that commitment,

which is sometimes disparaged as an arrogant urge for originality of any sort, is hardly that at all. Just as one would not criticize a physicist for trying to be original because he is constantly making new experiments or searching for a more generalized formulation of a theory, so we must admit that for the modern artist this commitment to permanent inventiveness or searching of his means is of the very essence of his profession. And it is a source of the artist's dignity, whether he is a good or a bad artist. It means that he is a live artist, and a live human being, that all his senses are working, and that he is open to new possibilities and suggestions of his medium.

Another important value of the modern artist is that his art is completely free. There are no rules, no hierarchy of privileged qualities, no absolute standards, characteristics, or codified methods, and there are no privileged materials. If for centuries bronze and marble were the only materials that a self-respecting sculptor would use for a statue, modern artists have discovered that fine sculpture can be made of glass, aluminum, plastics, or wood; some thirty-five years ago, one of the greatest modern artists ventured to exhibit bits of wood that had been glued and nailed together in an attempt to hit a right form. That introduction of a kind of vernacular, or everyday speech, into sculpture was a revolutionary assertion that immediately opened the way for the replacement of all the overvalued, precious, and boring materials of marble and bronze, by the vast possibilities of new modern substances.

And the same is true of form. It is true also of themes and of qualities. The modern artist believes firmly that there is no privileged subject matter or privileged method of working; there are no techniques so marvelous that a special value attaches to them that vulgarizes or discredits others. That extraordinary freedom is not only an artistic value, it is a human and moral value. It introduces into modern culture a sense of adventure and endless possibility and demands of the artist that he make of this freedom something worth while, that he justify this attachment to the new by achieving something that, in a modern idiom, is as perfect, as moving, as coherent in its own right, as the works of the older artists.

That conception is associated with a democratic, internationalist conception of art. The modern artists, unlike the artists of the sixteenth,

seventeenth, and eighteenth centuries, on the whole, deny that there is a privileged status with respect to creativeness; they deny that origin in one country rather than another or that a particular education, tradition, and background are more valid for art than another. The most humble individuals may create important works of art. A washerwoman may, if given canvas or pencil, produce a work much more interesting than her employer can, precisely because she has a simple, open nature and has no pretension to skill. This democracy of art and culture is connected with the growth of the School of Paris, with the establishment of the most powerful school of art in the world in the capital of France, a school, dominated not by Frenchmen, but by foreigners. The artist is accepted there as a man without a passport, whose worth depends upon his personality, his ability to produce objects of value. That is a fundamental, important aspect of our culture. It is only in modern times that the sentiment of the international aspect of culture, of the creation of value as being really human in a final and universal sense has become established. This idea had often been affirmed but was always limited in practice by the barrier of language and by national oppositions and, above all, by the general insularity and fixity of the styles of art in different countries, which made them like languages difficult for people of other countries to understand. Today, the creation of art is independent of language or speech. People who talk French, Spanish, German, Russian, English, and Japanese work together in Paris, exhibit together, and influence one another; their art in turn is exhibited internationally. Hence, the ideal of an international culture has been realized within a particular art for the first time in history—without translation and in advance of a true internationalism within the political sphere, but parallel to the international character of technology and industry (insofar as the manufactured goods of one country are sold in all countries of the world).

This sentiment of the genuine internationalism of culture realized through modern art, has had a far-reaching effect upon taste. For modern artists, all the art of the world is accessible, no matter who made it or when it was made, whether by primitive peoples or by civilized peoples, by the trained or untrained, by children or by grownups who have taken to art as a kind of therapy of the soul in their old age, and even the drawings of the insane. All these are now available in a way that was

not possible in the seventeenth or eighteenth century. The work of primitive peoples, of non-Europeans, of Chinese, was regarded in the West before the end of the nineteenth century as curios or objects not yet truly works of art. But, with the rejection of privileged contents and required modes of representation, and of the priority of the external world as the guiding or supreme model for the artist, it has become possible to respond to the arts of many different cultures. Not all cultures, however—for there are exceptions; but, on the whole, more of the art of the world is accessible to modern art than was available in the past. This broadening of taste was due to two basic aesthetic principles in modern art: first, that any mark made by a human being, any operation of the hand, is characterized by tendencies toward form, toward coherence, just as ordinary speech has its own unconscious rhythm and melody, its own order and the voice of one man cannot be mistaken for another's. So any mark made by the human hand tends toward unity, toward a pervading quality that organizes it and makes it one unmistakable thing. Secondly, every such product of the human hand or the human personality has what we call physiognomic qualities. It is felt by us instantly as a piece of the soul or the self that produced it. Just as the handwriting is instantly recognizable, and as the tone of voice is the vehicle of the personality that speaks, so any mark produced in the past by a caveman or primitive or Egyptian or Chinese or modern, is eligible for the status of art. It is sufficient to possess these two properties of form and expressiveness for a work to enter into the realm of art. Art is thereby removed from a very high traditional pedestal, and perhaps something is lost. But at the same time art is tremendously broadened and many more people have become conscious of the possibilities of art, and of the latent creativeness of man, than could have been the case one hundred or two hundred years ago.

These, broadly speaking, are the values of modern art at its best and we may even say in its average, its cross section.

Given these facts, certain questions arise. Is not all this achieved at the expense of social cohesion and integration and the artist's responsibility to embody in a vivid, convincing form the main ideals of a time? The modern artist appears to many an isolated, lonely individual on the margin of society—a bohemian in the sense in which gypsies and wander-

ing circus performers were called bohemians. In like fashion many hold to be belief in the isolation of the artist and his lack of contact with what is most vital within the world. We must make clear at this point what we mean by the *social,* and in what sense this art is not really *asocial,* as has been said. I am aware that this is not at all easy to clarify. It would require analysis of the precise nature of the concept of the social within our world. Just as the notion of art was at one time conditioned by the privileged status of certain kinds of art: high art as against popular and commercialized art, or the art of the very great masters, which deals with the noblest themes, and a more vulgar art which doesn't—the seventeenth- and eighteenth-century painters of portraits, landscapes, and still lifes were regarded as inferior to painters of allegories, mythology, and religious subjects—so the concept of the social today is infected with arbitrary stratifications. It is believed that the truly social is only that which pertains directly to the state, to political parties, to industrial production, or some organized group action. The notion of the social is thus limited to the institutionalized forms of the social. It is overlooked that within our society there also exist whole spheres of activity that depend upon institutions and yet in which we do not feel ourselves bound or limited by institutions.

Let me give a simple illustration of that by comparing a parade and a promenade, marching in a parade and going for a walk. In a parade—and parades were very frequent throughout antiquity and the Middle Ages and the Renaissance in liturgical processions and certain civic festivities and ceremonies—the individual who marches does not determine when he will walk, where he will begin, where he will end, or what he is walking for. The parade is a collective superindividual mode of walking. You don't walk for the fun of it, and you don't walk in order to enjoy the sights. (Nor do you walk because you expect that pretty girls will be on the same road.) Walking then is a regulated nonindividual mode that, nevertheless, provides great satisfaction to people who feel their solidarity with one another and who enjoy the rhythm and excitement, the unusual decorativeness and festive aspect of the whole occasion. Let us compare that with going for a walk today. Going for a walk means that at any moment when you have an impulse to walk, whether for the stroll, or for the air, or for the sights, or for the hope of

unexpectedly interesting encounters, or for solitude or as a stimulus to thought—a philosopher has said "our best thoughts come to us in walking"—whatever the purpose, walking is a free activity initiated by the individual at his pleasure and for whatever end he desires, and it can be abruptly terminated; it does not follow an externally fixed, predestined path but is itself subject to the will of the individual. That act of walking we consider a peculiarly modern activity. Farmers don't go for walks. The people in the Middle Ages did not walk for pleasure until urban life became highly developed. The first men who expressed a spirit of emancipation within the Renaissance of the modern world often gave importance to walking. The philosopher Diderot, when he wished to record the conversation, gave examples of very bold and intimate thoughtful sociable figures, entitled the dialogue, "Les Alleés." Walking is the occasion of a great experience of freedom. Freedom in thinking, freedom in motion, a self-determination by the individual. Is going for a walk an unsocial or an asocial act? Not at all. It is an inspired activity, which exists only in cultures that have realized a mode of organization that permits the individual to determine his life more freely. More people today choose their own vocations, which are not the vocations of their parents. More people choose their own mates rather than accept a marriage arranged advance by their parents. As the amount of walking in the world increases, there is also a greater critical spirit in the community and more people who are observant and given to a type of thinking that examines the world and all human things as important. Going for a walk then is part of a complex of personal activity, the creation of a mode of individual behavior, which is favorable to the experience of freedom and the creation of patterns that are congenial to released forms of individuality, comradeship, and the emancipation from the narrowness of parochial life.

Yet this going for a walk depends upon social institutions. It depends upon paved streets, upon the development of a higher level of urban organization. It depends upon the regulation of traffic. It depends upon the development of the market and the exposure of goods outdoors in the streets. It depends upon greater leisure and the freedom of individuals within the streets. There is also a transformation of the domestic world whereby women may walk unchaperoned. All of these conditions

belong together and do not simply constitute, as I said, a disintegrated and chaotic asociability but are the manifestation of a stage in the development of society in which the conditions of freedom are consciously pursued and made a part of social life. It is inconceivable without that grandiose development of the last four hundred years in which the old aristocratic feudal society based upon landed property and agriculture was replaced by a society in which trades and then industry became primary, and the middle class of merchants and bankers and manufacturers replaced the older feudal aristocracy and monarchy. And with that came modern democratic institutions and juridical relationships that include freedom of contract, a freedom written out in the law, even though it does not apply alike to all individuals within the society. You must bear in mind that these are conditions that, while generalized for the whole of society, are not, at the same time, equally applicable to all its members. This is a culture that is most developed at the top and least developed below but tends, with the increasing standard of living and the development of democratic institutions and, above all, the world market, to diffuse itself throughout the larger mass of the community. In a similar way the features that I have described as the individualism of modern art, far from being a denial of social relationships, are the fruit of a certain mode of social relationship. This mode is itself the consequence of centuries of struggle to overcome the repressions of or limitations on freedom and individuality vested within old established institutions and laws, which were superindividual and exempt from criticism. But the features also entail certain difficulties of life and a real inability of men to live happily under such conditions of freedom. The older repressions had at least some justification in the necessary conditions of life, materially and technically, at that time.

Modern art, as I have said, depends upon a new notion of individual freedom, but it is not shared by everyone and is itself a source of deep conflicts and difficulties within modern life because of the disparity between the assumed values (the legally or juridically described values, the constitutionally defined values) and the actuality of life for the great majority of people. The notion that modern art is pure, or that modern art is a Surrealist nightmare, or that modern art is meaningless, these are all partial and prejudiced views that depend upon the customary process

149

of isolating one trend within modern art, one feature of modern art, making that stand for the whole, and then attacking the whole through it. But actually, a great deal of modern art is gay and joyous and sensual, like the work of Henri Matisse. There is modern art that is austere and precise with a quasi-scientific attitude like the work of Piet Mondrian. There is modern art that is whimsical, playful, imaginative, and child-like—not altogether childlike—like the art of Paul Klee. There is an art that is exasperated and desperate, sadistic, full of violence and resent-ment, like certain works of Picasso. There is also painting of a grandiose inventive kind, by the same artist, Picasso. There is an art that tries to cope with the already familiar reality of our environments, by looking at them in a fresh way, as in certain modes of modern realistic painting. Modern art has an immense diversity of attitudes, but what unites the whole, as I have said, are these central positions with regard to the the-matic world and the spiritual attitudes implied in the structure or style and, above all, the human attitude that is simultaneously a moral and social attitude continuous with the most advanced and illuminating thinking of our time, which we see in those standpoints that I have tried to define with respect to the alleged asociality of modern art.

Given these facts—and, I believe that all I have said so far is true and that is why I say "these facts"—why is modern art so disturbing to peo-ple? Aren't we, after all, living in a world of freedom and individuality? Why under these circumstances and with this acceptance of the under-lying values of modern art and of creativeness as vested in the individ-ual, and in theory possible for everyone, why does this art strike the director of the Metropolitan Museum as meaningless or pornographic? Why does it disturb the president of this country, the former dictator of Germany, and the present dictator in Russia? There must be something very strange about it that keeps this art from reaching the world for which it was destined. Is it because, after all, we do not hold these val-ues? Is it possible that we are not really devoted to spiritual freedom? Or that freedom in art is too difficult or dangerous for us?

It is not easy to account for such conflicts within the very fabric of our culture, our whole life, and I want to make a few remarks about them. Despite the commitment to growth and inner freedom in our edu-cation, and in all the official organs of culture and morality and religion,

the truth is that most people are not inwardly free, fear freedom of thought and feeling, and moreover have long ago given up the effort to live nobly and creatively. At your age, when you do not have the responsibility to make your living, to find your way in a world of practical struggle, it seems obvious that one should be free to develop one's interest, that one should live according to one's ideal aspirations. But, most people, by the time they are thirty, are completely set in a routine of habit; they are, most often, doing things they don't want to do, that they would not have dreamed of doing ten years before; they feel themselves caught within a constraining mechanism of responsibilities, but only a rare person breaks from it. There is, however, within this world a striking exception, a means of overcoming the uneasy consciousness of conformism and lack of inner liberty. And by "inner liberty" I mean something different from the right to vote once a year or once every four years. I mean the taking seriously what you love, what you would like to be, what you would like to do—feeling what your own powers and possibilities are and risking what is necessary for high achievement within your own world as does the artist. That is very difficult, and most people are uneasy when confronted by the modern artist's manifestations of liberty. They are a challenge to those more conformist around them. And people, therefore, look upon the artist as somehow dangerous and even criminal. By his example he advises an activity that is impractical, that entails friction with the family, with the world around one. It is in conflict with the governing values of our society, which are based upon the accumulation of wealth and are involved in the admitted uncertainty of the whole market economy, the relation with others, and the need to do things to please others. A world that, while asserting that society is made up of free individuals, nevertheless, in practice, depends upon the admission that the individual is not free, although he is able to enjoy vicariously the ostentatious and deceptive modes of freedom presented in the movies, which parallel and parody the values of freedom and individuality in modern art. In Hollywood, we are not interested in whom the actor represents, but in the actor and actress themselves as two autonomous individuals with exceptional freedom of action by virtue of their charm of personality and some superior aptitude. The two things that make a man valuable today are mainly the aes-

WORLDVIEW IN PAINTING—ART AND SOCIETY

thetic of the person, the expressiveness of the individual in his outwardness, and, secondly, the power of the individual productively—the ability to make something, to fill a job—the personality considered both on the one hand as a magnetic charm, and on the other as a sheer aptitude or superiority. These themes, of successful individuality so basic to modern culture, are transposed into empty and absurd actions by actors and actresses, who in performing for millions of people offer them a momentary consolation or enjoyment of the triumphs, freedom, and satisfaction that are so scarce in their everyday existence. The film is an example of the commercialization of the leading values of modern culture, which are based upon the individual, upon the search for happiness, the idealization of the aesthetic, the personal, and the productive.

Why in its manifestation of freedom and in its appeal to the inner life, and in its projection of images that are veracious with respect to the strains and desires of the individual, why is modern art, which compels us to take our own inner life more seriously, in some sense, not avowable? We have feelings of guilt or tension with respect to precisely that exploration of the self that the artist is willing to face directly and to evoke in his work. It leaves us uneasy; it brings into the foreground the real disparity between our inner demands and our actuality. And that is why modern literature, especially, is so often accused of being immoral or unsuited to the modern individual. But the most violent attacks upon it are made perhaps by those who feel with deep uneasiness their spiritual weakness, their lack of integrity or sincerity with respect to this inner world. I may point out here that in the older tradition of literature, the great works, like *Oedipus* and *Hamlet,* are about incest, murder, horrible crimes. These are things that no one wants to talk about or to face in the world, and yet they are the subject matters of some of the greatest works of art ever created. Why then should one say that modern art is unhealthy because it refers to an interior world in a strange or exasperating way? (That is really incredible.) That one should at the same time admire those classic works of art that put in the center of the spectator's attention incest and parricide, then balk at a picture because it is violent or passionate or its subject matter is too "subjective" or violent—this is a most inconsistent point of view. It is obvious that they are ready to accept those old works because they can detach themselves

from them sufficiently, but it is harder to detach oneself from the insistent contemporaneity, the actuality, of corresponding images from our existence at the present day.

We come to the final point. Why, if modern art is so free and individual, if it is open to all experience and especially to contemporary life, why, then, does it fail to image the struggling, the heroic, the political, the social, the tragic life-experience of great masses of people at the present time? If that question is posed again and again at the present day, it has a certain point.

In the first place, in asking modern artists to introduce into the world of painting with concreteness and self-evidence that collective experience in its painful and tragic aspect, or even to project ideals and values of a collective kind, we must recall that contemporary affairs are not a necessary or inherent subject matter of art. It is often asked, "If Greek art expresses the civic consciousness of the Greek people, and medieval art expresses the consciousness of the religious community, and Renaissance art expresses the values of Florence and of the merchant world, of the Italian cities, why cannot modern art express our communal values in a corresponding way?" Yet, if after reading Thucydides' marvelous account of the wars of the Greek city-states and the downfall of Athens, you turn to the sculpture of the end of the fifth century B.C. and ask, "Where in Greek art is that world of Thucydides represented?" you must answer, "Nowhere." There are few, if any, images within Greek art that give us an insight into the fact that this is a period of tremendous struggle, of catastrophe, and that it marks the decline of Athens. In the same way, if you search in the medieval cathedral, of which the imagery is so often held up to us as encyclopedic, as offering the most comprehensive and fullest rendering of the world of medieval man, if you search there for an image of medieval social life and of the conflicts that terminated in the burning of the cathedral of Laon in the early part of the twelfth century, or all those experiences that led to the peasant uprisings, the struggles between the townsmen and the bishops, and the forging of the municipal democratic institutions, you will not find them represented in an explicit way. And the same holds true of Renaissance art. The demand made today upon artists, that they should present through modern art their world in relation to institutional life and in

the fateful historical struggles, is a specifically modern demand, which could not have been made before the end of the eighteenth century. It was only at the end of the eighteenth century that there emerged for the first time as a well-established idea the belief that art should present directly the experiences of ordinary individuals in their social, economic, political, and moral conflict, not as transformed into allegories or symbols, or as referred to with an already established system of religious ideas or of myths concerning those ideas, but, rather, in their everyday completeness and legibility. That is a modern idea that came about with the French Revolution, although there is already an approach to it in the seventeenth century. It is only in conflicts where there are also groups that are struggling for political power and that, in their struggle for political power, as in the French Revolution, assume doctrines, values released in a universalistic form, which speak for all humanity. At the end of the eighteenth and in the early nineteenth centuries, social life was based upon the formation of the new concept of man, in which the rights of man and the dignity of man and the powers of man became detached from the professional class of individuals. The middle class, in seeking to overthrow feudal authority, made itself the spokesman for all humanity, for the peasantry, the workers, for everyone. Although ultimately, the triumph was a triumph for them and not for the lower classes, it prepared the way for the demands on the part of the lower classes.

Within that great period of the end of the eighteenth and the first half of the nineteenth centuries we encounter figures like Jacques-Louis David, Francisco de Goya, Honoré de Balzac, Ludwig van Beethoven, and Stendhal, and others who, whatever their political opinions—and they were on opposite sides—nevertheless agree that the scope of art is the total social reality. It is a period of the discovery of social man in his completeness and historical nature. And it is within that context of experience that culture acquires the function of a critical instrument of thinking people who revolt against the past and envision or anticipate a world of the future, which they would help create. And it is in that period that evolved to the highest degree the most acute perception of the togetherness of people and the conflicts of interest within society itself. However, that notion of art and of culture declined after 1848 or

1850, and for a simple reason. When the class of society that came to power and helped to create this critical conception of culture was well established, it found itself in turn confronted by a lower group, the proletariat of Europe, which raised revolutionary slogans and demanded a genuine equality, an economic, as well as a social and political, equality. And, in the course of that, the dominant middle class, formerly a submerged group, began to recast the old formulations of its values; although it maintained them only for holiday occasions, it tended to regard the older institutions that had once been criticized—especially religious authority and fixed moralities—more favorably, as a useful instrument for maintaining the status quo. With that came a shift in culture, whereby culture, from being an instrument for the critical exploration of one's world and a manifestation of universal values, with all the pathos of attack upon repressive national institutions, gradually shifted its ground to the individual more private and passive elements within culture, to the sphere of intimacy and pleasure, which was itself the social product of the transformation of the society in the nineteenth century. With larger cities, the railroads, and the higher standard of living, it made the private sphere increasingly the bearer of culture. And that was possible for one important reason—namely, that with the establishment of that power, there was an enormous increase in standard of living, and a production of wealth far greater than what had been achieved before in centuries of human labor. As a result, the notion of culture as a mode of enjoyment, as pleasure, the capacity of the individual as capable to give to his private lifeharmony, ease, and decorativeness, glorifying his own freedom, became predominant. In consequence, the arts were increasingly concentrated upon the world of the senses and of pleasure, as in Impressionism, on all that pertains to discrimination of qualities of goods and to the amenities of life and, above all, of leisure, which had increased with the advances of modern technology. The sphere of art was increasingly bound up with the greater possibilities for individuals to live in an unproblematic privacy, to move freely, and to create their own environment. But, at the same time, it gave to many individuals a bad conscience. Those who had a high integrity and sincerity and were clear-sighted about their everyday relations became increasingly uneasy about the elements of hypocrisy

and injustice within the world they had accepted. And that theme is the most frequent in the advanced literature of the middle and the second half of the nineteenth century.

However, the process that I have described is a double one. If certain liberties are increased (for example, freedom of movement of individuals in space), others decrease in economic insecurity with decline of small enterprise and, above all, in wars, in which millions of people, independently of their own choice, are pressed into the fatality of a struggle that they could not have determined or foreseen and of which the consequences cannot be foreseen either and that, in the long run, are catastrophic. Within this world, then, the notion of individuality oscillates between affirmation of the sensory and the productive and feelings of exasperation and despair, and a search for an affirmation of the self as the only world of freedom.

This is clearest in Germany, during the period of the Weimar Republic and even earlier, when art was conceived as the only realm of personal and ideal freedom, whereas the practical spheres of the political, the social, and the economic were believed to be spheres of an unchangeable and repressive rationality, highly organized, impersonal, and unconcerned with the individual. Art therefore acquired a special pathos in a world in which it was the only realm of liberty available; but, it was not, however, the only liberty that one wanted. And it is his sentiment then, that the individual is caught between two worlds, that the world that is free excludes reference to the problems that are most vital and determining. On the other hand, the world of action, in which the fate of individuals is decided, is a world which is no longer regarded as eligible for culture. If we ask, "Why cannot that be overcome?" we may well find the answer in the outcome of attempts to surmount it. We discover that the attempts in the last fifty years to create a religious or a political art or an art of moral and social symbolism have had only a sporadic and ineffective existence. In some countries, especially in Germany and Russia, but even in the United States and in Mexico, only under very favorable conditions—where a social transformation is about to take place, where the individual feels a solidarity with a large group or is a member of a large group, which is avowedly directed toward the transformation of life, as the artist is concerned with the

transformation of his art—has the artist the impetus and courage and even the necessity to introduce into his art themes that belong to a wider collective world.

But that, as I said, is a very rare, exceptional occasion. In Russia, the official art is called Socialist Realism, but this art contains nothing socialist and nothing realistic—a fact that we can test by looking at the images, which show little of the real relations of people, of authority, and of oppression. And artistically they lack altogether that quality of freedom that has been so important in the art of the last 150 years.

In conclusion, let me say, however, that if a truly democratic society were realized (and by that I mean the kind of society that was fore-shadowed and sketched already at the time of the French Revolution and shortly after), a society in which no man has power over another, and the peculiarity of individuals is really respected in their everyday life and in their work, and not only in formal courtesies, I believe that under such conditions, the individualism of modern art would be maintained, but it would be another kind of individualism—with altogether new motives, motives arising from a genuine achievement of those values of love, of comradeship and joy that cannot exist unless these original social ideals are fulfilled.

(1948)[1]

[1] This lecture was first given at Columbia University, Butler Hall, in March 1948. It was given again and recorded at Dartmouth College on May 8, 1950.

HUMANISM AND SCIENCE
THE CONCEPT OF THE TWO HALF-CULTURES

IN WHAT SENSE IS SCIENCE A CULTURE? NOT IN THE SPECIAL work of a particular scientist, but in the wide prevalence of scientific ideas and knowledge and methods in many fields, and in the facilities and means of life that depend on science. In that sense the nonscientist lives in a world shaped by science. His use of his car, his radio, his TV, his drugs, food, and so forth, is part of a scientific culture. But the scientist who thinks of culture in a more elevated and creative sense does not accept this everyday use as a sign that an individual has a scientific culture, anymore than a poet regards the everyday familiarity with music, pictures, novels, and so on, as a sign of artistic culture.

Nevertheless, the proponents of scientific culture sometimes speak as if acquaintance with a scientific principle is a sufficient sign of scientific culture. If you know the second law of thermodynamics, you have scientific culture, just as knowledge of a play of William Shakespeare is an evidence of artistic culture. It is possible to learn this law in a physics course without possessing scientific culture in the sense that a philosophically minded scientist would accept as important. Scientific culture means having a scientific sensibility and imagination, being alert to quality in scientific reasoning and results, and being perpetually open to the new and important in science. It means also the striving to extend the boundaries of science, the application of science to a larger field. And should it not include a tact in the understanding of the limits of science under present

conditions—a necessary tact where the risk of pseudoscience is so great?

Scientific culture, then, is not the same thing as a scientific culture in the anthropological sense. One can live in a scientific culture without being cultivated in science—just as one can read books, hear music, look at paintings without exercising fine discrimination or participating actively in the processes of creation and criticism. The culture of Greece in the fifth century B.C. was artistic, philosophical, and political, producing great works in all three fields; but few Greeks possessed any of these cultures at their highest, although many, we may assume, were aware of them, as many today learn the second law of thermodynamics and recognize the paintings of Pablo Picasso.

The concept of two cultures would not be a problem if there was not a feeling of antagonism between different parts of our culture and if, besides, one did not look to them for solutions of the most difficult issues in social life, issues that are not matters of science or art. The greatest difficulties, which are the sources of anxiety and despair, are those of war, poverty, and lack of personal freedom. Since these difficulties have been increased by the scientific culture, many minds, and especially artists, but also some scientists, have decried science as a guide or a way of culture. In the proposed solutions, scientists are nevertheless indispensable, since the solutions depend on knowledge and methods developed by scientists. But the aims are not themselves peculiar to scientists; peace, well-being, freedom are common goals that everyone (or almost everyone) approves; but proposals for their realization are conflicting. Scientists are no more certain of the solutions than are artists or political leaders.

The question, Which culture is more likely to solve these problems? is not a scientific question and cannot be answered directly. No one doubts that his own solution is rational—even the Nazis gave reasons, and there are many who are not scientists who believe strongly in the method of free critical discussion and respect individual opinion. Science by its long experience of advance through impersonal discussion, experiment, testing, and analysis has strengthened our confidence in the advantage of this approach in all fields, including the arts and politics. The question is whether a training of the public, and especially political leaders, in the sciences would improve their judgment in dealing with matters of policy. Or would a better education in the humanities, which means literature,

make men more capable of wise decision? Obviously, in all matters of policy, the responsible minds are guided by the knowledge and views of those whose special business it is to understand the field in question. And such knowledge today, whatever the field, is increasingly subject to scientific standards. This is true of the arts as well as of technology and social affairs. But we can easily imagine a repressive society and a freer society in both of which those responsible for policy are constantly advised by the informed and skilled specialists who are trained in science. Both cultures are scientific, yet have different standards of what is desirable. And in both cultures are men and women educated in the humanities who conform to or maintain the goals of their societies.

The relationship of culture to the extremely difficult task of promoting and realizing goals that we regard as rational, humane, beautiful is not illuminated by the polarities of scientific and humanistic culture. This is the task of philosophy, and philosophers in our day have done only little to create an awareness of the logic of this relationship. Dewey, who struggled with it for many decades, was convinced that scientific method was the model for all problem solving; but he also believed that a scientific view of human nature entailed the devotion to the "consummatory" values and the growth of individuals in freedom and power of self-realization, which are today regarded as endangered by the scientific culture.

I have heard an eminent physicist (this was I. I. Rabi) argue (insist) that all schooling should be scientific, after the elementary level, and that whatever the arts scientists might need for recreation and diversion, the scientists could produce themselves. He asserted on the one hand that science was the most powerful force in our society and on the other that the value of science lies in its beauty, its widening the imagination. I would not trust such a man to make decisions about any ultimate goals; I have noticed more than once in his talk and behavior signs of philistinism, narrowness, crude conformity, and self-satisfaction; I have never known him to speak out against ugliness or injustice.

This is also the impression that he makes on some of his colleagues. He represents the culture of his science; they represent modern liberal culture, which is nourished by the arts, social awareness, and criticism, the movements to advance freedom and well-being.

(circa 1963)

ON DESPOTISM, FREEDOM, AND THE QUALITY OF ART

I T IS A COMMON VIEW THAT FREEDOM IS INDISPENSABLE TO ART and that art declines under social and political despotisms. This is not borne out by history; on the contrary, most of the great art of painting, sculpture, and architecture was produced under despotisms. Compare the old Orient, Egypt, Persia, India, China, Byzantium, and medieval and Baroque Europe. Today, however, we sense that an authoritarian state is baneful to art. Why is this so? Why was it not so in the past?

Older art was mainly commissioned (at least in its larger enterprises), and the practice of art was tied to a content prescribed by the ruler or his advisers; the individuality of the work was in the realization of images pertaining to an extrapersonal content. Modern art, especially since the late Renaissance, owes its content and form of activity to freely set tasks usually determined by the interest, the fantasy, and the experiences of the artist. These may be affected by the society in which he lives, as a walk is bound to the streets and roads, but the choices are personal.

This individuality of art, which is a mode of freedom accompanied by freedom of choice in other activities (occupation, place of life, marriage, pleasures, personal associations, etc., also freedom of the market, politics, etc.), shapes the whole conception of culture as a domain of self-development and free communication. One cannot underestimate its

depth and its consequences for the character of society. It has its limits and contradictions, but it remains basic.

It is accepted also in many features of modern despotic states, for example, Russia and China, which criticized capitalist society as limiting that freedom, promised self-realization of all citizens, the promotion of science as uninhibited activity of thought, and so forth. Even in fascist Germany and Italy, many of the forms of personal freedom were maintained in fields where they were not felt to conflict with the goals of the state. But where they did conflict, as in literature and art, and the state imposed tasks and constraints that were felt to be such, the arts deteriorated, i.e., the best artists could not continue to work, and young artists developed in a way that restricted their originality. The inherited styles adopted by the despotisms were not appropriate to the new tasks, since they came from a historical past in which the modern type of freedom already existed in art. Realism such as Ilya Repin's was a personal expression; in the twentieth century, it could only be retrospective not forward-looking. Under Hitler, an academic kind of Neue Sachlichkeit ruled, but even this art had originally been shaped for tasks different from those a state art required. And where it did fit, it betrayed its original weaknesses, the adaptation and insincere exploitation of art for purposes that could not excite the interest of the artist.

The old artist under a despotism did not feel the commission to be a denial of his freedom; he accepted it as part of the artist's task, just as an engineer does not regard the assigned problem as external to his nature and function as an engineer.

(1966)

ART CRITICIZED AS A CAUSE OF VIOLENCE

HAVE READ IN SEVERAL PLACES LATELY THAT THE DISORDER IN public affairs is due, at least in part, to the attitude implanted in the young by contemporary art. This art is characterized as a pure hedonism, a release of the instincts and especially the aggressive, destructive ones, and as committed to chaos. Those old enough to have experienced the first reactions to the new art of the first quarter of this century will remember, of course, that Cubist painting and Expressionism were criticized as a negation of order, principle, decency, and the very nature of art. And in connection with politics, they were condemned as "cultural Bolshevism" in Europe and the United States. What is novel in the present reaction is that contemporary art and, indeed, the whole tradition called "modernism" are made responsible for violence and for other manifestations of disrespect for the human person in the political behavior of the young. A sociologist has gone further and set up the new outlook shaped by modern art as a basic protagonist in the emerging "post-industrial" society; it is between the "hedonism" represented by culture and the "rationality" of the technocrats or expert managers of the production and ordering of services in the welfare state that will take place the coming struggle for power. (Cf. Daniel Bell, monthly leaflet of the Academy of Arts and Sciences, November 1967.)

I fear that the sociologist has had little experience of the new art.

The psychedelic style of poster with bright colors and flowing lines, much of it a revival of the Art Nouveau of the 1890s, is hardly an example of modernity in its ordinary sense of inventive forms. If he had taken the trouble to make the rounds of the galleries once or twice last year, he would have found that the current taste among young artists is for the so-called "minimal" and "systemic" in art, and for collaboration with the engineer in applying new electronic devices for producing spectacular effects of light, color, and movement, under control of the artist. If one wished to criticize the recent art as a whole, the most obvious charge one could make is that it is so impersonal, so closed to strong feeling and impulse, so dependent on a plan, a prescribed form and effect, and that within the individual work there is so little development of the main idea, so little surprise. Never have painting and sculpture been so regular and mechanical and so attached to fine differences.

The sociologist and political critic have confused with modern art the styles of interior decoration and display—which belong to the world of kitsch and banal illustration: the poster portraits of Che Guevara and Fidel Castro are tame images; the undulant and lurid decorations are a neo-Art Nouveau fashion; the genuinely new arts have had little part in the thinking and feeling of the students and hippies. It is perhaps in the theater that one can find a ground for the increasingly unrestrained act of self-assertion through obscene language and self-display. But one may doubt that this theater represents modernity at its best and most serious.

One can therefore dismiss the charge that the recent violence of teenage politics expresses the attitude of disorder and hedonism implanted by contemporary art as an ill-founded, ignorant idea, without support in the arts themselves. But one must ask why the sociologist and social critic so often turn to the arts as the principle of disorder in society.

In Bell's case the eagerness to find a formula for social life as a whole has more than once misled him into premature and superficial constructions. His slogan of the "end of ideology" appeared just as ideology, the bogey of sober rational minds, began once more to rear its unwanted ugly head. He had, therefore, to incorporate it somehow in the outlook of the rational minds, who now aim to realize by scientific methods the goal of equality, which is surely an ideological concept. But there are many who do not trust the technicians and managers to real-

ize this goal; they continue to attack the administrators as obstacles to this goal and venture to propose more drastic methods. One can't forget that the most rational methods are employed in destroying Vietnam and that there is a considerable rationality in the welfare administrator's handling of poverty and war and racial inequality. Instead of tracing the roots of the resulting disorder to the self-interest of the rational guardian of power and productive resources, i.e., to their hedonism, the sociologist sets up the pleasures of the young and their style of life as a perturbing force that makes for irrationality and may thwart the rationality inherent in our society that directs rationality to the goal of equality.

To spell out the sociologist's argument is to expose its absurdity.

That there is an aspect of "disorder" in contemporary art is evident enough from the reactions of many viewers. But one must not take this reaction as a sufficient clue to the degree of order and disorder in art. Order and disorder are relative terms, and what seems disorder at one time may be the model of order at another time. (No need to cite examples, which are familiar to everyone who can remember the judgments of various styles and types of art.)

The element of randomness in the composition of modern works is not the denial of order, but the ground of a new order. In Mondrian's paintings, which are today paradigms of control and finesse of balanced design, the elements have a considerable randomness—the straight lines are of unequal length or thickness; they determine open areas, cut differently by the four sides of the field, and are incommensurable with each other. Yet there are few works, old or new, that yield so clear an effect of deliberated stable form. And even the opposed art of Jackson Pollock, in its endless tangles and strewing of spattered spots, seems to us remarkably homogeneous in each canvas, all of a piece, thoroughly submitted to a consistent guiding hand, and, in the best works, of a great beauty of color, texture, and calligraphic line.

The appeal to chance or impulse in the making of modern works is a commitment to a particular ethos of freedom and individuality in both the work of art and in social life itself, but always subject to the sovereignty of art itself—which means: a final wholeness, order, inner completeness, and satisfying sensory texture of the words, sounds, colors, shapes.

The forms of randomness and personal expression created by artists of high originality can become means of quite different chaotic and tormented expression in the hands of other artists. So the twentieth century collage, which is at first a playful realism of materials and vernacular fragments of everyday objects, can be turned to drastic uses in publicity, film, and violent expression of disorder (cf. George Grosz).

(circa 1968)

The Future of the Arts

ARCHITECTS AND THE CRISIS

AN OPEN LETTER TO THE ARCHITECTS,
DRAUGHTSMEN, AND TECHNICIANS OF AMERICA

THE CONTEMPORARY STATUS OF INTELLECTUAL AND ARTISTIC WORKERS described in the pamphlet *Culture and the Crisis* is nowhere more evident than in the architectural profession.

OUR PUBLIC REPUTE

The architects, as artists and technicians, are a favored group in American society. They share the sense of constructive activity that is the promise of good art; they have the direction of great works, the design of our cities, factories, schools, and public monuments. They are intellectual and artistic sources of the human environment. Economically, too, their activity is of central importance. It involves one of the two or three largest industries in the world. The total product of their design reaches in a year into billions.

OUR ACTUAL CONDITION—SERVANTS OF BUSINESS

But considered realistically, they are only hired servants, dependent on business—on realtors, contractors, and speculators, whose interest, first and last, is exploitation, who are ready to sacrifice the artistic and social ends of architecture to immediate gain. The impressive quantity of American building is no sign of the skill of architects, but the unbridled, chaotic energies of individuals in a struggle for gain.

In this struggle, the vast majority of architects are only unorganized

workers, of seasonal and insecure employment, designers and technicians, used by businessmen or by complacent, "arrived" architects, who do little or no designing, but collect contracts and cater to the vanity and profits of business. The results of this collusion of building and business are evident in the miserable slums of large cities, in the depressing monotony and ugliness and sham decoration of the suburbs, in the continued exploitation of the better-paid workers and the lower middle class by deceitful campaigns of speculative building, by encumbering loans and mortgages, and in the complete choking of city life by the ill-controlled building of tenements, factories and skyscrapers.

ARTISTIC STERILITY

Even buildings that are not designed for speculation betray the weakness of a chaotic culture. For a society governed by the principles of business is hostile to frank creation. The rich, who are barbarously educated for an unproductive existence, in sport, idleness, and expensive affectations, require from architecture a conspicuous facade, with the recognizable ornaments of older, accredited aristocracies. Their palaces are therefore vulgar imitations of foreign or ancient villas. They are heavily advertised and photographed in the journals, and their designers are awarded prizes; but they look stale and stilted within a few years, as products of merely transient fashions and snobbery.

Hence, the spectacle of American building is the most shameful in all history. With unbounded natural riches, with the most developed techniques, and with an actual quantity of building unequaled in any culture, little of artistic value has been produced in the last fifty years. This barrenness is not the fault of individuals. There have been men of genius, but their seed fall upon sterile ground. Even the native vigor of imagination apparent in the provincial works of past ages has been lacking here. Our own buildings are clumsy, complacent pastiches of ancient styles.

SLUMS AND CONFUSION

Architecture, the art par excellence of foresight and methodical, calculated planning, has produced a city that is thoroughly chaotic, that betrays little thought in its whole, and that is a menace to the life and health of the community. The architect has learned from a hundred costly experiences

that he cannot build as an individual, that every house is part of a city, that its indispensable elements are social, and that its very existence modifies in some way, and is in turn modified by the surrounding buildings. He must, therefore, accept, even demand, a public control of building.

But he has learned from further experience that public control today is not control by the public or by men who really represent it, but by that small class, whose self-interest requires a free hand in the exploitation of the city. Public control has been the control of communal policy by the representatives of precisely those individuals who are most deliberately antisocial in project and self-interest. Public control has been control by the political agents of the business, speculating class, which has ruined our cities.

The criticism of liberal and philanthropically minded persons has hardly altered the condition. They have introduced housing boards and committees and some tenement regulation. But such regulation is rarely in the interest of the masses of the people. It affects only a small minority; its progress is only commanded by business and investment necessities and modifies only those conditions that are hostile to profits. The state, in exempting certain constructions from taxes, has fixed a rent beyond the income of most workers; it has abetted the existing basic disorder by aiding private corporations.

The failure to enforce the tenement laws is notorious. Such enforcement would inconvenience powerful business interests, whose profits are more urgent than public health. If today we hear a constant, ineffectual appeal by liberals for the demolition of the slums, let us not be misled by its "disinterested" character. The cry for the demolition of the slums comes more effectively from the realty interests and builders who demand a fresh field for investment and new projects of construction. These will not be designed for the workers or the present inhabitants of the slums. The poor will be pushed out into the unrentable, obsolete houses in other districts, and the slums will be converted into profitable "developments" for middle-class renters.

THE FAILURE OF PUBLIC CONTROL

The sources of this evil are not to be remedied by political regulation or subsidies. As long as the political power is in the hands of those peo-

ple who in the past have produced the very confusion that faces us, this confusion will remain. The evil lies precisely in the private ownership of the land and in the private construction of housing. A function of society that bears upon all individuals and is as essential as shelter must be a common possession. Until then it will repeat its old errors and poison the life of the entire community.

HOUSING AND CAPITALISM

It was the unanimous report of all countries, including the United States, at the recent conservative International Congress on Housing, that it is impossible for capitalism, unaided by state subvention, to build for the workers, since wages under capitalism are too low to permit a profitable rent for adequate modern shelter. It was the report of President Hoover's conference that over 9 million families in this country are inadequately housed. Even subsidies granted by the state governments to private builders would be insufficient to bring the newest buildings within reach of all workers. But why subsidize the class that builds chaotically and without foresight, that inevitably produces congestion, inflation, and finally the miseries of unemployment by its business policy? Such subsidies are subsidies for realtors and contractors, not for the workers.

FUTILITY OF TECHNICAL PROGRESS

You are told today that the crisis will be lifted by an impending boom in the building industries proceeding from the mass manufacture of cheap metal houses, to supply the needs of millions. This clamorous campaign for the renewal of profits only betrays the weakness of the present system. The sudden production of prefabricated houses at a low cost must cripple the realty value of existing houses; yet the financing of the new projects is inextricably bound up with the stability of older realty investments. At a time when we are suffering from the visible effects of uncontrolled production and speculation we are threatened with a renewal of the same vices in the name of social improvement through housing. But even the newest devices for cheap building cannot reach the majority of workers; those who are accessible will be burdened and exploited by such speculative building.

It is claimed that a revival of building would end unemployment. On the contrary, the sudden introduction of factory methods in cheap housing would irresponsibly abolish the work of several hundred thousand building workers, *without a planned redistribution of their labor, for which no agency exists in a capitalist society.* Such houses will be produced by another, smaller group of workers and will be erected in a fraction of the time required by present methods of building. It would eliminate thousands of architects and draughtsmen at a time when they could be usefully employed for social construction.

As long as technical innovation is controlled by business, it is applied or suppressed—for profits alone. It carries in its train immediate unemployment, the consequent reduction of wages of the employed, and overproduction, because of competitive building for profit, and the inevitable periodic congestion and crisis in which the architects are among the first to suffer.

(1932)

THE PUBLIC USE OF ART

THE PRESENT ART PROJECTS ARE EMERGENCY PROJECTS AND THERE-
fore have an obvious impermanence.[1] It is possible that after the
national elections an effort will be made to curtail them or to drop them
altogether.

To the artists, however, the projects constitute a remarkable advance.
For the first time in our history the government supports art, assigns
tasks to painters, sculptors, graphic artists, and teachers, or accepts their
freely created work, and pays a weekly wage. The projects may be lim-
ited and the conditions poor, but the whole program is an immense step
toward a public art and the security of the artist's profession.

What can artists do to maintain these projects and to advance them
further toward a really public art?

It is the common sentiment that with the support of the organized
working class these projects can be maintained. The art projects are
parts of a larger government program that embraces many groups of
workers, and the artists as workers can rely on the support of their fel-
low workers, who will second their demands. But the interests of artists
and industrial workers are not identical in this matter today. The indus-
trial workers wish to return to regular and full employment and to
obtain social insurance; the government projects and relief often reduce
them to the status of unskilled labor and establish a wage far below the
older union scale. The artists on the other hand would rather maintain

the projects than return to their former unhappy state of individual work for an uncertain market. Even during the period of prosperity artists were insecure; now during a general crisis they are, for the first time, employed as artists. Workers and artists are not of one class or role in society. Artists are usually individual producers. They own their tools and materials and make by hand a luxury object that they peddle to dealers and private patrons. They employ an archaic technique and are relatively independent and anarchic in their methods of work, their hours of labor, their relations with others. Under government patronage they acquire a common boss, they become employees or workers, like teachers and postal employees. But they are not yet really employees of the government, they are simply on emergency projects.

If conditions improve and the great mass of unionized workers are reemployed, what immediate interest will they have in demanding that one small group of temporary government employees, engaged in decorating buildings, should be kept permanently on the national payrolls, especially when the majority of workers have no assurance of permanent employment? Unlike the postal workers and the teachers, the artists do not satisfy a universally recognized need; their services are not available to everyone.

The possibility of working-class support depends on the recognition by the workers that this program of art has a real value to them. It depends further on a solidarity of artists and workers expressed in common economic and political demands.

We can learn from the example of the architects. It is also in the interest of the architects to demand permanent government employment. But how can the government employ them? Chiefly by setting up permanent national housing projects, and projects for schools, hospitals, and places of recreation. Now such projects, if designed to reach the workers, will have the support not only of the building workers, but of all workers, since they are poorly housed and feel the urgent need of such construction. The workers will, therefore, support the architects in their fight, since the demands of the architects are also important demands of the workers.

We also have the example of the teachers and free education. Public schools were won by the persistent struggles of the workers and the

mechanics societies of the last century; they were not simply presented to the people by a generous and enlightened state. The upper classes opposed them on the ground that free education would give the workers dangerous ideas. The workers demanded free schools precisely because schooling enabled a worker to read and write and to learn about the world; he could then defend his own interests better, form his own organizations, and judge more critically the dogmas of the church and the ruling class. But once the schools were established and the teaching was directed more and more toward fixing the workers' mentality along lines favorable to the ruling class, the teacher felt himself to be socially superior to the worker and alien to him. It was only when teachers showed their interest in the working class and its children, fought in the same struggles, united their organizations, challenged the school boards and legislatures in behalf of educational progress, that workers could be aroused to support the teachers in their special demands for better wages and conditions and for academic freedom.

It is necessary, then, if workers are to lend their strength to the artists in the demand for a government-supported public art, that the artists present a program for a public art that will reach the masses of the people. It is necessary that the artists show their solidarity with the workers both in their support of the workers' demands and in their art. If they simply produce pictures to decorate the offices of municipal and state officials, if they serve the governmental demagogy by decorating institutions courted by the present regime, then their art has little interest to the workers. But if in collaboration with working-class groups, with unions, clubs, cooperatives, and schools, they demand the extension of the program to reach a wider public, if they present a plan for art work and art education in connection with the demands of the teachers for further support of free schooling for the masses of workers and poor farmers, who without such public education are almost completely excluded from a decent culture, then they will win the backing of the workers.

But to win and keep this support, the artists—for the first time free to work together and create for a larger public—must ask themselves seriously for whom they are painting or carving and what value their present work can have for this new audience.

The truth is that a public art already exists. The public enjoys the comics, the magazine pictures, and the movies with a directness and wholeheartedness that can hardly be called forth by the artistic painting and sculpture of our time. It may be a low-grade and infantile public art, one that fixes illusions, degrades taste, and reduces art to a commercial device for exploiting the feelings and anxieties of the masses; but it is the art that the people love, that has formed their taste, and that will undoubtedly affect their first response to whatever else is offered them. If the artist does not consider this an adequate public art, he must face the question: Would his present work, his pictures of still life, his land-scapes, portraits, and abstractions, constitute a public art? Would it really reach the people as a whole?

If the best art of our time were physically accessible to the whole nation, we still would not have a public use of this art. To enjoy this art requires a degree of culture and a living standard possessed by very few. Without these a real freedom and responsiveness in the enjoyment of art are impossible. We can speak of a public and democratic enjoyment of art only when the works of the best artists are as well known as the most popular movies, comic strips, and magazine pictures. This point cannot be reached simply by education, as the reformers of the nineteenth century imagined. It is not a matter of bringing before the whole people the objects enjoyed by the upper classes (although that, too, must be done). These pictures and statues are almost meaningless to the people; or they have the distorting sense of luxury objects, signs of power and wealth, and are therefore appreciated, not as art, but as the accompaniments of a desired wealth or status. The object of art becomes an instrument of snobbery and class distinction. Art is vulgarized in this way and its original values destroyed. The abominable and pathetic imitations of upper-class luxury sold to the workers and lower middle class in the cities are often products of this teaching. The plans to improve the industrial arts, to produce finer housewares, textiles, and furnishings for the people run into similar difficulties. And as long as the income of the masses is so small, as long as the majority do not have the economic means to re-create their own domestic environment freely, such improvement of the industrial arts affects only a small part of the people. The very limitation of the market finally hampers their growth.

The achievement of a "public use of art" is therefore a social and economic question. It is not separate from the achievement of well-being for everyone: It is not separate from the achievement of social equality. The very slogan "public use of art," raised in opposition to the limited and private use of art, attests to the present inequality. From this inequality flow many of the characteristics of both the private art and the commercialized public art. To make art available to everyone, the material means for diffusing the degraded contemporary art, the printing presses and the admirable techniques of reproduction, must become the vehicles for the best art. But these today are commercialized; they are private property, although created and rendered productive by the labor of thousands. When they become public property, the antagonistic distinction between public and private in art must break down. Art would be equally available to everyone; you should be able to buy a print or a faithful replica of the best painting as you buy a book or a newspaper.

Before the levels of art that the artist values can become available to the masses of people, two groups of conditions must be fulfilled—first, that the art embody a content and achieve qualities accessible to the masses of the people and, second, that the people control the means of production and attain a standard of living and a level of culture such that the enjoyment of art of a high quality becomes an important part of their life.

These conditions are not entirely distinct. The steps toward the first are part of the larger movement toward the second. And since the latter exerts a powerful influence on the imagination of artists, it inevitably reacts upon art.

To create such a public art the artist must undergo a change as a human being and as an artist; he must become realistic in his perceptions, sympathetic to the people, close to their lives, and he must free himself from the illusions of isolation, superiority, and the absoluteness of his formal problems. He must be able to produce an art in which the workers and farmers and middle class will find their own experiences presented intimately, truthfully, and powerfully. The shallowness of the present commercialized public art would then become apparent.

On the other hand, the masses of the people must control production before they can control their own lives; they must win a genuine social

equality before culture can be available to everyone. Only free men who have power over their own conditions of life can undertake great cultural plans.

The artists who identify themselves with the workers in the struggle for this change, who find in the life and the struggles of the workers the richest matters for their own art, contribute to the workers a means for acquiring a deeper consciousness of their class, of the present society and the possibilities that lie before them, a means for developing a readier and surer responsiveness to their experiences, and also a source of self-reliance. The workers discover through art a whole series of poetic, dramatic, pictorial values in the life of labor and the struggle for a new society that the art of the upper classes had almost completely ignored. In strengthening the workers through their art, the artists make it possible for art to become really free and a possession of all society.

Now it may seem to some of you that this talk of socialism has carried us too far from the present program, that we ought simply to stick to our demand that the government extend the art projects to reach a wider public. I think this is a serious mistake. The artists must look beyond their immediate needs in making plans for a public use of art. They might obtain many concessions from Washington and win the support of large and influential groups of workers and yet be no better off in the long run, perhaps much worse. Even if in cooperation with the unions they begin to decorate the walls of union houses and the homes built for workers with government subsidy, they may find themselves without means of work or dependent on a brutal fascist regime.

The powerful unions in Germany were smashed by Hitler and their fine buildings confiscated. In Italy, while wages are being cut and the people marshalled for the battlefield, artists are employed by the Fascist regime to decorate the walls of the government unions with frescoes showing dignified, massive laborers heroically and contentedly at work.

Government support of art and the cooperation of labor unions and artists do not in themselves solve the insecurity of the artist. They may provide a temporary ease and opportunity for work, but the unresolved economic crisis will soon grip the painter again.

More important, this government patronage and this cultural cooperation with the unions may divert the attention of the artist and the

members of the unions from the harsh realities of class government and concealed dangers of crisis, war, and fascist oppression. Artistic display is a familiar demagogic means; the regime that patronizes art confirms its avowals of peace and unprejudiced concern with the good of the people as a whole. In 1764 after the ruinous Seven Years' War, the artistic adviser of the French king recommended that he decorate his new palace with paintings illustrating royal generosity, love of peace, and concern for the goddesses. Today this choice does not exist. A regime that must hold the support of the people today provides conventional images of peace, justice, social harmony, productive labor, the idylls of the farms and the factories, while it proposes at the same time an unprecedented military and naval budget, leaves 10 million unemployed, and winks at the most brutal violations of civil liberty. In their seemingly neutral glorification of work, progress, and national history, these public murals are instruments of a class; a Republican administration would have solicited essentially similar art, though it might have assigned them to other painters. The conceptions of such mural paintings, rooted in naive, sentimental ideas of social reality, cannot help but betray the utmost banality and poverty of invention.

Should the artist therefore abandon his demand for government support of art? Not at all. He must on the contrary redouble his efforts to win this demand, since the government project is a real advance. But he must develop in the course of his work the means of creating a real public art, through his solidarity with the workers and his active support of their real interests. Above all he must combat the illusion that his own insecurity and the wretched state of our culture can be overcome within the framework of our present society.

(1936)[2]

[1] The government employed artists under President Franklin Roosevelt's New Deal programs. The Public Works of Art Project begun in 1933 was replaced by the larger Federal Art Project (FAP). Part of the Works Progress Administration (WPA), the FAP paid wages to thousands of artists in the years 1935–43. Some of these artists worked on the many murals commissioned for public buildings by the Treasury Department in these years.

[2] Published in *Art Front* (November 1936): pp. 4–6.

ON THE RARITY OF PAINTING AND SCULPTURE IN PROJECTS OF ARCHITECTS

HE GENERAL TENDENCY OF ART HAS BEEN FOR A HUNDRED YEARS or more toward isolated work, that is, the easel painting and the sculpture without fixed destination. The art made for an architectural context, usually for a government or a church, or even for a university, has been a weak unoriginal art; the painters or sculptors commissioned were traditionalistic artists; their content as well as forms betrayed a lack of confidence in the resources of their own time and a failure of imagination. This corresponded to the increasing separation between institutions and the artistic and intellectual culture of the last hundred years. It was the case for liberal as well as conservative or reactionary institutions; art was an instrument that was applied with little regard for the quality of works. It has led to the widespread view that the state is inherently incapable of artistic choice and that art made for an institution is bound to enslave or degrade the artist. The development of totalitarianism has confirmed this attitude. Yet no one is unaware that in the past great art was produced for powerful rulers whether imperial or ecclesiastic, an art with a definite prescribed subject matter and ideological purpose. The conflict between the demands of art and the requirements of the state or church cannot lie, then, in the inherent nature of both fields, but in the peculiarities, historically developed, of the state and art in our time. We must ask whether this condition will persist or will change, whether our aware-

ness of this problem and our interest in a better relationship can contribute to a change.

Auguste Rodin, deeply moved by the cathedrals, dreamt of a great modern work that could be for our time what the portals of medieval churches were for the thirteenth century. No church would invite him to carve a modern portal; if it had invited him, Rodin would no doubt have been incapable of carrying out the religious program of its traditional beliefs. What he conceived as a modern counterpart was *The Gates of Hell,* the projected entrance to a proposed museum, inspired by Dante's poem but filled out with images of modern love and despair. This gigantic work, never finished, absorbed him for almost half his mature years; it was a permanent task—that one work that it has been said occupies an artist all his life—from which came so many of the individual sculptures and drawings that were his artistic fortune and his joy. The example of Rodin, aspiring to the comprehensive religious monumental work, is a parable of modern art in its relation to an organized communal thought. He conceived also a monument to labor, which never got beyond the stage of a first maquette. Neither in religion nor in modern feeling could he find the ground for a successful communal image. His *Burghers of Calais,* a monument to civic courage and self-sacrifice, was rejected by those who were bold enough to commission Rodin; it belonged to no building, but to the unformed open space (not an organized communal space) of the town, and represented the old bourgeois heroism as a purely internal moral choice, for which the civic ties were an invisible and unsymbolized background that the informed observer had himself to supply.

Why could not the great cities and states of the last hundred years in their pride of achievement and patriotic feeling call forth an art like that of the past, giving to the public places the splendor of the old Greek and medieval sites or of the Renaissance and Baroque towns and palaces? The answer is to be found, I believe, in the fact that the conditions that made for the power of the state in modern times also made for the unstately character of art. It was the emancipation of the individual from the bonds of family, church, and local commune, in the course of the great industrial and scientific development of the last centuries, that made art an increasingly personal affair. Painting ceased to occupy itself

with an imagery of religion and myth and history when the chief convictions and springs of behavior were those of practical activity guided by reason and strict observation and supported by the will and energy of the individual. The world of nature and the individual, his feelings and perceptions in everyday matters, and finally his mysterious core of personality, which set him apart from his fellows, became the chief themes of art and also the ground for new artistic effects. The old myths of religion, state, and custom might be acknowledged and even supported with great warmth; they were marginal to culture, which was rooted in the actual experiences of men who discovered in life itself new possibilities of freedom. No one willed the separation of art from religion and commune (or state); it came about gradually through thousands of occasions in which portraits and landscapes and still lifes—the poetry of the individual face, the surrounding nature, and the world of intimate objects—surpassed in quality and soon outnumbered the images of religious devotion, history, and myth. And in our time we have seen this secular modern content of the externalized object-bound individuality give way to a secular content of constructed, imagined forms in which the individual's freedom of operation, his unbounded inventiveness, and his hidden inner life are projected—it is the outcome of a life situation common to all in which the world is increasingly our own product, but also in which we feel more and more that the self is a mysterious play of unconscious forces that, in opposition to the conscious and practical life, represent our domain of freedom. This opposition of the rational-constructive and the fluid-irrational constitutes the polar framework of modern art and has been evident since the beginning of our century in the contrasts and oscillations of the many styles.

During this time, the roles of the church and the family in the positive development have declined; but the state has become more important and appears to possess a transcendent life of its own. The maintenance of the new order based on the primary place of industrial production has given the state many new functions; it has become a vast, impersonal, and intricate structure that concerns itself with almost the whole life of the individual, and is ever-changing, reacting constantly to new inner and outer stimuli that call forth adaptive measures. Its basic principles are recognized to be rationalizations of its power and

need for more power or of the interests of special groups within society that require an anonymous authority above classes for the maintenance of the economic mechanism. The state is, therefore, inherently outside the domain of culture. It is cut off by its impersonal, nondynastic character, its highly organized forms, from the poetry of older states with their heroic founders and occasions; the politics of the moment soon reduces the memory of the great leaders and experiences to expedients of propaganda in contemporary struggles that are felt to be confused, sordid, and irresolvable in human terms. The old state was closer to a daily life in which relationships were more often personal and the scale of activity did not impose a ruthless quantification of individuals. What has happened is essentially this: In the past, particular rulers were hated for their arbitrariness, but the monarchy or republic was accepted and even venerated as a good or necessary part of social life, with its own indispensable rationale of conduct; today, however, the state as such is in question and for many represents a principle of evil in human relationships, a danger to human survival. It appears to be inherently corrupt and corrupting.

The same attitude has appeared among artists (and others) with respect to the community itself. The concept of society as an organized whole, above the individual and constraining him irrationally, has entered into the conflict with the values of individual liberty and creativeness to which that society has given birth. (These values do not spring spontaneously from isolated individuals, but are an ideology peculiar to an historical state of society in which these values have a broad significance and enter into many common domains, such as economic enterprise, political decisions, religion, and moral life, as well as culture.) The artist feels an inherent antagonism between the demands of art and the conditions of life of the community as a whole and its everyday standards.

The freedom of development and work enjoyed by artists is an intrinsic good, in spite of the conflicts associated with it. He may feel economically insecure, but if he yielded to the advantages of a commercial or official art, he would experience a deep spiritual insecurity that for many artists is worse than the material.

There is a public art, but it is not communal and contributes nothing

of lasting value to the environment. It is the art of advertising, which now commands the public surfaces in the streets and buildings. Like almost all art today, it is addressed to the individual observer, but as a consumer of commodities; its imagery exploits his responses to color and shape and idea, not to give him joy and understanding but to induce him to buy what in many cases is a shoddy object. It cannot be compared then with religious propaganda, of which the imagery is an appeal to faith, love, and the respect for the holy through the beauty of artistic symbols, meditated continuously.

Can true art ever replace in the public sphere this insincere and clamorous commercial art? The public spaces have lost their sacredness; they are the field of competing appeals to buy cosmetics and clothes and food. The space created by the architect must allow for these images and signs; he must accept as a fact the probable effect of advertising on the appearance of his buildings. The most remarkable facade, with its own sculpture and painting, will be seen as part of a larger whole that includes the distracting architecture of gigantic displays and signs.

All works in the public field must be calculated for a short existence, not only because of commercial needs that limit their length of life but also because during that short life the original design may be curtailed or confused by adjacent ones that have been added without consideration of the total effect.

The painter and sculptor are, therefore, right to be suspicious of proposals to introduce painting and sculpture in the public space. They may be successful in exceptional sites, which are least exposed to the conditions described. But most of these sites will turn out to be sites connected with culture or isolated from the traffic of the city. They will be in universities, schools, hospitals, parks, scientific institutes, and centers for the arts—museums, concert halls, theaters, and libraries.

(1959)[1]

[1] This is the plan of the talk given in São Paulo and published in the Proceedings of the Congrès International Extraordinaire des Critiques d'Art Brasilia: São Paulo/Rio de Janeiro, Sept. 17-25, 1959. Reprinted in Portuguese in *Habitiat 2*, no. 58 (Jan.–Feb. 1960), pp. 4-5.

CHURCH ART

RELIGIOUS IMAGINATION AND THE ARTIST

I F ONE WERE TO WRITE A HISTORY OF RELIGIOUS ART OF THE last hundred years, it would appear that the works of greatest interest today from both an artistic and a religious point of view are works made by artists spontaneously and independently, outside the churches, uncommissioned, entirely for themselves—works that, in general, were rejected by the religious as lacking in some important respect from the point of view of their faith. On the other hand, such work has become so impressive during the last years that many who would formerly have rejected it are now attracted by it and even find in it a confirmation of what they regard as a most important religious insight. I shall refer to a few examples: Paul Gauguin painted several pictures of Christ in which we recognize a projection of his own feelings, an identification with the suffering Christ; they are an attempt to express the state of the artist as that of a sacred victim. That aspect of Gauguin's work was without commitment to a particular church or faith. Yet when we read his writings, we come upon appreciations of primitive religions and arts as well as of folklore and peasant art. In Gauguin's time, Vincent van Gogh and James Ensor, and in our own century, Emil Nolde, have produced religious paintings spontaneously, paintings of great intensity with subject matter from the Old and New Testaments and the lives of the saints. In all these we recognize that the conception of the subjects is not strictly bound to the tradition of reli-

gious painting or sculpture in any faith. It is theproduct of a self-guided religious imagination that selects from the texts or from memories of old pictures those elements that are attractive to a lonely disenchanted mind that feels itself to be outside the established institutions but identifies with some human content of the religious story. Moreover, in the development of painting and sculpture in the last hundred years, there have been tendencies toward the poetic, the irrational, and the primitive, which led artists, as it led poets, to appreciate certain aspects of religion that were congenial to their own imagination and art. The existence, then, of this type of religious feeling or—better—religious perception, without a confessional commitment, and the capacity of artists, like the poets, to express it in a fresh way made their religious painting and sculpture appear authentic in a manner one did not find in the accepted religious art of the time. The latter was more bound to tradition; it followed set rules of iconography and was generally the work of men without originality, men who had not, so to speak, lived the content of their religious subjects.

More recently, attempts have been made to win modern art for one or another religious group. At Assy, in eastern France, a church was constructed and decorated largely through the stimulus of a French Dominican painter, Father Couturier, who knew the artists personally and got them to collaborate in a large enterprise of religious painting and sculpture. That collection of works was created by men who, for the most part, were not observant Christians and had no strong conviction about religious ideas—traditional or untraditional. They followed their own sense of what was appropriate and produced a whole that has impressed visitors as no more than a museum, an episode in modern art rather than as a church building that owes its unity to a single governing thought, to a program of decoration rooted in a living tradition of consistent religious thinking and art. The idea of winning painters and sculptors, who were not primarily concerned with religious art, for projects of religious decoration and expression met great resistance within the church itself—I refer, of course, to the Catholic Church in France, but also in Italy and other countries where a similar problem existed. The main objection to this kind of art was not that the men who painted these works were atheists or Communists or had only

a vague idea of the religious content, but that in a deeper sense they were unable, because of their commitment to a modern style of art, to realize adequately a religious content that had arisen under very different conditions and that had its own values and tradition of representation and symbolism. It was objected that the Christ on the Cross by Germaine Richier suggested nothing of redemption or of the spiritual meaning of Christ's suffering on the cross. It was said that the work of Georges Rouault was in itself so ugly that it would provoke in the pious observer a disturbing sense of the body and its deformation rather than transmit a spiritual message. It is interesting that Rouault, the one painter of the twentieth century who was a deeply religious man and who almost alone among the advanced painters of his time continuously represented religious themes—themes from the life of Christ—received no recognition from his own church except from isolated individuals, such as a particularly sensitive Dominican or a priest. His work was not only criticized as ugly but in a book on modern religious art written by a canon of the church of Marseilles, with over two hundred pictures of modern religious art, no allusion was made to Rouault. On the other hand, Paul Cézanne, who in the last fifteen years of his life was a faithful churchgoer, never undertook a religious theme. We observe, on the one side, an art with a religious content produced by men who are not identified with the religious institutions; on the other side, the indifference of the religious institutions to members of their own faith who, in a sincere way, undertake to produce works of religious art. One can perhaps account for it by the decline of the role of the churches culturally, by their failure to maintain a living relation with what was new and fertile in the social and cultural life of the time. But I wish to concentrate rather on the question of what kinds of relations were possible under existing conditions. I speak here as an outsider, as an historian and observer to whom any kind of art, whether religious or secular, is of great interest. One can point to the fact that the failure to assimilate the new art is itself a denial of the tradition of the churches and synagogues. For if we turn to the past, we see that the style of church art for nearly two thousand years has been the style of the period; the innovations in architecture, painting, and sculpture became at once the forms or styles of whatever art had to be produced

for the churches. However, the argument that is used to justify a more receptive attitude to contemporary art in the religious institutions rests upon a misunderstanding: It ignores the fact that in older times, for the most part, though not always, the new styles of art, the innovations of which I speak, were themselves produced by artists who developed those styles in tasks of the church. Gothic architecture arose in the course of constructing churches; a series of new enterprises of church building stimulated the architect to find new forms. These innovations did not come in the building of castles or homes or city halls; it was primarily in church building that the new styles were created. Hence, there was a particular accord of the new styles with the problems of expression and realization of church aims in architecture. Correspondingly, the creation of a new style of sculpture, the Romanesque, was a consequence of new programs of church decoration. It was not in secular art but in religious art that Romanesque sculpture arose, and the same may be said of the art of stained glass. In the nineteenth and twentieth centuries, on the contrary, all the important developments in painting, sculpture, and architecture took place outside the religious sphere and for tasks of such a nature that their very existence was a challenge to the primacy of religion in spiritual, moral, and social matters. Hence the church had to ask: To what extent would the adoption of these new styles of art, created in contexts so foreign to the interests and mode of thinking of the church, be a counterinfection that introduced into religious thinking and feeling secular values and conceptions that were judged incompatible with basic religious beliefs? This is the essential problem that distinguishes the crisis, if you wish to call it that, of religious art in the nineteenth and twentieth centuries from the situation in previous centuries.

Of course, I have not given a strict account. One can point to exceptions in older times as well. One can observe that the Jewish synagogues of the Middle Ages were built in the Gothic style, a style that had not been developed for synagogues. In Spain and North Africa, they were designed in a Muslim style. On the other hand, one could answer that, granted the difference of origin, granted that the Jews adopted the local style, wherever they lived, and were happy with it, and commissioned for their own use buildings of a real magnificence

and individuality designed by non-Jewish architects, it was the larger community of culture, which included the neighboring associated religions, sometimes in strife, sometimes in harmony, that made possible the use of a common style or language of forms in architecture, painting, and decoration even for peoples who had different faiths. One can observe, too, that in the early Christian period the architecture of the church and its decoration, including painting, mosaic, and stone carving, are often indistinguishable from contemporary pagan art or from the contemporary secular art of the palaces, the imperial court. That is true to such an extent that there exist sarcophagi of the third and fourth centuries A.D. in which it is difficult to say, in spite of their rich sculpture, whether they were made for a Christian or a pagan. Both pagan and Christian sarcophagi are decorated with the symbols of the Good Shepherd, a figure shared by several religions during that period. The presumed unity of style and religious content is not as strict, not as necessary, as has been supposed. But for our own century, at any rate, the problem is of a different order. In our time, much that arises within secular culture on the ground of individual experience, and very often connected with a sharply critical attitude to existing society and institutions, is bound to raise in the minds of those who are committed to the existing order, and especially to the established religions, some doubt as to the compatibility of that culture with prevailing religious beliefs or the needs of the churches.

A new situation has arisen from the character of contemporary art: The prevailing abstraction, so-called, suggests the possibility of an art for the churches, without symbols or imagery and therefore without specific doctrinal allusion. Among the different kinds of abstract painting, one in particular seems to warrant a place in the temple: the kind that reduces the elements to the fewest, even to a single absorbing note, a visual clang that, through its possession of a large field, even of an entire wall, dominates the space of the room and endows it with the subtle quality of that color and form. By excluding imagery and familiar symbolism and offering to the viewer's eye a concentrated and highly stabilized or persistent essence to contemplate, it induces a serious mood of aesthetic meditation like that evoked by certain works of medieval church music. In divesting itself of all reference to material objects and

in striving for simplicity and purity, this art has something of the spirit of kenosis in the religious sphere.

It is not for me to say that this art is right for one or another religious group today. It is not in origin an art of a church, though one might discern in it a residue of an older religious attitude, displaced to a personal sphere. It is the work of temperaments that, whatever their religious outlook, are heirs of a tradition of spirituality.[1]

This art at its best is too decided and imposing to be regarded as simply a potential decoration of a church, neutral to the religious concepts like the embellishments of an altar or pulpit. It has some kinship with the occasional austerity of modern architecture that has renounced ornament and that is now accepted as a suitable style for the church and synagogue; but this architecture can also be a shallow cosmetic art no less than some abstract painting. (The line between ornament and expressive painting is not always clear.) Besides, for the religious viewer, even when beauty is the sole criterion, the context of the building as the house of a particular community of belief, a place of preaching, prayer, and rite, will impress on its major parts and hence on the paintings on its walls, some allusiveness or connotations that reinforce ideal meanings and goals of that communal use.

In the decision to adopt a new art for the church there is implicit a policy with respect to contemporary culture and the ideas and values that sustain it, including the resolutely independent attitude of most artists in setting their own tasks. As that culture is in deep and continuous conflict with itself, and its arts show an extraordinary variability at the same moment and from year to year, the choice of an art for the walls and windows of a church or synagogue will be guided by a judgment of the compatibility of the selected art with the outlook of the religious group as well as by a sense of the genuine individuality and beauty of works and of their abiding expressiveness for more than the taste of the moment. Decision will be exposed to the pressures of fashion and competing currents of taste outside the congregations. The churches cannot rely here on a view already set by their traditions and shared by all the members; much, if not everything, depends on the initiative and self-reliance of a particular inspired individual—a minister, priest, or layman—whose convictions about art are strong enough to

surmount the usual constraints of denominational opinion and the tastes of parishioners. All this is familiar enough and has perhaps been debated and resolved already. I bring it up as a caution against too ready and optimistic a view of the cooperation of advanced contemporary artists and the churches.

(1963)[2]

[1] The "one note" painters, Barnett Newman and Mark Rothko, were later to decorate the Rothko Chapel at St. Thomas University in Houston, Texas—Rothko did the paintings and Newman did the sculpture. Both Dominique de Menil, with her husband Jean, the donor of the paintings, and Philip Johnson, the architect, heard this lecture.

[2] This talk was delivered at the Annual Meeting of the Society for the Arts, Religion and Contemporary Culture held at the Museum of Modern Art in New York on February 5, 1963. Printed in *ARC Directions*, no. 7, Fall 1969.

THE FUTURE POSSIBILITIES
OF THE ARTS

W HOEVER ACCEPTS THE LIBERTY OF THE ARTIST TO CREATE IN THE most willful manner, and whoever believes in contemplative and expressive values, must limit the idea of social relevance in art to the common needs of the individual for contemplation and expression rather than to general economic, social, or political contents.

But in a society harassed by the inadequate functioning of its own institutions and keenly aware of the urgency of certain material problems—even for the successful attainment of nonmaterial ideals—every practice, every cult that is not destined to liberate man or to transform society is felt to be a theft from human energies or a cowardly concession to established interests. And especially where these cults or practices are socially irresponsible or are supported by the very interests that are questioned, even attacked for their unsocial, reactionary nature, we challenge them to defend their very right to existence.

What can possibly be the position of the painter in a more rational more sociable society? This cannot be answered directly or absolutely, but there are several possibilities that are worth discussing. One is the eventual laicizing of painting as an art, not merely because of social changes, but because of the very nature of painting as an art today. By laicizing I mean the reduction of painting to a nonprofessional activity, to a sort of amateur, dilettante occupation of man's leisure, somewhat like lyric poetry at the present day. No lyric poet lives by lyric poetry; he

lives by a trade or profession and in his leisure composes poetry that is either published or read to friends. Now this is possible in poetry, because the art has a limited material character; it does not require a specialized education; it does not demand a complete devotion to a technical study that absorbs the entire life of the artist; it demands neither studios nor workshops. And given the modern informal style of verse and the complete liberty of expression, the poet is even less a professional than in the Middle Ages or the Renaissance.

A similar change has taken place in painting. Impressionism destroyed the older techniques of painting, substituting for the carefully meditated synthetic, studied composition, which was planned on paper and then transferred to canvas after detailed studies of the individual figures, a more direct, swifter technique in which the picture was created instantly from the landscape in the open air, rather than in the studio. The finished picture acquired the character of the ancient sketch. The swifter the execution, the more spontaneous the vision of nature, the better the result. A picture could be made in twenty minutes. With the Post-Impressionists the painting was even liberated from the landscape model that his predecessor had respected. The picture became primarily a creation or expression of a subjective moment; with this heightened subjectivity even the study of an external world ceased to be indispensable. It is at this time that the notion of primitive changes from the pre-Raphaelite, nineteenth century conception of an art as skilled, as organized and crafty as that of the fifteenth century in Italy, to a naive unnaturalistic art, like that of the Negroes of Africa and the art of contemporary little children.

To paint, then, in the twentieth century requires no elaborate skill in drawing, no stock of conventional knowledge, but sensibility, feeling, and a strong impulse to creation. The painter has ceased to be a craftsman or a learned man; he is a creator in the pure sense of the philosophers.

Painting has become more and more laicized. Because of the identification of painting with everyday aesthetic experience, with landscape, horse races, city scenes, spectacles, painting entered a democratic phase, an uninstitutional content; it became a part of daily life, in painting landscape and still life and a familiar mobile world. And to achieve the effects we value in modern spectacles, it developed an adequately rapid

and informal technique. This style, more subjective than any in the past and free of the restricting authority of fixed subject matter, was gradually transformed into an even more subjective style, in which the artist's feelings or special vision became paramount. The idea of self-expression must dissolve the fixed elements of a style, because what is valued in the self is unique and immaterial, independent of conventions. And hence at this period, in the twentieth century all drawings, however crude, drawings by children, by madmen, by laborers, by invalids, are examined with the greatest interest as forms of self-expression and, for psychiatrists especially, provide diagnostic material. At the same time, the idea of self-expression—the outcome of a democratic tradition, as well as of inner currents in art—is extended to education, and in the upbringing of the child, drawing and painting become essential parts of his training. But we should not say training. For if in the older instruction in drawing he was taught a canonical naturalistic perspective and told to master the technique of imitation of nature, it was because art was a profession with fixed rules of craft and an elaborate technique. This required a training. But the modern child is not trained to draw; he is given the simplest materials and asked to work freely. He is encouraged to express his fancies, his feelings; he is not corrected for inaccuracy of drawing, but the naive qualities, the purely infantile, youthful traits, the freshness and simplicity are valued. This schooling, which admits a greater freedom than ever before, implies the highest valuation of self-expression and conceives of the ultimate career of the individual not merely as social, but also as personal-aesthetic, as a sort of intensified personal culture that transcends occupation. In former times there was a similar conception of the superiority of the spiritual activity to the material; the worth of an individual lay not in his economic vocation but in his piety and moral qualities. And the education of a child was mainly religious. But whereas the inculcation of religion imposed a uniform social pattern on all the children and a subordination to a fixed authority, the church, the modern teaching treats each child as if he were a little artist whose happiness it will be to express himself, to develop his sensibility without respect to authority or institutions.

I cannot enter here into the difficult question whether this character of education was influenced by the changes in modern painting or aes-

thetics. What is more important at this turn is to recognize that this conception of schooling implies the laicization of art or self-expression and at the same time the heightened valuation of self-expression, however eccentric.

What do these changes in art in the last sixty years imply with regard to present and future society and what are the future possibilities of the arts themselves?

The arts themselves play so unimportant a role in economic life that it would be foolish to infer from the history of art the possible social-economic changes of the future; it is only because they reflect to some degree the common human world that they can illustrate, or confirm for us, a deduction made from more central activities and institutions of the day. The Romantic philosophers believed that poets are the unacknowledged legislators of the world; with the almost complete silence of lyric poetry at the present time, we might suppose that this legislation is also properly ineffective, if existent. This silence is itself a consequence of the nature of the world in which poetry cannot legislate, and to some degree informs us about this world.

If the arts cannot tell us what will happen, they indicate in a forcible manner certain characters of our life that are crucial for the changes of our present society. This is most apparent in architecture. Compared with ancient or any preceding architecture, the modern architecture of the most advanced technical type implies the utmost socialization and practicality. Whereas the old house was a closed-off unit, massive and permanent, the ideal of the modern architect is a radical urbanism, in which the whole city is reorganized for human ends, with extreme practicality, without ornament, without artifice, without permanence, but with flexibility, mobility, and the greatest reliance on common services. The architect who has brought these ideas into the greatest prominence is the Swiss-born Frenchman, Le Corbusier (Charles-Edouard Jeanneret), who is politically conservative, who never questions existing economic structures, except from an aesthetic moral viewpoint, and who has developed his style from technical-hygienic considerations. His ideal of good building is social, economical, urban—collectively planned building; he condemns the liberal, philanthropic garden city as wasteful; he urges the greatest standardization in order to achieve the

greatest personal comfort and decency. It is a testimonial to the social nature of his work that he was called to Moscow as an expert in city planning and architecture and that his projects have been adopted there with much enthusiasm. Thus a bourgeois architect, in adopting the standards of capitalistic machine production to the utmost point, has helped revolutionize the forms of building and has conceived of architecture as a high social function. His practical projects have the air of technically planned utopias; his forms are acknowledged as the finest of modern constructions.

If, then, we consider architecture as symptomatic of society, we must conclude that the whole tendency of recent architecture is toward social responsibility, an exact, unsentimental technique of building, and the utmost flexibility in ordering our environment.

But when we turn to painting, the situation is quite different: in architecture—the sense of human needs, and rigorous techniques, and immediate social relevance; in painting—isolation from the public, the creation of luxuries that only few can understand, and still fewer can own.

The painter works by himself—the architect consults an army of workmen, engineers, experts; the architect must be objective and idealize this objectivity as the source of his aesthetic style, whereas the painter treasures his feelings, his peculiar private sensibility, and is often incapable of living with ordinary people because of his sensitiveness. The architect knows he alters the environment and people by his projects, the painter mistrusts his audience and his patrons.

We can readily understand the difference when we compare their respective creations. And we must ask, If the architect will become more and more important as our society with a strong will imposes an ideal form on life, what sense will there be in the painting of pictures, especially the pictures we have described today? For no matter how much we may admire these pictures, we know that only a few painters can produce them and that they are beyond the purses of most people.

From an economic viewpoint the art of painting is a monstrous anomaly. Of a thousand paintings made in a given period, perhaps fifty will be sold. Of the fifty painters who produce them, perhaps no more than ten sell more than one or two pictures in this period. And yet,

despite the great supply, the cost of the paintings tends steadily to increase, and what is more astonishing, the number of painters also increases. These men create objects for which they have no market, no orders. They create from a necessity that is not economic, yet they hope to live by their creations. And with this peculiar impracticality, this isolation from ordinary social principles, these producers are intensely proud, self-assured, and feel superior to the producers of merely marketable goods. For them the commercial artist, i.e., the artist who works to order and for a known buyer, is an inferior being—a sort of aesthetic prostitute, who sells himself to the first bidder.

Is it possible that this precious individuality is a necessary part of our intensely socialized world? Is he the guarantee of spiritual values, of disinterested living, of pure contemplation and free expression in a society in which every act must normally be justified by an economic purpose? Does the extreme subordination of the individual in public life require this exaggerated romantic individuality in aesthetic creation? Is the increased interest in arts in recent years a consequence of the minimizing of aesthetic values in daily, practical existence and the decay of religion? And is the peculiar character of our art, its detachment from social contexts, its abstraction and eccentric, private self-expression, the complement or essential nature of the art of a technical, machine-governed society? Aesthetics and the philosophy of art, have produced two central interpretations of art, in the last fifty years, which anticipate and parallel the changes in art itself—namely, the idea of aesthetic contemplation as an ideal divorced from practical motives or consequences, and secondly, the idea of aesthetic creation and enjoyment as means of self-expression.

Does this mean, then, that the painter will be even more encouraged in future society, since he rises from a substratum of individuals animated by a similar respect for the individual expression? I doubt this because parallel with this change in general culture is an increased social consciousness and a valuation of the practical, the efficient, the organized, and the rational. And at the present day especially the artistic world is the most notorious example of the impractical, the egoistic, the disorganized, and the irrational. The artist is the impractical analogue of the capitalist; the egoistic, creative economic man, socially irrespon-

sible, often chaotic, efficient by virtue of less ambitious engineers, but characterized by a powerful will to attain a personal victory or fortune. For such men we have a decreasing respect, and already they feel the necessity of justifying themselves by pointing to their role in developing the country, their numerous philanthropies, their patronage of art, and so forth.

In a society in which the production of wealth is a communal activity, and classes, other than technical ones, have disappeared, the artist must live by his labor. But we have seen that his present labors are impractical and the sale of his pictures can hardly support him. If he lives, it is by an excessive valuation of his works that only a capitalist society can sustain. No workman can afford a good modern painting, not even a drawing.

The state cannot afford to sustain artists for the simple reason that only a few are good artists and every man today can be an artist. The taste of officials is notoriously questionable; none of the great artists of the nineteenth century (except the academician Ingres) was recognized by the state until very late in life, and even then after much persecution.

Therefore, it would seem to be probable that in a socialist society the painter would cease to be a professional and would become an amateur like the lyric poets and the photographers. This is already indicated by the fact that in Russia the government supports only those painters who are also laborers or propagandists.

Those painters who by character and force of imagination require the greatest projects and materials will probably turn to another but related art. I refer to the cinema, which by its very nature is the most modern of the arts and fulfills the entire preceding development. It is the most highly socialized and modern, in its mechanical production, in its union of drama, painting, photography, and music, and finally in its cinematic character, already dreamed of by the aestheticians and painters of the early twentieth century who sought to render movement as such and a completely mobile, highly subjective material.

This art is the most vital art in Russia. It performs unique social services, more so than drama insofar as it is mechanically reproduced and hence can reach the widest audiences, and insofar as it is perfectly flexible in its subject matter or scope. It can render concretely landscapes,

interiors, worlds, inaccessible to drama, and it can produce these effects with a richer visual quality than any play.

In the pursuit of this art the artist becomes again a technician, a practical man, an important citizen, an agent of public education, pleasure, propaganda; he has a material that admits the greatest range from inhuman objectivity to unlimited fantasy.

The relation of cinema to painting deserves a careful inquiry, for it will reveal to us the possibilities of cinema and, further, it may inform us of its real aesthetic nature and its most productive principles. I believe that cinema is a necessary continuation, despite its apparent realism and objectivity, of the most subjective modern painting, even of such unintelligible fantastic schools as Cubism, Futurism, Expressionism, and Surrealism. The great impulse to a superior cinema came from the German Expressionist movement; we must recall that Futurism and Cubism are especially significant in art in that the first had the hopeless ideal of suggesting the absolutely dynamic or kinetic in a fixed image and that the second destroyed the simultaneity of a pictorial whole by decomposing it into minute facets, without a clear enclosing form, and by showing several aspects of the same object at the same instant. These are protocinematic visual arts, inadequate strivings to attain a cinematic visual flow corresponding to the *durée* of consciousness or of feeling. It is unlike drama in which a real world is experienced and our normal perceptions operate; for in cinema it is an abstraction, a projection of the real world that is mysteriously unrolled and continuously, silently replaced before us. One is an action, the other a cinematic spectacle. The Futurists tried to achieve the cinematic by photographing various moments of an action on the same photographic plate; the cinema reproduces them on successive plates or films that can be reprojected to represent the original dynamism.

(1957)

The Profession of the Artist

ON THE ART MARKET

T HE PRESENT STATE OF THE ART MARKET IS DISTURBING TO ARTISTS and others. The extraordinary prices paid for contemporary and older art seem pathological. Any abnormality creates uneasiness and questioning. If prices represent intrinsic value, it's hard to reconcile $100,000 for a Blue Period Picasso or $80,000 for a an Andrew Wyeth with prices once paid for a Rembrandt; or with prices recently paid for the greatest modern masters. It suggests insincerity, speculation, and the tri-partite play of self-interest, pecuniary interests, and social status in the acquisition of art. Moreover, the presence of these acquisitive interests in the market affects museums, the general public, and artists. The market was never innocent in its judgment of art, but this new awareness of art as a precious speculative commodity now corrupts all awareness of art. The knowledge of prices and possible gain through art enters into common perception of art. It also makes artists keenly aware of sales price as a measure of value. Attached now to the speculative market in increasing dependence, art becomes also an object of intense publicity. The literature of art assumes a new banality and a striving for public attention. There is a new and distasteful aesthetic of art propaganda.

There has been a change in the catalogues of shows of dealers and museums in the fullness of biographies and the cunning selection and suggestiveness of items—the list of exhibitions, owners, reviews, articles, and books, the dossier of the artist as an advertisement, more

important than the old-fashioned preface usually written by a friendly poet or critic. Costly catalogues with color plates are for sale.

There is resulting hostility among the community of artists, the effects of intensified competition, which includes greater publicity, a loss of older mutuality and bohemian gaiety, even violence against the successful—both Willem de Kooning and Rothko have been assaulted.

It is said that the success of a few artists leads to neglect of the following generation, including the comrades of the successful group. Is this a change from the past? Did not the success of the Cubists and of Matisse affect the market for minor Cubists and Fauves?

In the nineteenth century the Salon as the chief place of contact of artists with the public became larger and larger: Prizewinners were guaranteed government support, commissions, purchases, portraits, orders, and appointments in government schools. Juries had a power of life and death over many artists who could show only in Salons. Few dealers handled contemporary paintings. The fight against the jury system, however, did not solve the problem. New Salons, independent places of exhibition, were set up by artists, but the economic situation remained about the same. Increased wealth, especially in the United States, led to a great increase in the number of dealers. The Salon was decentralized by free enterprise in the exhibition of art, and the great demand for certain artists freed them from dependence on dealers, much as in the seventeenth century.

Much of the interest in art buying today lies in the gambling aspect; it is attractive to people who are accustomed to gamble in the stock market and to watch new fields of investment; it is not a primary source of income but an activity in which the business habits become the source of social prestige as culture-promoting and culture-indicative signs, and at the same time produce more wealth for the owner; they are also parts of a style of life.

Art as a form of free enterprise is joined here to the market as a form of free enterprise. The collector is freer as a collector than he is as a businessman. The test of value in business is saleability, demand; in art he observes also what is in demand; as an imaginative businessman he anticipates demand. If a businessman was clever enough to buy Pollock and de Kooning and Rothko in 1947–52, he was an unusual personal-

ity with some artistic flair, or exceedingly well-informed by artists and critics close to these men.

What is disturbing is not that people profit by the rise in prices of art, but the effect this knowledge has on the attitude to art everywhere. Art becomes even more of a commodity than ever before; the relation to art is infected with all the diseases of business enterprise.

In art we see in an acute form the effect of commodity psychology and profit attitude on the whole of society today. The effect in art can't be isolated from the nature of the economy as a whole and the resulting qualities in the culture.

The great interest in painting and sculpture (versus poetry) arises precisely from its unique character as art that produces expensive, rare, and speculative commodities.

(c. 1960)

On the Support of Artists

HERE HAVE BEEN RECENT PROPOSALS THAT EVERYONE SHOULD BE guaranteed a certain minimum income. Increased productivity today implies increasing unemployment or shorter employment. There may be a limit of efficiency in a shortened workday or work week; hence, large numbers of unemployed are likely, especially among the older population. There is also a longer period of education. The problem of leisure is far from solved, even far from clear.

The proposal for universal guaranteed minimum income and the acceptance of unemployment was already made about 1900 by the anarchist Naquet and discussed in 1919 by Bertrand Russell in *Proposed Roads to Freedom*.[1] But with an important difference. The older proposal was inspired by a socialist perspective and hence by the idea of freedom, of individual choice. In an economy of abundance one is free to choose to work or not to work. Healthy well-educated individuals will want to work, but some will want to engage in set projects, in a work with a considerable routine; others will prefer to create their own pace, to experiment, to engage in long reflection, study, travel, association with like-minded and other people, to undertake projects of art that cannot have a fixed schedule of work. For such, Naquet and Russell saw the necessity of a minimum income to permit creative idleness. One cannot foretell the outcome, but from the viewpoint of a happy society, it is worth while supporting all who wish to live in this

way, since only through a wider practice and interest are the best achievements possible.

The value of art and philosophy to the community is not measurable. Works of art are precious objects that give important qualities to the life of society. What we would not give to have an equivalent of the Parthenon, Chartres, the Sistine Ceiling, the works of Rembrandt in our city? Or another *Iliad, Divine Comedy, Don Quixote?* Such things are extremely rare and of the deepest import. But works of the second quality and the third are no less desirable, and when a society possesses them, it preserves them, with a sound instinct of their universality, their value for future generations.

From this long experience we derive the confidence that wealth allotted to art and artists is very well spent, though the result can't be predicted in detail. It is the best, the most sensible gamble we can make. The problem of producing art is a serious one for the statesman as well as the art lover. Not because art provides the monuments that commemorate victories and great men or contributes to the love of country, but because art gives to the everyday life of the community a particular excellence that is no less desirable than prosperity and peace. If education is for the achievement of a high standard of life and mastery of the skills needed for that standard, art is a major element in that standard of life. Only the enormous expenditures for military purposes, connected finally with maintaining wealth, prosperity, power, have accustomed people to think of the budget for the arts as necessarily a quite minor thing. But without war the spending for education and the arts would certainly become the major elements in the national budget.

Today our sense of the cost of art has been completely confused by the state of artists. On the one side, the notorious poverty of artists— very few can live by their art and must practice some other skill in order to live, and this life is itself shabby, uncertain, harassed. On the other side, the incredible prices paid for works of painting and sculpture— canvases by living artists sold for \$30,000 and even up to \$100,000. That these prices are not a measure of quality in any absolute sense is obvious from the fact that a poem or musical composition of corresponding quality brings a small fraction of those prices. It is the fact of unique possession by a purchaser, the material character of the painting

or sculpture, that determines the price, once there is a demand for it. You may have the poem for the dollar that it costs to buy the magazine in which it's printed; the painting is something to be owned privately, exclusively, and therefore calls out the competitive ambitions of the wealthy. In its fantastic price the painting is not different from the unique defective postage stamp that brings a bid of $30,000 at an auction. The stamp is not a treasure of mankind, the painting is. The one is a product of chance, disturbing the uniformity of insignificant mechanically made items; the other is the product of sensibility and intelligence, working with unpredictable success in an original, unduplicatable way.

We do not know how to increase the yield of art, and many are satisfied to accept the uncertainty of art as a permanent mystery of nature. But we do know that great art is never isolated as a product. Wherever we look, we see that around the great artist stand hundreds of men and women eagerly devoted to the vocation of the art. The achievement of great art is itself a stimulus to further work by those who have been stirred by the achievement. The great numbers who wish to be artists are a sign of the vitality of art, its irresistible appeal. Of course, many who turn to art are not true artists; there are neurotic types who are drawn to art without being able to sustain their interest. But even this attraction is an evidence of how art works; it excites and inspires.

The example of communities in the past as well as our recent experience gives us confidence in the advantage of a sustained and large body of practitioners of the arts.

(circa 1960)

[1] Bertrand Russell, *Proposed Roads to Freedom—Socialism, Anarchism and Syndicalism* (New York: Henry Holt and Company, 1919), p. 104.

The Responsibility of the Artist

SOCIAL REALISM
AND REVOLUTIONARY ART

█N SHARP OPPOSITION TO SURREALIST AND ABSTRACT ART IS THE
program of revolutionary art. It represents in a partisan spirit
moments of social life directly involved in the movement for radical
political change. This is necessarily an unclear and unstable program. It
admits a range from neutral images of factories and men at work, from
portraits of leaders or representatives of the working class, typical
through their heroism or suffering, and satirical pictures of the class
enemy, to more dramatic, grandiose images embodying directly the slo-
gans of revolution or situations of struggle, that is, positive revolution-
ary action. Since they present elements of revolutionary consciousness,
all these subjects have a value for the radical partisan, apart from the
artistic character of the work. If certain of these, like the spectacle of an
industrial landscape and the passive suffering worker, are condemned by
radical critics as sentimental and even defeatist during a period of mili-
tant doctrine, they are revived and cultivated in a succeeding moment of
popular reformist slogans when the imagery of intransigent opposition is
forgotten. All organized radicalism has had a sporadic and recurrent
character, and the artists who have submitted themselves completely to
the line of a political party have, therefore, been unable to develop a con-
sistent art; whatever new experiences and conceptions they have
absorbed in the process of creating a new art, they have had to abandon
in obedience to the change in the political line. The political change may

have been right or wrong, but its effect on the artist, whose imagination is guided by the party, has been to weaken the spontaneity originally stimulated by his conversion to socialism. Hence, if the partisan painting of the past twenty years has produced no distinctive style, like Cubism or Constructivism, which are also tied to a common set of ideas, the character of the revolutionary movement, its changing fortunes and direction, its philistinism, are partly responsible. It has not attracted the major talents in modern art; gifted painters who have supported the revolution politically have made only sporadic attempts to create partisan works; they have followed their own artistic line as more sure, more relevant to aesthetic problems. The political party (Communist Party) submits them to philistine criticism and guarantees no livelihood to revolutionary art unless it is immediately effective as cartoon or poster. Although modern artists are contemptuous of financial success and live in extreme poverty while forming their art, they are afraid to change their style if it means a loss of patronage. Nothing will promote an art so much as the assurance of a continuous support or publicity. The existence of a Popular Front government in France, which commissioned works of art, did more to give a kind of self-evidence to the idea of a Social Realistic art than the fifteen years of persuasion after the World War.

The conception of an art expressing the ideas and experience of the revolutionary movement remains a valid one. The Stalinist cultural front may in fact be criticized for its clumsiness and incapacity in promoting such an art. In its obvious human and historical aspect, it is a challenge to the most advanced artists of our time, who value their creative freedom, their flexibility of vision, and their ability to poetize every subtlety of consciousness; but this consciousness of class, of struggle, of purpose, of the interdependence of individual and society, they have shunned or ignored. Their difficulty in absorbing such material betrays the real limitations of their imaginative freedom.

But the demand for an art inspired by social ends does not come only from the Communist Party. Other groups, reformist, liberal, and even reactionary, make a similar criticism of abstract art and support a popular collective art. The Nazis, who condemn modern painting as degenerate, have commissioned hundreds of paintings and statues addressed to the people, glorifying the common man, the militant, the

party hero, and the world of disciplined labor in the fields and factories. And in the United States, the New Deal administration has an elaborate program of art, decorating its buildings with mural emblems of progress and democracy. Artists who were won to mural painting by the arguments of Communist critics in 1932 were decorating the government offices in 1934. Thus the revolutionary culture seems to prepare the way for an official art. [In the same manner, novelists and economists who explored the world of labor for their revolutionary writing became the skilled (and anonymous) journalists of the conservative magazines of industry.] This is not peculiar to our time. In the past, when the masses have become more insurgent and artists radicalized, the ruling group has adopted quasi-revolutionary or radical forms of art. After the Seven Years' War, at a moment of economic exhaustion and unrest, the ministers of Louis XV recommended that he decorate his new palace with paintings of the king distributing alms and consoling the widows and the victims of the battlefield. The king preferred nymphs and erotic allegories. But at the end of the last century in Belgium and northern France, when the great strikes and political unrest provoked novels and paintings of industrial struggles, of the misery of the poor, the Christian reformists, in turn, had Christ represented as a labor leader, or as an arbitrator, and taught class collaboration through their Social "Realism."

During the last fifty years such art has been condemned as propaganda by the artists who remained outside. They supposed that the propaganda function entailed inferior artistic qualities, as if there were an inherent antagonism of propaganda and art. While most propaganda is artistically of a low order, this is not a necessary condition; it is also true that most works created simply to express the artist's feelings are bad art and that works made as formal constructions are often formally quite weak. Propaganda is the soliciting or effecting of partisanship; art is the use of certain historically developed means in expressing ideas, feelings, experiences, and perceptions and in creating particular effects for the pleasure of the senses. Therefore, art may be a means of propaganda (there is also an art of propaganda), and the partisan ideas and experiences may be the subjects of painting or poetry. Neither propaganda nor art excludes the other, but certain attitudes to the propaganda task may

be prejudicial to good painting, just as certain kinds of aestheticism lead to very weak art. A work may have the effect of strengthening partisanship, though such was not the primary intention of the artist; the Christian painter in the Middle Ages did not concern himself with the calculation of religious effects on the spectator; hence, Friedrich Hegel could say that, in the Middle Ages when religious art was a conventional, almost natural task, one did not have to be pious to create convincing images of a saint, whereas in the nineteenth century, ardent Christian painters, who sent their brushes to Rome to be blessed by the pope, did not create a comparable religious art. But even the propaganda of the moment does not exclude art, and we will see later how, in the earlier nineteenth century, painters uninterested in politics could create grandiose works of art with a timely subject that aroused political sentiments. And during the last year, the Spanish painters Picasso and Joan Miró, who had intransigently practiced a personal art, were excited by the civil war in their motherland to create works directly destined to win partisans for the Loyalists. These may be inferior, as painting, to their more abstract art, for they pose new problems not resolved in a single effort. For the artist they do not mean an abandonment of art, but on the contrary the searching out, even the creation of, new means for the new task.

The history of political or social art during the last hundred and fifty years—that is, of art that is directly inspired by the viewpoints of the radical movements or expresses a direct response to political events— this history is very instructive for the criticism of current theories of revolutionary (or socialist) art.

It teaches us that at every moment of political insurgence in Europe there has arisen an art of social protest, whether symbolical or realistic, doctrinal or humanitarian. This is evident in 1789, in the 1830s, in 1848, in the late 1860s, in the 1880s, and at the turn of the century. In the first three moments it had undoubtedly a formative influence on the style and general direction of the art of the period and was supported by the greatest artists of the time. The revolutionary Neoclassicism of David, with its brief realistic moment toward 1793, the Napoleonic style of Antoine-Jean Gros, the art of Daumier and Courbet, were developed under the direct impulse of the progressive political movements of their

day. But after 1848, these movements were without real influence on the artistic innovators and constituted for the most part either an incidental interest of the best painters—as when Manet represented the execution of Maximilian or when van Gogh painted the prisoners in jail—or the subject matter of academic liberal and radical artists. Only in journalistic art, in prints and drawings, was there a continuous tradition. But it should also be known that in this later period, there were many artists in the vanguard of the movement of painting, like Pissarro and Paul Signac, who were anarchists or Jacobin republicans but who excluded their political ideas completely from their work.

After 1848, the art of social and political meaning was dominated in its sentiments and forms by the nonpolitical art. Manet's *Maximilian* is seen like an everyday spectacle, van Gogh's prison figures have the pathos of all his figures whether imprisoned or free; Théophile-Alexandre Steinlen's scenes of poverty are conceived in terms of the emotionality and picturesque scenes of the contemporary nonpolitical art.

This marked difference between the period before and after 1848 may be explained by the changed meaning of revolutionary interests after 1848. Before that time, the radical movement was directed by economically powerful bourgeois groups against feudal privilege or the alliance of the latter with a financial aristocracy. After 1848, with the complete victory of the bourgeoisie in France (it had long before been won in England and the United States), the radical movement was antibourgeois and depended on the workers and the lowest strata of the middle-class. The artists by their middle class origin and by the very practice of their art are tied in habit and imagination to the attitudes of the bourgeoisie. They may denounce the philistinism of the bourgeoisie, but their ideas of freedom, their patronage, their individualized activity make them equally hostile to the insurgent workers. Only the imminent collapse of bourgeois society, the conviction that they can no longer rely on their older support even in the least degree, are necessary to force upon them the alternative of a new art.

If Mexican art after 1920 is really fertilized by the revolution—at least more than the art in Russia or any other country in the world—it is partly because the movement was a bourgeois revolution enlisting the support of almost the entire cultured stratum of the country in the strug-

gle against the great landholders and foreign imperialists. The backwardness of this colonial country with no film industry and general illiteracy, the positive survival of native arts, gave to monumental painting an importance it could hardly win in more developed cultures.

The bourgeois class in Europe could not illustrate its demand for equality of all mankind by concrete images of contemporary oppression and inequality; it did not really desire this equality and only demanded certain rights for itself, which were to be won in the name of humanity. It could only favor the representation of ancient heroism and tyrannicide, since it desired above all new norms of action, and norms guaranteed by their noble origin. Since it thought all men originally equal and the present inequality a degeneration, it appealed to a past experience of alleged equality for its norms of bourgeois virtue.

In Théodore Géricault's art the victims of the *Medusa* and in FIG. I
Delacroix's art the insurgents of the barricade appear without the goal and the guiding allegory. The intensity of the moment of releaseis resolved into a common undramatic mobility of a mass of similar individuals. Daumier's *Riot* shows the crowd surging forward across the picture, not into depth or the foreground; it is at once more realistic than either Géricault's or Delacroix's paintings in capturing the movement of a human mass, dispensing finally with the formal pyramid and the dramatic focus; but this change of style corresponds to a sense of the movement of the people as a spontaneous, general, and constantly reenacted event, rather than a decisive revolutionary occasion. Daumier's imagination is more limited than the Romantics', when it must, present institutional concepts and distant goals. When he wishes to represent the Republic, Daumier returns not only to the traditional triangular scheme, but uses it to frame an allegory of the Republic, which is in turn the familiar symbol of Charitas, the nursing woman with exposed breasts and dependent children. What he sees directly and with an insight peculiar to himself is the amorphousness of the people as an urban throng, united impersonally by some common vehicle, or catastrophe. In his series of Fugitives, the procession is formed by fleeing figures who jostle each other anonymously, driven along the same path by a common external force. In the same way, his *Third-Class Carriage* assembles in one compartment travelers who belong together but have no common

FIGURE 1. Theodore Gericault, *The Raft of the Medusa*, 1819, oil on canvas, 491 x 716 cm, Musée du Louvre, Paris

FIGURE 2. Honoré Daumier, *Third-Class Carriage*, c. 1863-65, 65.4 x 90.2 cm, The Metropolitan Museum of Art, New York

interactions. In the version we call *Winter,* they are all muffled and FIG. 2
repressed, in the *Summer,* they are all relaxed and cheerful. His theater
pictures show with a wonderful vehemence and precision the different
individuals aligned beside each other, isolated from each other, but tied
to a common object of attention. In later art these people become inert
or they retain their mobility only as a distant stream of traffic. It is this
perception of the crowd that Daumier alone was able to express; it is
based on the experience of the new nineteenth-century bourgeois city-
world, with its free citizens, its self-conscious individuals, caught up and
harassed and conducted by the same paths, vehicles, spectacles, sur-
roundings, and enthusiasms. But it is a humanity that palpitates con-
stantly and, in Daumier's probing, eternally sketchy and tentative, yet
exact drawing, in its endless responsiveness, is like the old suit with the
indefinable creases that preserve the impression of habits of sitting and
gesturing and the thousand and one accidents of posture; in the same
way, Daumier draws a face with a physiognomic corrugation formed by
an unceasing experience. His humor attacks rigidity and contrivance, all
forms of complacent, self-sufficient character, all norms, in favor of an
alert awareness of the flow of human desires. His art is not Balzacian
except in its comprehensiveness and robust acuity of vision; even more
than Balzac's, it springs from the new experience of democratic possibil-
ities in the shapeless but characterful and dissonant life of the city, which
provoked in the 1840s all those delightful *"Physiologies"* of the various
professions and quarters, to which Balzac and Daumier both contributed.

The revolutionary paintings of David represent individual heroes in
moments of resolute will or tragic death. His most impressive and most
realistic painting is of a single figure, Marat, dying like a Stoic in his
bathtub, pen in hand. The Napoleonic pictures of Gros are already more
militant and human and betray the existence of a democratic tradition
even in the rule of a dictator, in showing the latter as a hero surrounded
by suffering and heroic masses. In Géricault, these masses are indepen-
dent of the leader; they are all heroic and suffer as victims of an artisto-
cratic viciousness. His *Raft of the "Medusa"* is consciously a protest, on
a grandiose scale; it represents with great dramatic force the sailors
abandoned in midocean by treacherous officers; a Negro culminates the
pyramidal group; he is the first to see on the horizon the distant boat

FIGURE 3. Eugène Delacroix, *Liberty Leading the People*, 1830, oil on canvas, 260 x 325 cm, Musée du Louvre, Paris

FIGURE 4. Gustave Courbet, *A Burial at Ornans*, 1849-50, oil on canvas, 314 x 663 cm, Musée d'Orsay, Paris

that is to rescue them. Gericault had planned a great series of paintings to illustrate the struggles of the Negroes for their own liberation; he died before they could be painted. His ardent militancy reappears in Delacroix in 1830, with its army of workers and middle-class citizens advancing on the barricades in *The Twenty-eighth of July: Liberty Leading the People.* The pathetic masses of Gros and Géricault become aggressive and firmly united; but this painting is otherwise abstract and Romantically passionate. A symbolic figure of Liberty leads the insurgents; these combatants in their variegated costume and odd weapons are impulsive spontaneous fighters; their enemy is not shown, their goal is symbolized in the goddess of Liberty, it is their impetuous advance that really constitutes the picture. Daumier's work presupposes this feeling for passionate life and movement, this fusion of the aggressive and the suffering—which is Romantic passion, but unlike Delacroix, the everyday world is the densest field of real sufferings and contrasts. Like Delacroix, Daumier has no programmatic militancy, but a vast sympathy and understanding. It is Courbet, an exact contemporary of Karl Marx, who is the first programmatic, consciously revolutionary painter, who announces himself as politically radical, who says, Let us now paint some good socialist pictures. But his radicalism is Proudonist and individualistic; it is an affirmation of his liberty, which has no responsibilities or limits. He knows only himself and what he sees, and admits his independence of the latter, recognizing it only as another and equal part of material nature. His works exhibit a powerful, rich, static materialism, a wonderful feeling for hard and fleshy substance, for rocks, trees, mountains, ocean waves, massive clouds, large animals. His socialist pictures, despite the clamorous program of modernity, are concerned with antiquated forms of labor, men cutting stone with simple tools, women working on the farm. His magnificent image of *The Burial at Ornans,* embodies the most advanced aspect of his feeling and thinking; a Christian burial, of which the center is a hole in the ground, in a field of barren rocks and close-cropped meadows, a funeral in which no one looks at the cross, in which men in shirtsleeves assist the digging, and the small community is assembled with a drastic realism of portraiture. Death here is a purely material event, society is made up of various generations of clerics, small business folk and mourning women. Courbet

FIG. 3

FIG. 4

was a member of the Paris Commune, its minister of art, and was tried afterward for the destruction of the Vendôme Column; persecuted and exiled, he died a broken man, in misery.

After Courbet there is no revolutionary painting, no really critical art, until the 1890s or the early twentieth century. The path from David to Courbet shows a shift from the isolated individual hero to the mass, but in Courbet this mass becomes inert, a collection of individual substances. After Courbet all dramatic form, all conflict of wills, and all pathos disappear from painting for almost forty years. When it returns in painters like van Gogh, Rouault, and Picasso, it is a purely individual sensibility. The Harlequins of Picasso are isolated figures even when in a group; they are united by pity, sympathy, common misery, or wistfulness, but never in action. The complex interdependence of forms is never an expression of interaction, simply adjusted arabesque. Subsequent works of Picasso are concerned with an individual figure with a marvelous inner complexity, like a figure in James Joyce or Marcel Proust, whose complexity results from an analysis into fine overlapping components of which no two are complete or commensurable.

In a sense there was no conscious revolutionary art before the twentieth century, just as there was no long planned, methodically studied revolutionary practice before recent times. For a brief moment during the French Revolution, artists asserted the revolutionary duties of art and the artistic duties of the Revolution. The artist as an expression of the popular will must represent those ideals and situations that will inspire the people to a higher goal; at the same time, the Revolution must bring security and real freedom for the artists. These views had only a short life; under bourgeois democracy they degenerated into their opportunistic counterparts, artists as official decorators of the state, the state as the official patron of art, a degeneracy that was inevitable since the French Revolution could never achieve these goals, and since the artists were not conscious of the real direction and outcome of the revolt. This incomplete insight is reflected in the very forms and subjects of the revolutionary art, in the classical stories, which far from being a merely accidental matter, a previous tradition re-utilized by radical artists, were part of the broad movement of bourgeois insurgence since the middle of the eighteenth century.[1]

RUSSIAN ART

The Russian Revolution and the uprisings in Central Europe gave an immense impetus to the idea of a new revolutionary art supplanting the advanced art of the Expressionists, the Cubists, the Futurists, and the abstract schools. In Russia, two broad groups claimed the title of revolutionary, those who represented incidents, figures, and symbols of the Revolution, and abstract painters for whom the constructive and mechanical forms seemed to be the highest expression of a new anti-bourgeois society built on the logic of the machine and striving for universality in every field. Today, twenty years after, the first group alone survives in Russia, and its art is the official art of the state. It is subsidized more fully than any official art in capitalist states and has every means for realizing the doctrine of what has been called revolutionary art, proletarian art, and Socialist Realism at different times. The net result is a mediocrity and artistic conservatism unequaled in any capitalist country and distinguishable from the academic art of Europe and America chiefly in its quantity and undeviating optimism. It is only in countries like the United States, which are themselves backward in painting, that this Russian art enjoys any prestige. Elsewhere it is excused by sensitive friends of the Soviet Union by the argument that Russia being without traditions of painting and largely a peasant country cannot overnight build a new art of high quality; it was centuries before Christianity could realize a great expression.

These excuses, however, are based not only on a failure to analyze the character of this art, but on a mistaken notion of the actual state of Russian art upon the eve of the Russian Revolution. Russia just before the war was one of the most advanced European countries in artistic culture. Not only did it have the great nineteenth-century tradition in literature and music, a tradition basic for the best art of the twentieth century, but in the decade before the war, it was Russian art and taste that made some of the most original and vigorous contributions to modern art. Among the first purchasers of the painting of the Post-Impressionists and of Picasso and Matisse, at a time when they were hardly recognized elsewhere, were the Russian merchants Sergei Shchukin and Ivan Morozov, whose collections now form the basis of

the great Museum of Western Art in Moscow. The Russian periodicals of art from 1910 on, especially *Apollon,* brought to Russia the most advanced ideas of Western Europe. But more important is the actual contribution of Russian artists to the new movements. The names of Wassily Kandinsky, Marc Chagall, Kazimer Malevitch, Mikhail Larionov, Aleksandr Archipenko, Vladimir Tatlin, Alexey von Jawlensky, Chaim Soutine, Jacques Lipchitz, Naum Gabo, and Antoine Pevsner are primary in the development of twentieth century art. It is true that Kandinsky and Chagall worked outside Russia, but their contribution was rooted in experiences and tendencies that were undoubtedly native to Russia. And when the Revolution broke out, these men were invited by a Bolshevist regime with liberal artistic ideas to important posts in the cultural program of the state. The first few years after the Revolution were a period of extraordinary ferment in Russian art. But already in 1919 and 1920, the modern artists were harassed by hostile criticism and misunderstanding, and with the New Economic Policy their studios were closed and many of them left the country for Western Europe. Their conceptions did not die out altogether, but the alternative illustrative art became official, received the highest honors, and finally determined the public taste.

Hence, it cannot be said that the feudal backwardness of Russia is directly the cause of the present low state of its painting and sculpture. The techniques of these artists are so traditional and archaic that the technical backwardness has little importance. On the contrary, the persistence of traditions of old Byzantine painting, and of handicraft, the naive enjoyment of life in a peasant country, however poor, should under the awakening of consciousness, have inspired a high art of painting. It is from Spain, a parallel feudal nation, with only a restricted and new capitalist development, that have come Picasso, Juan Gris, Miró and so many other gifted modern artists. And it should be pointed out further that both extremes of modern art, its love of the personal, mysterious feeling and its bold technological fantasy based on a lyric of calculation, the poles of Kandinsky and of Tatlin, issue from the historically determined irregularity within Russian society, its old peasant culture, its newly assimilated industrial technique. Even the decadent Russian aristocracy had a positive value for the new Russian culture, for

it had promoted high standards of entertainment and luxury, and its intelligent and critical elements were passionately devoted to culture. The writings of Russian scholars on the history of art, even if lacking the philosophic breadth of the best German writers, were recognized by their Western colleagues as on a par with their own. In studies of classical, oriental, medieval, Byzantine, and later art, Russian scholarship and connoisseurship had great authority. Kondakov was the dean of Byzantine studies for all Europe. And even during the Revolution the young generation produced remarkably fine investigations of past art, in a spirit of aesthetic analysis parallel to the advanced Russian and Western arts, and often independent of Marxist assumptions.

The character of the official art of the present degenerate phase of the dictatorship of the proletariat reflects its own causes and throws incidentally a light on the regime itself.

There is a vast body of painting dedicated to the glorification of the government and especially of Stalin. This painting has a direct propaganda function, being destined for public buildings throughout the Soviet Union, for workers, clubs, and schools. It represents incidents of the Revolution, more and more frequently episodes illustrating the leadership of Vladimir Lenin and of the present high officials. Those in which Stalin appears are notoriously falsified historically, being based on recent textbooks, which supplant the accounts published shortly after the Revolution. These pictures are in a dull literal style that continues the native historical painting of the last quarter of the nineteenth century, a painting based on the academic salon art of the 1870s and 1880s in Paris and Munich. This painting is bad not merely because it is hypocritical and sycophantic; we have enough evidence of religious painters who did not believe yet created religious masterpieces to discredit so simple an explanation. The truth rather is that the demand for such painting on the part of the regime gave a greater importance to the academicians and servile craftsmen for whom painting was nothing more than a construction of scenes of life according to an unimaginative philistine taste; it also encouraged the toadies, the sycophants, the zanies, and the naive adorers of the regime. Their art displaced the art of more original and vigorous personalities and because of its official support diverted the younger artists into similar paths or discouraged art altogether—making it a

weak appendage of the bureaucratic voice. When this is presented as the best art and all other art is decried as bourgeois or decadent, what gifted, ardent young mind would want to become a painter? The Baroque art of the seventeenth century, which glorified the absolute monarch, created the imposing background and emblems for a hierarchy that did not pretend to democracy; the artist imagined forms of glorification to suit an acknowledged superiority of position. But the painters of Stalin are "democratic" or "socialist" painters, and their art is developed as an expression of popular life. Hence, there is a necessary conflict between feudal and democratic ideas; the painters do not dare yet to show Stalin as actually superhuman, to give him the value of an icon, but at the same time, their everyday representation is haunted by the necessity of subordinating all life to one man. It is as if the little Dutchman or a Vermeer should have been required to show continually a powerful statuesque figure with flashing eyes. His intimate manner would be confused by this task and would not develop in its original direction, nor would the assigned task ever be realized in its own frank terms. In Holland, the official art of the state was a separate style, now forgotten; it symbolized the heroes and powers of the government in classicistic paintings that may still be seen in the Dutch town halls. They were not paintings for the homes, and quite different artists were employed for such official work. But in Russia there is no independent art, except for very obscure and repressed artists who dare not lift their heads. There is no class like the Dutch bourgeoisie to patronize art individually. The regime of Stalin, with its special interests and tastes, exercises a social selection of art, causing the gradual disappearance of useless art and the more intense production of the useful or well adapted.

There is a tendency to crystallize a heroic style, which may become dominant in time. The emphasis here is less on the episodes, on the expression of individual faces that so delights the petty bourgeois, than on the disciplined strength of masses of people, the brusque heroic force of the leader, realized through stylized postures, accented lines, and the vast dimensions of the works. Alexander Deineka, a former poster artist, is the leader of this tendency. Its closest parallels are to be found in the work of the Swiss Ferdinand Hodler, in his mysticism of force and his brutality. It is a military-athletic style of masculine figures, parade

forms, monumental posters of authority and masses of human beings as unindividualized disciplined energetic fighters. During the last few years similar styles have appeared in Germany and Italy and Poland.

The nonpolitical art in Russia continues the middle-class liberal art of the last century. The paintings of industry, images of factories, bring us back to Adolph von Menzel and Constantin Meunier and the early Impressionists, but are less poetic and serious, less human in their emphasis on the mechanical and the gigantic, an emphasis that is utterly unimaginative and has not profited by the perceptions of the Futurists, the Constructivists, and men like Fernand Léger. The agricultural paintings are tourist images celebrating the sunshine on the farms, the vast fields and crops, the handsome farmers; they are like the academic pictures of other countries glorifying the happiness of the provinces. They pass imperceptibly into painting of sex and recreation and sport, illustrations of the picnic, courtship, summer idylls, and vacations, and the statues of athletes, a crude Hellenism of the naked body as a purely physical unit in a moment of competition. This art is impersonal and unpsychological, possessing an animal complacency without the charm of Auguste Renoir or the culture of the senses that we enjoy in the best Impressionists. It corresponds to the emergence of a labor and bureaucratic aristocracy that is plebeian and enjoys a petty bourgeois leisure. No problems exist for these people; they are contentedly enjoying life as Stalin has commanded them. The Russian painters are even more unfortunate than the Americans; they cannot paint starvation and misery, which exist in Russia and which at least provoke a keener small eye for the picturesque.

If there is a superior art in the book illustrations it is because the classics illustrated still offer to the artist a higher field of perceptions and impel him to imagine beyond the conventional complacencies of a socialist Cockaigne the actual struggles of the individual, and the ambiguities of history. The book as a private object still admits an intimate art of engraving.

The spectacle of Russian art today would seem to be a living refutation of the current arguments for Social Realism, for revolutionary art, or for an art inspired by socialist ideals. But this Russian art is neither revolutionary nor socialist nor realist. It is the crude mass product of the steady bureaucratizing of the Russian state since 1919 or 1920. If some

Marxists have asserted in a dogmatic manner that there is a direct dependence of art on the political order and that all art is propaganda, the present government of Russia seems to have set about to make all art serve the state directly, as if to fulfill the doctrine. Was not the doctrine perhaps a direct reflection of the will of certain dominant sections of the Bolshevik Party to subordinate all social life to the requirements of the state power? But this is not a necessary Marxist view and runs contrary to the whole tradition of socialist freedom and the democratic values of the proletarian revolution. The sympathizers in capitalist countries who echo these doctrines or tacitly accept the present state of Russian art as a model for their own countries do socialism the greatest disservice and even hinder the development of art in Russia.

Today more than ever the bankruptcy, politically and culturally, of the Soviet-led revolutionary movement and the imminence of catastrophic impacts in the capitalist world set before the serious artist and intellectual the necessity of judging his society and reformulating his goals. And this will undoubtedly direct the artists to new experiences and problems that will, in turn, transform their art. The response of painters like Picasso and Miró to the Spanish uprising, and of Max Beckmann to fascism, is a sign of the new direction. The artists have reacted spontaneously to their horror and oppression, not according to a doctrine or command. And in this fact lies the hope for a living modern art on a level of everyday awareness.

In the United States, the predominance of academic and figurative art, the general repugnance to abstraction, made it easier to preach the notion of a realistic revolutionary art. It won the painters who were torn between nature and abstraction and who found at last a nature elevated by a doctrinal consciousness and an historical perspective. But today this consciousness and perspective have been dimmed and obscured by new interpretations that bring the passive artists back to the academic and national interests that they once denounced.[2]

PROBLEMS OF REVOLUTIONARY ART

The modern painter who wishes to represent social reality and revolutionary struggle—this entails attentiveness to human life and char-

acter—has far greater difficulties to overcome than does the poet or novelist. These have always dealt with human beings, even when literature was most aestheticized and indifferent to social reality. The models of the self-absorbed literary artist have been writers like Proust and Joyce, who, whatever their indifference or insensitiveness to large sections of society and to whole fields of human action, have a marvelously sure perception of individual feeling. The modern writer had to be attentive to the minutest variations of internal life; in his subjectivity, he was a delicate and refined observer. The great painters of the same time, men like Picasso and Matisse, on the other hand, have only the slightest interest in acting and feeling human beings. They convert the human subject into an abstruse arabesque or intense spot of color. Their human beings are faceless or expressionless, separated from each other, or bound together through deformations that negate their human character or their psychological richness; they are ultimately still life, if the natural shapes are preserved. This reduction is not inherent in art, but in a certain style of art, a style that had an historical necessity, but not the eternal validity that is claimed for it. But even the more realistic contemporary artists have much the same character. Those who in opposition to abstract art call themselves objective painters are scrupulously objective about apples, pots, furniture, buildings, machines, mountains, nude bodies—essentially impersonal objects. The objectivity is tied to neutral things, to elements that lack entirely an essential interaction, that do not communicate with each other, or that show the effects of active pervading forces. This is evident even in the forms of such pictures in the peculiar arabesques and cryptic, arbitrary juxtapositions.

The writer who becomes a Communist cannot help but inject his new philosophy into his writing. As a writer he is dealing constantly with human beings and the situations out of which have grown his revolutionary convictions. There is hardly a corner of human life that is not put into a new light by revolutionary philosophy. In becoming a revolutionary writer he has sometimes only to extend and deepen his ordinary range of observation and interests rather than to turn to an entirely new material.

For the painter, on the contrary, it is possible to remain attached to "pure" art long after his new convictions have ripened. His work may

appear to him independent of society, since it is not primarily a representation. It has its own system of signs and values, like the work of the mathematician, which is unaffected by social convictions.

When an artist who has painted in this manner resolves to paint a momentous or moving reality, which today is the reality of class struggle and the decay of capitalism, he experiences the utmost difficulty in conceiving his new material. His whole practice of art has unfitted him for the representation of a large field, dense in meanings, with interacting, changing, differentiated human beings. He must create for the first time images of great occasions, continuities of action with gradations of feeling, the plastic equivalents of complex ideas, and the realities of environment as acting on masses of people and yet as the creation of these same people. If art were simply a synthesis of form and a subject, one could say: The talented painter who has occupied himself so long with form has only to acquire the "right" content and add it to his form, and he will have produced a successful art. The reason this cannot be done is not merely that a new form is required for the new content, but that the older form was inseparably tied to attitudes that still govern his seeing and feeling. Extreme aesthetic specialization has come to determine the kind of objects and relationships that will interest him as well as the way he will paint them. His material has hitherto embodied contexts of private activity, of self-contained and inconsequential play, of contemplation and pure visual enjoyment. His elements were rarely enveloped in meanings, allusions, undertones of sentiment, real experiences in the everyday world, which played a formative role in the conception and had to be weighed consciously in the process of painting. He had never to say to himself that such and such a coloring or arrangement was not right for the conflict or action he was representing. The neutrality of meanings was not an absence of meanings, but a reference to a world in which all objects are instruments of individual pleasure or contemplation (flowers, cards, mandolins, faces, grotesques, etc.) and have no important consequence. It is, therefore, extremely difficult for the artist to weigh his forms in terms of meanings and to explore his subjects for their more detailed significance. Years devoted to cultivating such a neutral sensibility so govern the eye and the mind that for the painter to move to a realistic social art requires a drastic change in his whole activ-

ity. It is not that he ceases to be an artist in the older sense, but that he confronts at every point problems entirely foreign to his older habits. For a gifted abstract painter, the determination to be a revolutionary artist, or the very idea that he must become one, may have a demoralizing effect; it may create an internal crisis in which the artist is neither the one thing nor the other and trembles to take brush in hand. He has, besides, a difficult economic problem, more difficult than the writer's. The writer's skill permits a variety of livelihoods, compatible with his chief goal; whereas the revolutionary painter creates an unsaleable commodity that absorbs his whole effort. Neither the working-class nor the middle-class sympathizers can buy oil paintings, and mural painting is even less reliable as a source of income. That artists today, nonetheless, have the will and the courage to enter on this difficult path is a powerful sign of the bankruptcy of capitalist culture. It promises so little to the sincere artist, it antagonizes him so completely, that revolutionary sympathies are increasingly common, almost a matter of course, among young painters.

The artist who has gone beyond the stage of inserting into a painting, conceived entirely in terms of his original subject matter and form, some detail that signifies, however vaguely or precisely, his new revolutionary sympathy, will seize first upon the most striking and common aspects of the world he wishes to render, just as an archaic artist draws an object in its simplest form and makes the few parts equally clear. He identifies the revolutionary struggle with the demonstration, the picket line, and the unemployed, or with the obvious personifications of the capitalist class. This in itself is not a weakness; but we must confess that we still have no satisfactory, no "classic" representation of even these themes, which are so simple and so frequently attempted. In general, they are rendered as spectacles; the appearance or composition of the scene predominates over its inner life, its psychological tensions and latent meanings. These do not presuppose qualities intrinsically foreign to painting; they are situations that may be realized concretely through painting, as we can judge from the dramatic and psychological values of older arts. The difficulty is not that the solutions hitherto achieved are static, but that their movement is mainly picturesque or formalistic, involving on the part of the spectator a merely complementary filling out of the sug-

gested objects in the scene, a recognition of places and types of person, rather than an active penetration of a densely worked out picture, with an inexhaustible richness of human relationships. But as little as one can penetrate a flat surface, so little can one penetrate a representation devoid of meanings. The purely formalistic study of older arts has blinded painters to the richness of significance in these past works, a richness manifested in postures, gestures, expressions, and formal devices, which are still legible, despite our ignorance of the original meaning and symbolism of the whole.

It must be pointed out, however, that the artist's experience as a "pure" painter is not altogether a hindrance in his new art. It is not merely that the old technique and developed sensitivity to colors and shapes and handling are still valid—to a certain degree these are conditioned by the underlying attitudes of the painter and may have to be changed. But there are intimate conditions of his former practice that survive in the new art in a transfigured and heightened way. He is not passing from an art of pure fantasy to an impersonal realism, but from an inventive, resourceful, highly conscious manipulation of neutral shapes, to a representation of reality that requires the utmost imagination, individual inventiveness, and flexibility of form. The world he now wishes to depict is too complex and many-sided to be photographed in cold blood. His view of it embraces such energies and interplay that his perception of the simplest event must embody more than meets the eye, and no single scene by itself can be wholly adequate or the highest goal of his realistic imagination. He must develop, if he wishes to attain the desired intensity or comprehensiveness, formal devices that, while foreign to the snapshot appearance, are capable of widening and deepening the scope of the meanings in a representation. In this effort he maintains the traditions of conscious formal freedom established by the art of the last thirty years, but on a new plane and in a context that thoroughly transforms the original sense of this artistic independence. The revolutionary cartoon and mural exhibit this continuity of art to the highest degree; in their most realistic aspect they are much less realistic than the corresponding easel pictures and often recall the creations of abstract art; but they are, in consequence, far more compact or extensive, pointed or thorough, in their realism.

The revolutionary artist does not find at hand an already digested material, a repertoire of traditional compositions of important subjects, like the old church pictures of Christ Enthroned, the Baptism or Crucifixion or the Last Judgment, from which he can proceed. He begins as an individual artist who must create his own themes as he created his abstractions or neutral compositions of objects. He has the whole responsibility of his conceptions. There are no formulas or prescribed rules of revolutionary painting. He is absolutely original and individual in creating this social art, which binds him to a group. As a member of this group he shares a common experience and is stimulated and guided by general principles and practices that have crystallized in long struggles and constant discussion. But as an artist he requires now a courage and self-reliance of an order other than his self-reliance as a pure artist. For whereas in the latter situation he judged his works in an absolutely sovereign spirit, admitting no judgment of a layman, his work now is addressed consciously to the masses as well as to artists. He does not merely desire the masses' respectful approval as a sign of his technical success; he desires their critical absorption of his work as a sign of its real effectiveness. In addressing himself consciously to a wider and more serious audience to whom the subjects of his art are their most vital experience and matters of life and death, he takes on a series of new responsibilities, practically unknown to artists in the past.[3]

(1938)

[1] Dated August 21, 1938.

[2] Dated August 21, 1938.

[3] The essay was retyped and signed—Meyer obviously was going to publish it. It is not dated, but may also date from 1938 when he was writing on Revolutionary art.

That he had been thinking about the subject for years is evident from his sharp, highly critical review of the John Reed Club Art Exhibition, "The Social Viewpoint in Art," published in Feb. 1933, pp. 23–24 and his later reply to Jacob Burch's defense of the show in the *New Masses,* March 1933, pp. 26–27. These articles can be conveniently read in the reprint of *Quait* (that the author was Meyer Schapiro was unknown to the editor) in *Social Realism as a Weapon,* David Shapiro, ed. 1973, pp. 66–73. [—Lillian Milgram Schapiro]

THE FINE ARTS AND THE
UNITY OF MANKIND

O NE OF THE CHIEF VIRTUES DISCOVERED IN THE FINE ARTS IS
their exceptional power of unifying mankind. Where the litera-
ture of foreign nations and of past cultures is accessible only across the
barrier of language, the works of painting, sculpture, and architecture
may be enjoyed directly through the eyes and the humanity of their mak-
ers experienced in the expressiveness of forms. The minds of all the peo-
ples of the world are brought to us through their visual arts. We may be
unable to converse with a Chinese or Hindu in his own tongue; we
would have the greatest difficulty in sharing his way of life; but through
his imagery and design, his heart and deepest thoughts are directly avail-
able to us. The experience of art is, therefore, felt to be more than an
aesthetic delight. It contributes to the real fraternity and mutual under-
standing of mankind. All this is taken so much for granted that, as in
other matters where there exists a wholehearted assent, its grounds and
implications are hardly ever pursued. The principle of the universal kin-
ship of the fine arts is adopted as axiomatic, and from it is deduced the
necessity of more college courses in the history of art or more funds for
museums. I propose to consider here the grounds and consequences of
this belief in the unifying power of the fine arts.

In the first place, it is important to recognize that this receptiveness to
the art of all mankind is only a recent and modern thing. It is inconceiv-
able before the nineteenth century. We cannot imagine such latitude of

taste in the Middle Ages or the Renaissance. Albrecht Dürer might admire the beauty of Aztec metalwork, and Montaigne after him might be charmed by the naive patterns or West Indian stuffs; but vast regions of foreign and even European art would be excluded from their view as contrary to the true nature of art. It is unlikely, moreover, that the old curiosity about exotic arts led people to discover and to value the "minds" of their makers. The feeling of cultural distance between their own and the foreign arts blocked such cultural fraternization as we enjoy today. John Ruskin, who was one of the most passionate critics of the nineteenth century and was most keenly aware of the universally human in art—he did more than anyone in England to make the Gothic primitives aesthetically available—could write in the 1850s that Englishmen had the duty to preserve all the old European art that survived; for outside Europe, what art is there? he asked, "None in America, none in Asia, none in Africa; in Europe alone, pure and precious ancient art exists." If, then, we suppose that art is an international tongue and that humanity may know itself as a single whole through the fine arts, we must also recognize that this possibility was admitted by civilized mankind only recently and is largely the result of modern conditions, including the advanced arts of our own day, which have shaped our present tastes.

This fact, obvious as it may seem, is worth mentioning, since some writers who hold up the primitive and medieval arts as models of true art, in contrast to the presumed eclecticism and aestheticism of our own time, are unaware how much their own responsiveness to these distant arts and their arguments about the universality of a certain kind of art as a vehicle of perennial human values rests upon modern taste. Without the contemporary art that they exclude from the true arts, the latter would hardly exist for them, at least in their present breadth.

But this openness of our taste, unique in the history of mankind, is less extensive than we suppose. We imagine, because one is able to pass in the museums without inward constraint from the room of Italian quattrocento art to the room of African primitives, or from the Impressionists to the Egyptians, that no art in the world, past or present, holds plastic or spiritual secrets from us. We imagine that once we have given up the standards of realistic and Classical art and have freed ourselves from the criteria of exact representation or harmony with nature

or a special norm of spiritual greatness, our receptivity is complete. But I dare say that in twenty years from now our judgments of many arts, registered in the magazines and newspapers and sales prices and historical books of art, will seem shortsighted and even foolish, just as the judgments of 1900 sometimes strike us as blind. Our enthusiasm for newly discovered primitive arts is kindled by energies and desires that are often diverted from other tastes. If we come to admire Oceanic art, we can barely tolerate Greek sculpture, except in its most barbaric phase. If we experience with rapture the wooden African idols, we turn away from the Benin bronzes as hybrid, impure works, too naturalistic to carry the vital impulses of their primitive makers. Whoever has followed the oscillations of taste during the last twenty years must have observed the instability of these judgments; even Cézanne, who has entered the books as the classic modern, has become a bore to many painters, and one may predict that if Georges Seurat's star is rising, he will appear before long as a dry and pompous intellectual, dreadfully stiff, a willing accomplice of the mechanization that was overwhelming modern society and was forcing more sensitive and humane artists, like van Gogh, into an antimechanical art of spiritual protest. I do not share these opinions. I simply point to trends of aesthetic doctrine in order to show that our liberality toward the most varied styles and our eagerness to enlarge the aesthetic horizon do not exclude a certain narrowness and arrogant partisanship in taste, especially when we attach ourselves to the newest creative ideas in art.

But there is a more serious limitation in the modern universality of taste. It lies in the grounds and content of our judgments of the foreign, ancient, and exotic arts. How is it possible for us to enjoy all these strange objects that our parents and grandparents found merely curious or grotesque, when not ugly and incompetent? It is possible because we have discovered a common element in all art (independent of representation), expression, or design, which has acquired a preponderant importance because of the aims of modern painters and sculptors. Our response to primitive works is, therefore, often only a search for qualities that we value in modern art. When a critic describes an African sculpture, he tends to see it as a Cubist object; his description is all planes and lines and volumes and masses; or, if he is an Expressionist,

234

then the work appears to him pure instinct and intensity and underground impulse, or the vehicle of a metaphysical worldview. The Surrealist finds in his favored objects mystery, disquiet, and the marvelous or some obscure symbolism of the unconscious. Now such characterizations are not necessarily false, although sometimes they are confused and say nothing intelligible. But they also make us aware of distinct qualities of past art that we have been unable to see up to that moment for want of the proper attitude and general ideas. I believe that the application to older art of the new concepts of structures and expression, which have been developed in modern practice, is a progress intellectually; for besides widening the scope of taste to include so many hitherto impenetrable works, they have deepened our understanding of the formal mechanics and expressiveness of art in general and have brought us closer to the artist's process. But that advance does not justify the belief that we have now gotten to the bottom of works that our ancestors completely ignored, or that we may now understand the soul of the primitive through his art in a degree impossible through other means. In admiring the geometrical forms of prehistoric art as examples of a pure creativeness, or as a manipulation of elements derived from the medium and the technique alone, we are admiring the prehistoric artist as if he were a modern man. Or, what unites him to us is the universality of a particular process of imagery, the mode of symbolic figuration common to children, primitives, untrained civilized adults, and modern artists who have been able to free themselves from the habits of naturalistic vision in drawing; in judging this mode to be superior to the traditional perspective drawing, we tend to disregard the less obvious individual peculiarities of primitive as well as modern work and misinterpret the naturalistic aspect of older art as essentially photographic and unartistic. In the same way, when we respond to the expressiveness of foreign arts, we isolate the physiognomic aspect of shapes as something universal, and we are inclined to abstract this aspect from the peculiarity of the culture and of people's thinking and feeling, as if the expression were also possible in our own day. In obliterating the real differences between these remote cultures and the modern, we are stylizing their arts into analogs of our own. And for this reason, our own arts are grasped in a vague manner, as a general formativeness or expressiveness

or fantasy that we do not have to penetrate very far once we have the conceptual key or have come to recognize a few of the signs of their modernity. The most unique, complicated, genuinely new structure of a Cubist painting is dissolved in the general concept of "design."

That is why we sometimes feel that this vast accumulation of art is only a small heap; that in bringing together so much in one room or between the covers of an illustrated book under a common title, we have imposed on them a monotonous sameness. For over twenty thousand years mankind seems to have been doing the same thing, arranging forms in space, making marks that smile or frown or show the rhythmical operation of the energetic hand. If we detect some differences, we order them easily into a few stages of a cycle, predestined in all the arts and observable in every culture. The universality of art is postulated as a restriction of possibilities, a reduction of all arts to a common denominator of modern taste.

Why is it impossible for the primitive or the Asiatic contemporary to share our perception of the universality of art? True, he may be aware that all peoples make implements and decorations and perhaps images; but these remain for the most part unintelligible to him; his own arts have a necessity arising from the conditions of his own culture, and he cannot admit the equality of the arts of other cultures, since their special aims or contents are for him unusable. Other peoples, other styles, he will say. It may be that our culture alone has reached a stage in development where art has been so far emancipated from extra-artistic demands and aesthetic theory so developed that a truly detached standpoint has been found for observing the universally human and grasping the common features of all arts; just as modern mathematics, which has recognized the arbitrariness or conventionality of special assumptions of Euclidean geometry and created other geometries proceeding from different postulates, has also formulated general transformation rules for relating a theorem of one geometry to a theorem of another, and has even created a pure geometry embracing them all. But there is reason to doubt that the contemporary view of art has reached that degree of detachment from its own special and often unconscious, extra-artistic assumptions, even if it be admitted that the modern concepts of form and expression, insofar as they are objective and controllable in their application, are a

great advance in that direction. For in practice, the experience of foreign and ancient art rests on the isolation of the forms from their original content and function and sometimes involves even a loss of concreteness in contemplating the forms themselves. An important aspect of older arts is necessarily slighted because of the bias occasioned by the nature of contemporary art. We are able to enjoy an idol, and images of Buddha and Christ, not only in complete indifference to their destination and meaning, but even in ignorance of these. The universality of our insight therefore rests on the exclusion of the cultural particularity of works from our vision. Those who concern themselves especially with those meanings are in general partial to a single kind of art or apply the conservative norms of style that limit the universality of taste. If we suppose that all art is accessible to us plastically, we must admit that this easy access entails for us today, on the whole, the avoidance of the original values of the works; it is therefore wrong to suppose that we have penetrated the essence of a culture when we have observed with sympathy its artistic styles.

The same may be said of the understanding of contemporary art as an expression of our own society or culture. As long as insight is restricted to the artistic as the formative and physiognomic, we will hardly be interested in the historical necessity of our art. Artists have, in general, a keen sense of the contemporaneity of their work; they see their art as the result of all that came before, and they sense also that it corresponds to a diffuse sentiment of people today, answering to spiritual necessities that the artists feel intensely and assume to be common to other awakened spirits. But this awareness of the modernity of their work, which is often a ground of judgment as when a Constructivist asserts that given our science and technology and need for clear thinking and efficiency, only mechanical abstract forms can serve as the themes for a great modern art—this awareness may be a principle of contraction in taste and in the perception of the contemporary world: It throws out as irrelevant all the opposed tendencies in social life; it disregards the sources and effects of the current of feeling that has been singled out as the specially modern par excellence; and it makes the artist and his friendly audience insensitive to the contrary moods in both modern and past art.

As long as our own art is not well understood in its peculiarity of style and in its historical necessity—that is, in its relations to the conditions

of life today—we are unlikely to control in a critical manner the biases that will be applied by modern taste to the art of the past or of other contemporary cultures.

Now these biases are present in our very description of universality. The belief that the essential in every style of art, what allows us to call it art, is the plastic coherence experienced in isolation from all other aspects, provides one of these dimensions. Another dimension is social: the belief that the people as a whole, the culture in its human extensiveness, is directly reflected or expressed in the art. Still another is the depth or organic completeness of the revelation: the belief that in knowing how people in different cultures have felt, imagined, and designed forms, we understand the driving forces and integration of their lives. Each of these beliefs is questionable, and false conclusions have been built upon them. It may even be asked whether they do not, under certain circumstances, contribute to divide mankind and to blur understanding.

The first bias assumes that in the productive activity of man, the formal is more essential and more valuable than the substantial and the practical. I do not intend to discuss here the distinction between form and content. I refer only to the narrower view, more common than is supposed, that the forms constitute the work and that the subject and the meanings are only its pretext or by-product. The meaning of the image, being ephemeral and tied to the service of cult or institution or magic, is less human, less universal than the style, in which a more basic process of figuration has been at work. This is not an academic problem of historical interpretation. We see its bearing in the kind of teaching that regards the aims of art as the self-sufficient manipulation of forms or direct expression of feeling—a view related to the idealistic history of mankind as a movement of ideas and styles. Or one may accept the differences as valid and necessary and maintain that through art alone one can come to comprehend this variety as human and good; the description of an odd custom will make us laugh or feel disgust, but the native work of art in which it is imaged will lead us to recognize the quantum of genuine feeling in this custom, the psychological reality of the primitive's attitude. In the first case, one disregards the alien content in order to focus on the pleasing or exciting forms; in the other, one observes the unique forms in order to reach a more sympathetic view of the custom. Both

approaches are apparent in studies of religious art. There are scholars and artists who love medieval art in spite of their distaste for Christian doctrines and rites; others are led to understand these, to admire them, even to adopt them for themselves, because of the powerful effects of the art. The late Eric Gill wrote that it was the music of the Gregorian chant that gave him the full certitude of the truth of Catholic faith.

The latter kind of approach is obviously impossible for someone who is concerned exclusively with forms. And without insight into the content of beliefs, habits, institutions, actions, it is an illusion to suppose that we understand other peoples. To attempt to do so would be like judging individuals by their handwriting alone, without ever venturing to read what is written, much less to consider their daily lives.

Yet even this attention to the content of art is limited and limiting if it is held to be a sufficient guide to human ends. What would we know of the world-historical significance of the struggles that made possible modern democratic ideals and to a large extent certain characters of modern art and even the notion of the universality of art that we are discussing, what would we know of all that, if we relied on the fine arts as our chief source? We may pretend to see these things in the qualities of the art of the middle class, as Hegel in interpreting the realism of Dutch art of the seventeenth century related it to their social life; but in accounting for this realism by the peculiar conditions of the Dutch people at that moment, he applied his knowledge of their political, economic, and religious history, which he could not have derived from the paintings themselves. One can easily multiply examples to prove that our best insights into the content of art requires the constant consultation of other documents and fields.

There are, however, critics and scholars who believe that the universality of art (and, indeed, its true importance) lies in its expression of certain perennial human ideals in a noble and moving form. Great truths of metaphysics, religion, and ethics are conveyed by art more effectively than through any other means. The ideas of Lao-tse, Buddha, Moses, and Plato, St. Augustine and St. Thomas, Eckhart and Blake, form a single truth, which is available in the great masterpieces of art. To grasp all these is to understand the unity of thought and the universe that thought comprehends. For this view the individualities of artists, the differences

between the works, are unimportant, the various styles are only an outward dress. The essential content of art reappears in various cultures and times, wherever these are true cultures, normal rather than diseased or decayed through loss of the essential truths. Art not only presents these truths, but the history of art demonstrates their universality and necessity in showing that they are held at all times and places by the noblest minds.

But this universality turns out, upon examination, to be something limited and arbitrary; for it excludes as many, if not more, works that express contrary beliefs and attitudes. The legends of creation are notoriously incompatible; the world is sometimes created by the fiat of a beneficent god, sometimes by an evil demon; sometimes it is self-created or evolved, sometimes it is generated by a sexual act. The pretended unity of metaphysical tradition is itself a myth, which has to be defended with the paradoxical assumption that the contradictory beliefs are only dialectical negations and the stages of ascent to a higher truth, reached in overcoming the negation. Under this theory there is no real error, and it is wrong for those who believe they possess an absolute truth to condemn error, since the latter must always be a partial truth and a step toward a higher doctrine that also abolishes their preceding beliefs. No, the unity of art cannot be grounded in this presumed perennial metaphysical content; the unity lies more likely either in the common processes of perception and expression or in the historical continuity of the developing functions and relationships of art, processes, and functions that operate in all subject matters and attitudes, in all materials and styles, and are therefore insufficient to determine the value of particular works incorporated into a larger mold of understanding built upon other sources besides the arts.

The assumption that there is in art an easy path to unity and an immediate insight into remote truths about the minds of distant peoples may stand in the way of the desired unity. Conviction that rests on immediate intuitive experience is obviously dogmatic and inflexible. The belief in the fixed psychological characteristics of races, the notion of humanity as formed of antagonistic breeds with distinct, inherent psychological dispositions, owes more perhaps to the insights of historians and critics of art than it does to biologists or scientific students of human

240

behavior. And the consequences of such beliefs we see in the fruits of imperialism and nationalistic policy. The perception of essential cultural and racial traits in art has done more to divide than to unite mankind.

On the other hand, the same method errs in creating a factitious unity where more critical methods of study bring out the fact of division, stratification, conflict in a culture. The political and economic historian observes different classes, with opposed conceptions of what is right and what ought to be; the historian is often inclined to cover up all this diversity and conflict either by disregarding the special class or institutional context of the arts he is studying or by blindly assuming that what he has found to be the mind of a particular artist represents the thought of society as a whole. The history of society becomes thereby the history of a single block, all of a piece; and for simplicity, its spirit is finally raised above the material world and exhibited as a thing in itself, wound up from within for a destined movement, as long as the energy of the concealed springs of the spirit is there to move it.

This tendency to substitute impressions of the art of a people for a study of its actual institutions and life brings us to the final aspect of the modern idea of the universality of the arts. The interpreters who sense the spirit and pattern of a culture through the arts sometimes pretend to give us an insight into history itself. They are ready to deduce the events of the culture, the changes, fortunes and destinies, from the character discovered through the works of art. A great scholar, Alois Riegl, in studying the Dutch group portraits, in an admirable work that should be translated into English, could not refrain from a footnote in which he accounts for the Boer War then current (1902) by the traits of character inherent in the Dutch people and manifested in the group portraits of the seventeenth century. Such an opinion, deduced from a systematic theory of racial psychology built upon the insights provided by works of art, is ridiculous as an attempt to explain modern political history.

As a means of promoting the unity of mankind, the insight into art is a questionable method as long as it rests upon the assumptions and exclusions listed above. One could argue that of all possible means of bringing peoples to understand each other the study of the fine arts is one of the most problematic and superficial. The aspect of literature that is always assumed to be its defect for this purpose is perhaps one of its

strongest qualifications as a means. To know a foreign literature well, one has to learn the language; but this is impossible without mastering a rich vocabulary of special terms, without reproducing an activity peculiar to that people, namely to read, write, and think in its language. If our understanding of classical and medieval and Renaissance art is so superior to our insight into Far Eastern and Central American arts, it is because we read the languages of the first group; we have the help of philologists (Nietzsche said: a philologist is a man who knows how to read) who have provided us with the means of entering more deeply into the culture of these peoples. And no doubt, our insight into Chinese and Indian art grows with the availability of texts and knowledge of their historical world. Even music has claims to a superior effectiveness in bringing to us the moods and dispositions of its creators, although I am not prepared to defend this seriously; the emotional suggestiveness of music is relatively more direct than that of the visual arts, more nuanced and like literature, destined for a fully attentive audience. The material character of the fine arts as precious objects often stands in the way of a full dedication of the observer. They are permanently stationed before us and therefore require no fixed, concentrated attention, like music, which can only be experienced when performed or reproduced, or like the poem, which has to be read through in a predetermined order; the fine arts invite a leisurely, random, recurrent perception; their works may be caressed and savored without being possessed intensely; they are the typical arts of dilettantism and bric-a-brac and interior decoration. I do not say this in order to discredit their value for the mutual understanding of mankind, but to make clear the difficulties that stand in the way of such a functioning of the arts.

Let us grant, however, that they can contribute to this—that the schooling that has awakened in the student an appreciation of the arts of all peoples past and present, insofar as they are available, and has at least taught him to open his mind to the impressions and delights that these arts may give him—such a schooling would also prepare the ground for a sympathetic attitude to foreign and less civilized peoples, since the student would take with him from such an experience of the arts the conviction that other human groups have an inherent dignity through their spiritual gifts.

Granted this, one could still ask: Is this a sufficient ground for developing a friendly, even fraternal, feeling among our people for other races, and especially for the repressed groups? How does this compare with other means for effecting the same attitude? And, secondly, how is it possible to create this attitude in the entire community?

The ideal of art as a socially unifying means is an extension to the whole of humanity of a function once limited to the particular group, whether civic, national, or religious. The monuments of Athens strengthened the sentiment of civic unity by recalling the common heroes, beliefs, rites, and legendary or historical experiences of the Athenian people; they created a constant image of local beauty that could be identified with this city alone, like the temples represented on the coins of Hellenistic towns as emblems of the localities. They pointed to the continuity of life and of ideals within the same place for generations and centuries. This kind of unification through art rests, however, on a conception of art different from that of the modern. For when we speak of uniting all mankind through art, we abstract art from those aspects of its original content and application that are local or national. We cannot share the beliefs of the foreign peoples, and even if we are led to see the common humanity in the particular beliefs, it is by virtue rather of desires and processes operating in the formation of these beliefs than of the original content, which was indispensable for those who created it. The sentiment of unity inspired by the recognition of the universally human in art cuts across group culture and denies the exclusiveness of ancient loyalties, or at least limits them. In this fact we can see the connection with our own times when local or national boundaries and interests have become problematic because of the extension of the economic sphere of any large powerful country to the entire globe and the global character of national conflicts. In wartime, the culture of a nation undergoes a curious interpretation; its national or local peculiarities are insisted upon and revalued as the highest achievements; at the same time, this national culture is actively propagated abroad and "exchanged" for the foreign cultures of allies or potentially allied nations. Such a practice presupposes that cultures are not inherently foreign or inaccessible, that the people of the different countries enjoy this modern aesthetic attitude, which is independent of local tradition. In the

Middle Ages, there is already something of this in the practice of sending with envoys to foreign courts precious works of art; the finely painted book of Bible images in the Morgan Library reached the Persian court from France in this way and was later brought back to Europe by a returning embassy. We see in this application of the concept of universality of art how it not only is bound to modern cultural conditions, but also serves economic and political interests, which are, in the long run, unfavorable to art, either through the violent destruction of the great surviving works of the past or through the impoverishment of humanity, which restricts the creation of new art and the development of culture in general. This is no argument against the appreciation of foreign art; it shows only how naive is the view that such appreciation is in itself an unequivocal instrument of mutual understanding and progress.

In the efforts of nations to establish cordiality with each other, there are two powerful means: the economic provisions for favorable trade (or military support) and a favorite means, the mutual acculturation of the two peoples by the exchange of works of art, by exhibitions, books, travel, tours. If the means are created for showing the peoples each other's arts, not because they will get to know each other through the arts, but because any friendly intercourse, any occasions of common pleasure, will unite people. The Peruvians who look at American films, the Americans who enjoy Peruvian textiles, do not arrive at any judgments of the peculiarity of each others souls; they are simply enjoying the arts, and there are few more innocent and reliable pleasures. To assume that the mutual prejudices are thereby overcome is more than doubtful. The foreign travelers in Italy in the nineteenth century had little respect for the "natives" whose ancient arts inspired them to ecstatic judgments. The colonial officials in Africa, Asia, and the Pacific who collected and studied the arts of primitives for the museums of the mother country sometimes with judgment and great insight could still regard these peoples as unfit for independence; their studies often were contributions to a field of ethnopolitics, which regarded with interest everything that could be learned about the native cultures as a means of keeping them in subjection. Even the solicitude of officials who were stimulated to preserve the native arts is suspect; by discouraging the assimilation of European culture, they withheld from the natives the

knowledge and the techniques through which they might win their freedom. The same paternal European appreciation of foreign cultures has operated in Asia to limit the aspirations of the indigenous peoples: By asserting the unchangeable psychic peculiarity of Asia as over against Europe, one tried to justify the domination of Europeans on that continent; one was glad to concede that the East was all spirit and the West matter, if only one could convince the Orientals that they should leave power, arms, trade, and industry to the Westerners and adhere to their ancient traditions. Experience shows us then how the appreciation of foreign arts as guides to the souls of foreign peoples may be an instrument of domination.

In our own country, the problem is more painful and close. We have a great minority, the Negroes, whose status, eighty years after the Civil War, is a scandal; in many communities, they still cannot exercise the rights guaranteed them by the Constitution, even during a war against fascism in which Negroes are members of the armed forces. Now it is notorious that for years the "inferiority" of the Negro has been justified through his arts. His so-called gifts for music and dancing were indicated as signs of his soul: He was accustomed to slavery, one said; he accepted his inferior place with cheerfulness; he was by nature an entertainer, a clown, a funny man, an energumen of expression; there are Negro educators who have tried to direct Negro artists back to the old African styles, as if these represent the inherent mind of the black peoples.

While philosophers and scholars dream of the unifying influence of art upon the whole of humanity, this unification is being effected practically and disastrously by contemporary American arts that are beneath their notice. The movies, the radio, and the commercialized music and dance of the United States are carried everywhere, like American machines, and replace the native popular arts. The products of Hollywood are accomplishing what the higher culture is incapable of doing, creating a worldwide audience with common tastes, idols, and reactions. Where the modern aesthetic viewpoint conceives of the unification in depth, in both time and space, through the understanding of the whole of human achievement, this new instrument of unity entails a narrowing of perception, an indifference to all that is not of this moment; neither past nor future exists for it, and whatever belongs to feelings and aspirations

other than those admitted to Hollywood is a dead or bizarre curiosity. Yes, an international popular art exists already, and anyone who takes seriously the ideal of a truly human, universal international culture must come to grips with it. It has defenders who maintain with some show of argument and with quotations from Aristotle and Thomas Aquinas that the people should get what is suited to their mentality and needs and that two arts are therefore necessary, one for the masses and another for the elite of culture. But it is doubtful that the movies are really suited to the needs of the masses—whether films, which create a false image of social life, which place in the foreground of their content the standards of success, morality, and human worth that permeate those films, contribute to the well-being of humanity.

The hostility of peoples is rooted in conditions that go much deeper than the impressions implanted by the study of art. The oneness of mankind may be admitted in principle by those educated in past art, but their response to the issues that divide mankind into antagonistic groups is rarely determined by this admission. More often, the insight given through art is used to justify disunity and oppression. And for the great majority of the people, who have little experience with exotic and ancient arts, this means of unifying mankind scarcely exists at all. As long as the human race is divided by the national and class stratifications, by barriers within society, the real unity of art and the desirable variety of its manifestations will hardly be perceived by more than a few individuals.

As long as our relation to the arts of foreign peoples is contemplative, they do not serve to unite us; for the meaning of their art to them, being practical and an element of a culture to which they cling, is not shared by us, and its significance to us, being a part of our own culture, is in a similar way unavailable to them. It is only when we attempt to participate in their life, or they in ours, when we acquire common aims, that the arts can become a means of mutual understanding. But our participation organically in their lives, as lived today, is not possible: We have no desire or right to convert ourselves into primitives or strangers; but on the other hand, we know that for them to be civilized and to enjoy the fruits of science and the results of our wider experience and larger tradition, it is necessary that they overcome not only the constraints of

their economic and social backwardness, but also the constraints of modern power. And in our belief that all peoples must become free, if wars and social catastrophes are to end once and forever, the confidence in the human worth of all peoples is supported by our admiration of their arts, which assume another physiognomy for us, when understood more deeply as both an aesthetic and a social necessity.

Our future is linked to that of the colonial peoples, not because we have to trade with them in order to maintain our own standards of living, but because the present intolerable division of the globe into the rulers and the ruled cannot be overcome without the cooperation of all the ruled in the struggle for a common freedom.

The trend to universality in art is based on the value of the individual, that is, the conception of humanity as made up of free individuals rather than of nations, races, classes. Just as Greek art strengthened the ties of Athenians with one another as citizens of the same community through their common participation in Greek art, so, too, can modern art strengthen the ties of all peoples with one another as participating together in a world art. The grounds of this world art are those contents of art that are rooted in the individual rather than in institutions, churches, states, and restrictive communities; they are the contents of individual experience, perception, desire, and creativeness; just as science is both individual and collective, local and global, and based on a common process of human intelligence and cooperation toward knowledge, so art strives toward a corresponding universality based on the common human organism and life problems. But the attainment of such an ideal is still remote; as an ideal it is limited to a few in each country; in totalitarian countries, it is even forbidden as an ideal, although the greatest teachers of the German and Russian peoples have avowed just such a conception of humanity and culture.

(1943, 1947)[1]

[1] Meyer Schapiro dated the end of the manuscript July 1943, but on a page in the manuscript in a marginal note, mention is made of Malraux, 1947.

JUDGING ART

THIS TEXT HAS BEEN INCLUDED BECAUSE IT REFLECTS A CRITICAL *way of thinking in which the point is made by witty fabulation. It possesses to a high degree the qualities of intelligence, affability, and humor that gave a characteristic charm to the converse of intellectuals of its century. Of course the problems posed here are hardly resolved and the issues are still with us.*

—Meyer Schapiro

GENIUS AND METHOD

There was an argument between Grimm and Le Roy about the genius that creates and the method that produces order. Grimm detests method; according to him it's the pedantry of literature. Those who know only how to arrange would do as well by keeping quiet; those who can learn only from what has been arranged would do just as well if they remained ignorant.

> Le Roy: But it's method that brings out what's good.
> Grimm: And that spoils things.
> Le Roy: Without it one wouldn't profit by anything.
> Grimm: Only by tiring oneself, and it wouldn't be better for it. Why is it necessary that so many people should know something beside their own jobs?

They said many other things that I'm not reporting, and they would still be talking if the Abbé Galiani hadn't interrupted them as follows:

"My friends, I remember a fable; listen to it. It will be a little long, perhaps, but it won't bore you. —One day, in the depths of a forest, there arose a debate between the nightingale and the cuckoo about singing. Each one prized his own talent. 'What bird,' said the cuckoo, 'sings as easily, as simply, as naturally, as rhythmically, as I do?'—'What bird,' said the nightingale, 'has a lighter, a sweeter, a more varied, more striking, more touching a song than my own?'

The cuckoo: 'I say very little; but it has substance and order, and one remembers it.' The nightingale: 'I love to talk; but I have always something new to say, and I'm never tiresome. I enchant the woods; the cuckoo makes them sad. He is so attached to his mother's lesson that he won't dare risk a tune that he hasn't taken from her. As for me, I recognize no master. I play with the rules. It is especially when I violate them that I'm admired. How can one compare his tiresome method and my happy flights!'

The cuckoo tried several times to interrupt the nightingale. But nightingales sing all the time and never listen; that is one of their little faults. Ours, carried along by his ideas, pursued them swiftly, without bothering about his rival's reply. However, after some debate they agreed to leave it to the judgment of a third animal. But where could one find this competent and impartial third party to judge them? It takes much trouble to find a good judge. They went looking for one everywhere.

They were crossing a meadow when they saw an ass, a very grave and solemn one. Since that species was created, none had borne such long ears. 'Ah,' said the cuckoo on seeing them, 'we are really lucky; our argument is a matter of the ear; there is our judge; God made him precisely for us.'

The ass was browsing. He hardly imagined that one day he would be a judge of music. But Providence finds amusement in many other things. Our two birds swoop down before him, compliment him on his gravity and his judgment, expound to him the subject of their debate, and very humbly implore him to hear them and decide.

But the ass, scarcely turning his big head and not losing a single bite, made a sign to them with his ears that he was hungry and that he wasn't

sitting in court that day. The birds insist; the ass continues to browse. In browsing his appetite is allayed. There were some trees planted as the edge of the field. 'All right,' he said to them, 'you go there: I'll come along; you'll sing, I'll digest, I'll listen to you, and then I'll tell you my opinion.'

The birds flew off very swiftly and perched on a tree; the donkey followed them with the air and pace of a presiding judge in cap and gown crossing the chambers of a courthouse: he arrives, he stretches himself out on the ground and he says: 'Begin, the court is listening to you.' It's he who is the whole court.

The cuckoo says: 'My Lord, don't miss a single word of my argument; note well the character of my song, and above all deign to observe its artifice and method.' Then strutting and clapping his wings repeatedly, he sang: 'cuckoo, cuckoo, cuckookoo, cuckookoo, cuckoo, cuckookoo.' After having combined this in all possible ways, he was silent.

The nightingale, without any preamble, deploys his voice, soars in the most daring modulations, sends forth the newest and most subtle songs; they are breathless cadences and notes; at times one heard the sounds descending and murmuring in the hollow of his throat like the water of a brook muffled and lost among the pebbles, at times one heard them rising, swelling little by little, filling the air and floating there as if suspended. It was in turn sweet, light, brilliant, pathetic; and whatever character is assumed it was expressive; but his song was not for everyone.

Carried away by his enthusiasm, he would still be singing; but the ass, who had yawned several times, stopped him and said: 'I surmise that all you have sung is very beautiful, but I don't get it; it seems to me bizarre, mixed up, incoherent. You know more than your rival, perhaps; but he is more methodical than you are, and as for me, I'm for method.'

And the Abbé, addressing M. Le Roy, and pointing to Grimm with his finger, said: 'He is the nightingale and you are the cuckoo, and as for me, I'm the ass who decides in your favor.'"

(Translated from Diderot, *Lettres à Sophie Volland*)

(1970)[1]

[1] Published in *Anon*, December 31, 1970.

LIST OF ILLUSTRATIONS

Philosophy and Worldview in Painting

FIG 1. Pierre Puvis de Chavannes, *Philosophy*, 1896, oil on canvas, 4.35 x 2.20 m, Boston Public Library.

FIG 2. Paul Gauguin, *Where Do We Come From? What Are We? Where Are We Going?*, 1897, oil on canvas, 139 x 375 cm, Tompkins Collection, Museum of Fine Arts, Boston.

FIG 3. Paul Klee, *Limits of the Intellect*, 1927, mixed-media oil and watercolor, 53.8 x 40.3 cm, Staatsgalerie moderner Kunst, Bayerische Staatsgemäldesammlungen, Munich.

FIG 4. Max Ernst, *The Little Tear Gland Goes Tic Tac*, 1920, gouache on wallpaper, 35.6 x 25 cm, The Museum of Modern Art, New York.

FIG 5. Giorgio de Chirico, *Great Metaphysical Interior*, 1917, oil on canvas, 95.9 x 70.5 cm, Museum of Modern Art, New York. Gift of James Thrall Soby. Photograph © 1998 The Museum of Modern Art, New York.

FIG 6. Giorgio de Chirico, *Self-Portrait*, 1913, oil on canvas, 80 x 53.1 cm, private collection.

FIG 7. Pablo Picasso, *Painter and His Model Knitting*, 1927, etching, 19.4 x 27.8 cm, illustration for Balzac's *The Unknown Masterpiece*.

FIG 8. Albrecht Dürer, *Artist Drawing a Model in Foreshortening Through a Frame Using a Grid System*, 1525, woodcut, from *The Art of Measurement* (Nuremberg, 1525) (B. 149), private collection. Photo: Foto Marburg, Art Resource, New York.

FIG 9. Jean-Baptiste Siméon Chardin, *The Monkey As Painter*, c. 1740, oil on canvas, 73 x 59.5 cm, Musée du Louvre, Paris. Photo: Eric Lessing, Art Resource, New York.

FIG 10. Pablo Picasso, *Still Life with Chair-caning*, 1912, oil and oilcloth on canvas edged with rope, 29 x 37 cm, Musée Picasso, Paris.

FIG 11. Jean-Baptiste Siméon Chardin, *Still Life with Haunch of Meat,* 1732, oil on canvas, 42 x 34 cm, Musée Jacquemart-André, Paris. Photo: Giraudon, Art Resource, New York.

FIG 12. Claude Monet, *Bordighera*, 1884, oil on canvas, 73.7 x 80 cm, The Art Institute of Chicago. Mr. and Mrs. Potter Palmer Collection, 1922.426.

FIG 13 Rembrandt Harmensz. van Rijn, *Hendrickje at an Open Door*, 1650s, oil on canvas, 86 x 65 cm, Gemäldegalerie, Staatliche Museen, Berlin. Photo: Foto Marburg, Art Resource, New York.

FIG 14. Jean-Baptiste-Camille Corot, *The Dance of the Nymphs*, 1850, oil on canvas, 98 x 131 cm, Musée d'Orsay, Paris. Photo: Giraudon, Art Resource, New York.

FIG 15. Jean-Baptiste-Camille Corot, *Rome: The Forum Seen From the Farnese Gardens*, 1826, oil on paper mounted on canvas, 28 x 50 cm, Musée du Louvre, Paris.

FIG 16. Caspar David Friedrich, *Monk Before the Sea*, 1808-10, oil on canvas, 110 x 171.5 cm, Schloss Charlottenburg, Berlin.

FIG 17. Gustave Courbet, *The Sea*, oil on canvas, 50.8 x 61 cm, The Metropolitan Museum of Art, New York, Purchase, Dikran G. Kelekian Gift, 1922 (22.27.1).

FIG 18. Claude Monet, *Garden at Sainte Adresse*, 1867, oil on canvas, 98 x 130 cm, The Metropolitan Museum of Art, New York. Purchased with special contributions and purchase funds given or bequethed by friends of the Museum, 1967 (67.241).

FIG 19. Claude Monet, *Rocks at Belle-Île*, 1886, oil on canvas, 60 x 73 cm, Ny Carlsberg Glyptotek, Copenhagen.

FIG 20. Diego Rodriguez Velázquez, *The Spinners*, or *The Fable of Arachne*, c. 1657, oil on canvas, 220 x 289 cm, Museo del Prado, Madrid. Photo: Alinari, Art Resource, New York.

FIG 21. Annie Wood Besant and C.W. Leadbeater, *Thought-forms* (London: Theosophical Publishing Society; New York: J. Lane, 1905), figs. 8-9.

FIG 22. Vasily Kandinsky, *The Last Judgment*, 1912, 34 x 45 cm, Musée National d'Art Moderne, Centre Georges Pompidou, Paris, Nina Kandinsky Bequest.

Social Realism and Revolutionary Art

FIG 1. Theodore Gericault, *The Raft of the Medusa*, 1819, oil on canvas, 491 x 716 cm, Musée du Louvre, Paris. Photo: Alinari, Art Resource, New York.

FIG 2. Honoré Daumier, *Third-Class Carriage*, c. 1863-65, 65.4 x 90.2 cm, The Metropolitan Museum of Art, New York. Bequest of Mrs. H.O. Havemeyer, 1929. The H.O. Havemeyer Collection (29.100.129).

FIG 3. Eugène Delacroix, *Liberty Leading the People*, 1830, oil on canvas, 260 x 325 cm, Musée du Louvre, Paris. Photo: Giraudon, Art Resource, New York.

FIG 4. Gustave Courbet, *A Burial at Ornans*, 1849-50, oil on canvas, 314 x 663 cm, Musée d'Orsay, Paris, Gift of Miss Juliette Courbet, 1881. Photo: Foto Marburg, Art Resource.

INDEX